BEYOND GLAMOUR

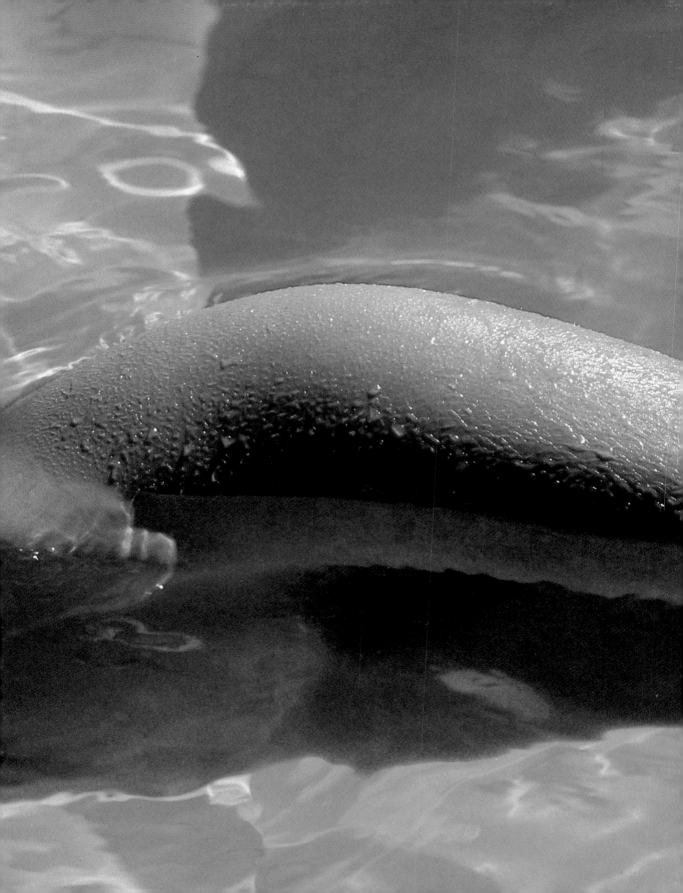

BEYOND GLAMOUR

A GUIDE TO NUDE PHOTOGRAPHY

MICHAEL
BUSSELLE

BLANDFORD PRESS
POOLE · NEW YORK · SYDNEY

Series editor: Jonathan Grimwood
First published in the UK 1987 by Blandford Press
Link House, West Street, Poole, Dorset BH15 1LL

Copyright © 1987 Michael Busselle

Distributed in the United States by
Sterling Publishing Co, Inc,
2 Park Avenue, New York, NY 10016

Distributed in Australia by
Capricorn Link (Australia) Pty Ltd
PO Box 665, Lane Cove, NSW 2066

British Library Cataloguing in Publication Data

Bussells, Michael
 Beyond glamour : a guide to nude photography.
 1. Photography of the nude
 I. Title 778.9'21 TR674

ISBN 0 7137 1650 9

Typeset by Keyspools Ltd, Golborne, Lancs
Printed in Hong Kong by Toppan Printing Co.

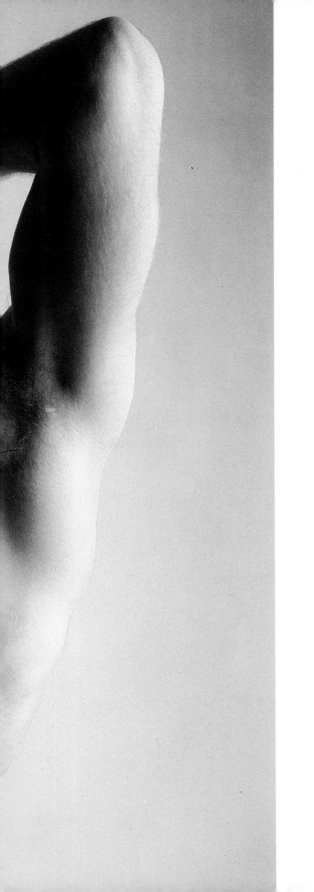

CONTENTS

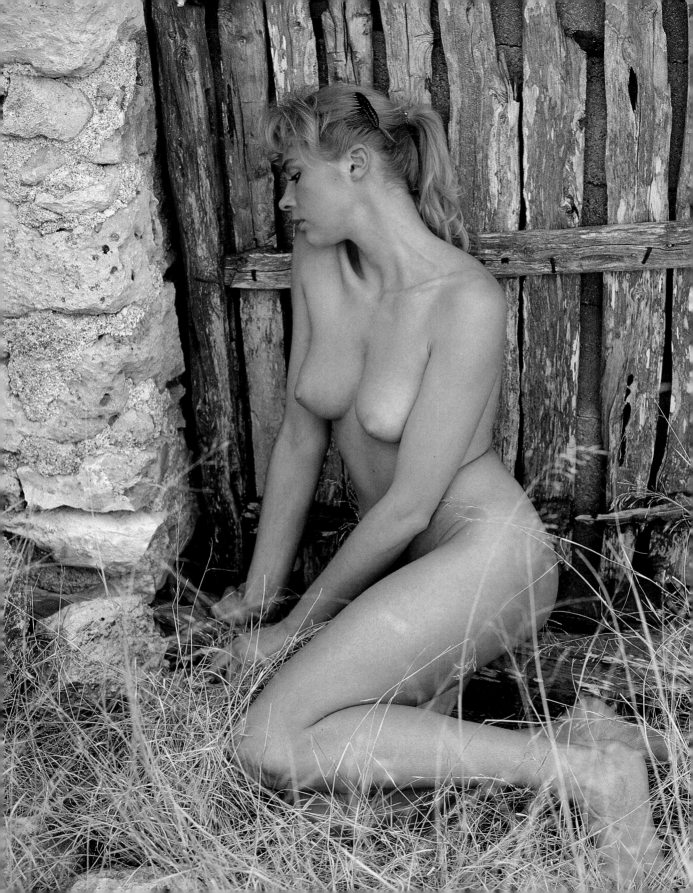

THE MODEL

Choosing a Model

The first step in a photographic session for portrait or nude pictures is obviously to choose a suitable model. The choice is a very important one. There are a number of points to consider and the first will probably be where to look. Model agencies are the most simple and direct means of finding a model and will provide you with a wide choice of different types and personalities. In addition such models will have a degree of experience and professionalism which can be a valuable asset, particularly if you are a beginner in this field.

You will find that most major towns and cities will have at least one model agency. They will have a register of all their models and will arrange for you to meet them and look at their portfolios. This will give you an idea of their range and scope. It is important to appreciate that by no means all models are willing to do nude work and you should make quite clear at the outset the type of pictures you want to take. In addition, professional model fees are quite high, especially for nude work, and if your pictures are for your own use rather than for publication it may not be

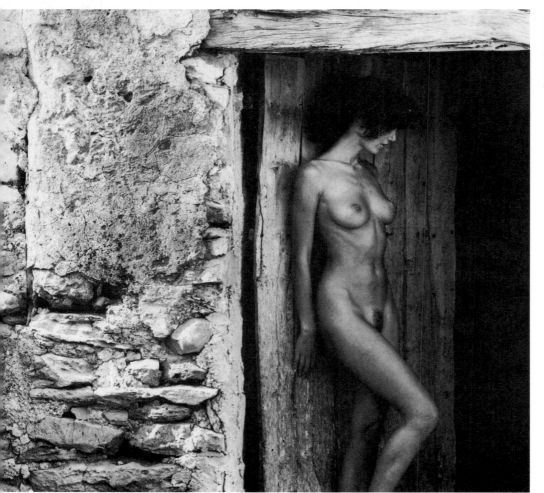

A professional model will have the advantage of being unselfconscious and have the ability to pose in a relaxed and natural way. *Rolleiflex SLX, 150mm lens, Ilford FP4, 1/125 sec. at f8.*

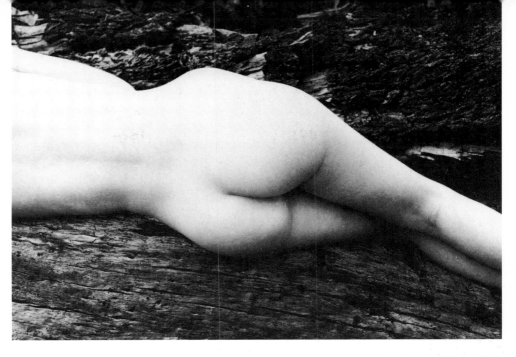

An amateur or inexperienced model can often be suitable for more abstract images such as this; the impersonal nature of such pictures can overcome problems of selfconsciousness. *Rolleiflex SLX, 150mm lens, Ilford FP4, 1/125 sec. at f5.6.*

possible to afford or justify such fees. Most model agencies however have a continual intake of new models and since they are usually inexperienced and need pictures for their portfolios it is possible to approach the agency and model concerned to arrange a test session at no cost. In this way you can offer the model the opportunity to gain experience and to supply a selection of photographs in exchange for their time. It is generally understood that pictures taken at such sessions will not be used for publication unless previously agreed. In any case it is very important to ask a model to sign a release form when photographs are intended for publication. This is simply a letter of agreement between you and the model giving you the rights to use the pictures for any agreed purpose.

In addition to professional model agencies there are a number of agencies which provide models specifically for amateur photographers. Such models are usually semiprofessional and their fees are correspondingly lower. They are often allied to a hire studio, and these can usually be located in the classified sections of photographic magazines. Another method of finding models, less expensively, is to approach the life class at a local art college or maybe a weight training or fitness class.

Most photographers, however, have friends or acquaintances who would make a suitable model if approached in the right way, and of course a personal relationship can help considerably to create a rapport and to make the session relaxed and enjoyable.

The next point to consider is what qualities to look for in a potential model, and this in turn will depend upon the type of pictures you want to take. In the field of professional glamour photography the range of suitability is very narrow. Most models who do this type of work tend to be, or become, stereotypes in order to conform to the media-fuelled fantasies of the glossy magazines. However when pictures are being taken for your own satisfaction the choice becomes much wider since you do not need to be restricted by these very limited concepts of beauty.

The most important qualities for a nude model are a relaxed and possibly a fairly extrovert personality, although this would not be so important with someone you know well. A good skin is also a consideration as is a body with pleasing lines and proportions. A plump and rounded body or a lean boyish figure can look as attractive as the conventional 'pin up' type of figure when photographing the female nude. The stereotyped shapely figure can even be a handicap when taking pictures of a more expressive or interpretive nature. The types of model favoured by photographers like David Bailey or John Swannel for example, are very different from those chosen by the photographers who shoot for the 'girlie' magazines.

11

Directing a Model

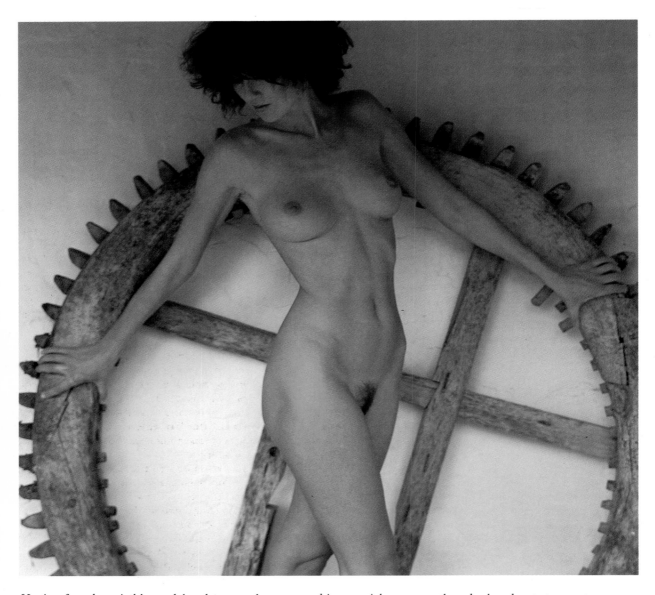

Having found a suitable model and arranged the first session, it is important to learn how to work together to produce the results you want. The first, and most important, step is to establish exactly what it is you want to achieve. Nothing is more likely to create an awkward and unproductive session than not having a clear idea of your objectives. Being

prepared is essential to a smooth and relaxed session. You should write down, or even sketch, the ideas you have for shots and list all the things you will need, such as props, backgrounds, clothes and even the type of lighting if used, together with any special lenses or accessories. These ideas should then be discussed with your model, ideally a day or

A photographic concept like this should first be explained, and then the model allowed to adopt a natural and relaxed pose without excessive direction from behind the camera. *Rolleiflex SLX, 80mm lens, Fujichrome RDP 100, 1/60 sec. at f4.*

so before the session. This will allow him or, more usually, her to become involved right at the outset and will enable her to contribute to the pictures in a more positive and practical way. She might, for example, have clothes or accessories which she could bring along to the session to help establish a particular mood or style.

It is also important to create a comfortable and relaxed working environment, whether in the studio or outdoors; privacy is obviously an important factor with nude photography, particularly when working with an inexperienced model. It can be very distracting to have people around who are not directly involved with the session, and you should ensure that you will not be interrupted. Since most sessions will last for several hours you should also consider the creature comforts. The studio that you use should be warm. If working outdoors make sure that there is somewhere comfortable for the model to relax and warm up if necessary

between shots. Refreshments are important and it can often help to have background music.

When setting up your first shot you should first talk through it with your model, explaining how you would like her to be positioned, and even describe the type of lighting or effect that you want to create. A good rapport is essential and this will be more readily achieved if you can communicate both your ideas and your enthusiasm. Posing is something that an experienced model will have an instinct for. A good model will automatically arrange herself in a pleasing and photogenic way and often all you will need to do is to make minor adjustments or even simply shoot as she alters her pose.

With an inexperienced model however you are likely to have to intervene more and possibly even demonstrate what you want. In some cases you might have pictures available which illustrate the type of pose you want, from a book or magazine perhaps. It is important, however, to avoid over-direction. Try to achieve what you want by suggestion rather than by asking your model to move specific limbs in a certain way or into a particular position. This will almost invariably produce a stiff and selfconscious effect. If your model is not comfortable and relaxed in a certain pose the result will usually not be worth having. If a certain idea does not seem to be working it is far better to abandon it and move on to something else. You can always try again later. To persevere fruitlessly for too long will tend to undermine the rapport you have built up.

It is also important to talk to your model. Keep up a constant train of conversation, encouragement and praise. Even an experienced model will find working in silence disconcerting and will respond best to favourable comments and flattery. With an inexperienced model it is essential to reassure her that she is looking good and that you are pleased with the pictures you are taking, even if you're not! A tripod can be a very important piece of equipment in this context because it enables you to set up, frame and focus your camera and then to leave it positioned allowing you to give more attention to your model. For the same reason it is also essential to be thoroughly familiar with your camera, lighting equipment and accessories.

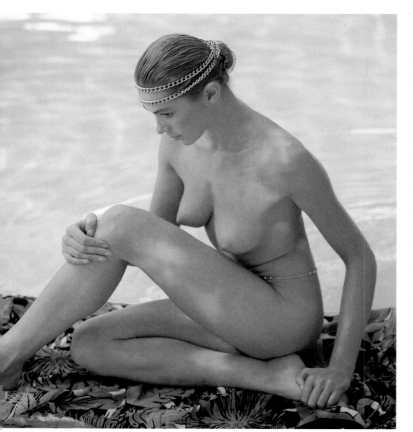

A discussion with your model prior to the session will enable her to contribute clothes and props, as well as ideas, to a picture or setting. *Rolleiflex SLX, 150mm lens, Fujichrome RDP 100, 1/125 sec. at f5.6.*

Hair and Make-up

With conventional glamour pictures the model's hair and make-up are given special attention, usually with the express purpose of creating a glossy, larger than life, image. However, when photographing girl models in particular, even a natural and uncontrived look requires some consideration, and there are often occasions if a particular mood or style is required when this element of a picture needs to be carefully controlled. In many professional glamour sessions a hairdresser is employed to create an elaborately styled effect with a model's hair, but this is seldom necessary for pictures with a less commercial purpose. However hair can be a problem even with the more simple and natural approach.

Loose strands of hair can look very unattractive and messy, particularly under backlighting or when shooting out of doors. The most basic care in this respect requires that the model should brush her hair to tidy loose strands and to lacquer them into place. With long, shoulder length hair, it may be preferable to ask the model to wear it brushed back off the face, perhaps into a pony tail, especially when shooting on location when there is a possibility of wind. Loose hair in such conditions can be very disruptive.

With girl models, it is seldom advisable to use no make-up at all, even if this is the effect required. When shooting full length pictures, or when the figure is small in the frame, it is usually necessary to give the model's face some extra definition. For this reason some eye and lip make-up is usually necessary especially when shooting in black and white. It is important to appreciate that the camera tends to accentuate any faults or flaws in the skin and the presence of freckles or blemishes will be much more noticeable in the picture than appears visually. You should be very critical of such things, particularly when quite close up or when tightly framed pictures are taken. An application of a natural tinted base or foundation make-up is usually all that is necessary to overcome this problem. This applies equally to a male model, especially if he has dark facial hair and a potential five o'clock shadow.

Few people have completely flawless bodies and a similar application of a tinted foundation should be used to mask any blemishes that might be visible in the picture. A point worth considering, long before the session starts, is that of tight clothing. The marks, made by a waistband for example, are almost impossible to remove with make-up and it is usually necessary to wait for some time for them to fade. It is obviously preferable to avoid them in the first place by asking the model to wear very loose clothing to the session.

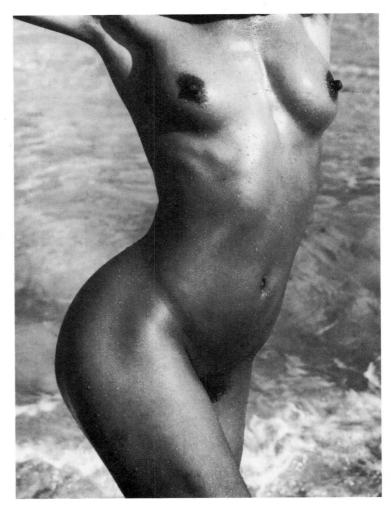

In its most basic form, make-up can be used to mask blemishes and enhance the appearance of the model's skin, such as is given by a light application of oil in this beach shot. *Rolleiflex SLX, 150mm lens, Ilford FP4, 1/250 sec. at f11.*

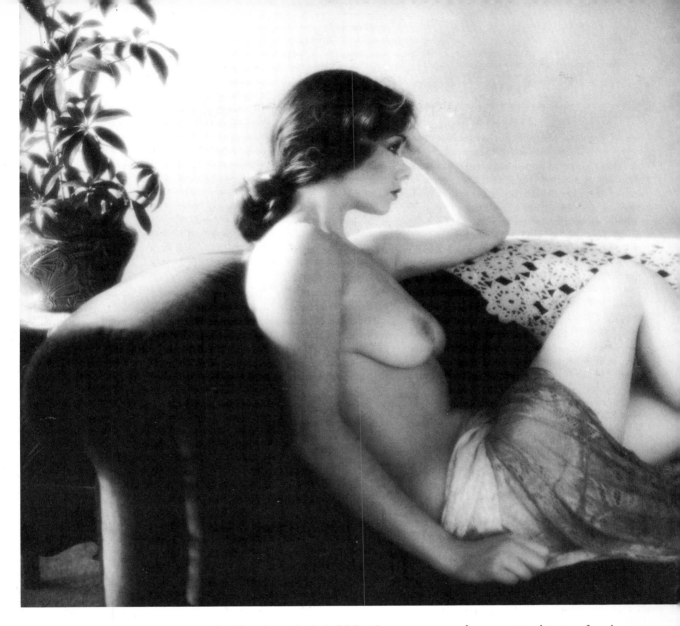

The model in this picture has used both her make-up and hair in a quite simple way, to help create successfully a slightly romantic, Victorian mood. *Rolleiflex SLX, 150mm lens, Kodak Tri X, 1/60 sec. at f4.*

In many situations it can be helpful for the model to apply a little oil to her body. A slightly tinted oil such as *Ambre Solaire* can help to give the skin some colour as well as a slight sheen, and in certain lighting conditions this can create a very pleasing effect. It should be well rubbed in, however, as a skin which is too oily will create strong, harsh highlights. This is particularly effective when taking pictures in which you want to emphasise skin texture, such as with a tanned body on the beach perhaps.

In some instances, as when creating special effects, it may be necessary to employ a more exaggerated or unnatural type of make-up. When taking black and white pictures with a red filter for example, normal lip colour will record as almost white and it is necessary to use a very dark, bluish, or even green, lip colour to make it record normally. There are also many ways in which the make-up itself can be used to create an unusual effect. However this requires a degree of expertise and unless the model, or someone else, has some experience with these techniques it is probably best not to attempt it. If it is not well done the result can easily appear crude and contrived.

15

Clothes and Accessories

It may seem paradoxical to discuss clothes and accessories in a book on nude photography, but they can be an important element of many pictures. In some instances they create a mood, while in others they simply add visual interest and create an additional element in the composition. In some situations a completely nude body is simply not appropriate. Another consideration is that some models may not be comfortable posing completely nude, and where clothing can be used in a natural context and not in a coy or selfconscious way this can be the best solution. Another point to consider is that of taste. Difficult to define at the best of times, taste can become a positive minefield in the realms of nude photography, and, while partial nudity is far more acceptable socially than it

was a decade or two ago, pubic hair and the male organs can create an undesirable response. It is sometimes better simply to avoid the problem by having your model partially clothed.

Since the purpose of this book is to deal with the less commercial and less glamourous aspects of nude photography, the traditional trappings of the professional glamour model are rejected in favour of more simple, everyday clothes such as shorts, skirts or even swimming trunks or briefs. Try to ensure, however, that the clothes you use do not look silly or out of place in the chosen setting or location. When working with a girl model, clothes with a soft and flowing quality can be very useful, adding an element of movement in outdoor pictures as well as being flattering

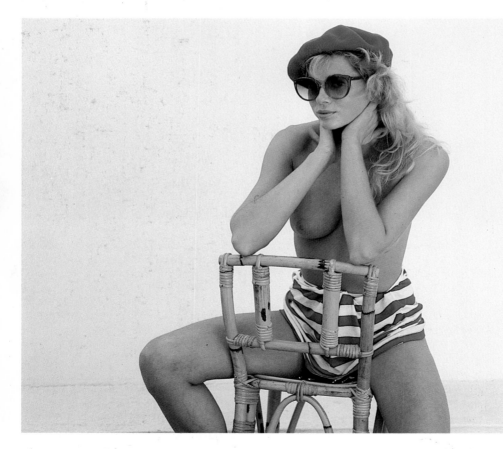

The blue beret and striped fabric around the model's waist provide the only primary colour in this picture, giving both additional interest and a focus of attention to the off-centre composition. *Rolleiflex SLX, 150mm lens, Kodak Ektachrome EPD, 1/125 sec. at f5.6.*

and sympathetic to the body. In this respect, often a length of fabric can be useful as it can be draped in a variety of ways, and a selection of colours and textures can help you to create a range of different effects quite simply and easily.

Both the colour and the texture of the clothes you use are a vital consideration since they will often be a dominant element of the composition. Colour can be used to create either a tonal or colour contrast, or alternatively to produce a soft harmonious quality in the picture. The texture of the fabric can also be used to create a strong photographic quality, especially when it is juxtaposed against skin. A dominant texture like silk, fur, leather or even a simple coarse cotton fabric can be used to create a strong tactile quality in the image. This can often be used to heighten the erotic element of a picture, when this is wanted.

Accessories, too, can be important to a picture. When photographing girls out of doors, scarves and hats can be helpful both as elements in the composition and also to help to control the hair when there is a breeze. Items like these can also be used as something for the model to hold, often helping to create a relaxed and natural pose. In some situations jewellery can be used to add interest and to create a mood or style, although you should be careful to prevent such things from becoming distracting. Quite often an interesting and attractive accessory can be used as a dominant feature in a picture, especially with close up or tightly framed shots. With a male model, for example, you might use a belt with a heavy or ornate buckle.

Clothes can also be used to add an element of modesty in nude photography – the belt and athletic support worn by the model in this shot allow more freedom in posing as well as being quite appropriate accessories. *Rolleiflex SLX, 150mm lens, Kodak Ektachrome EPR, studio flash at f11.*

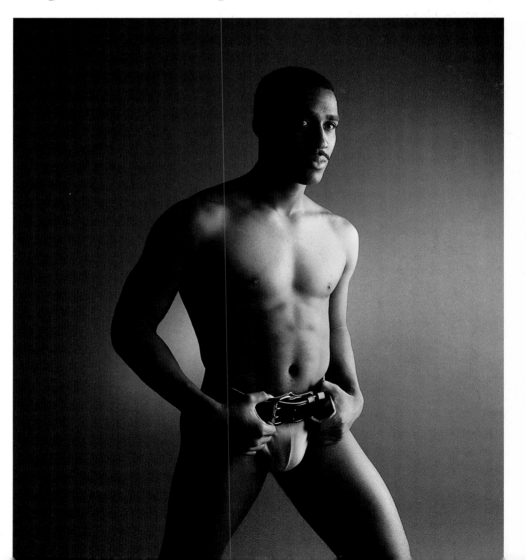

Posing for Head-and-Shoulder Shots

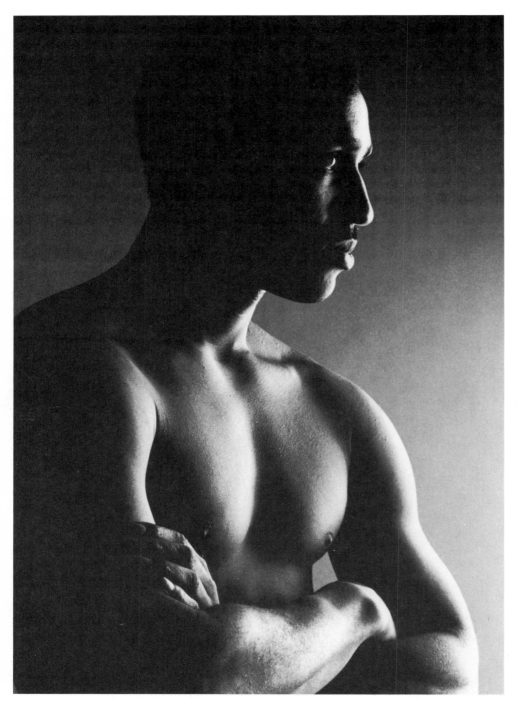

The model's folded arms in this picture help to create a degree of muscular tension, emphasising the powerful physique, which a lower camera viewpoint also enhances. *Nikon F3, 105mm lens, Ilford FP4, studio flash at f16.*

The first point to consider with any type of pose is to ensure that the model is both comfortable and relaxed. A possible exception to this might be when a particularly contrived effect is required or perhaps a body shot in which muscular tension is needed. For most head-and-shoulder pictures however this will not be the case. When shooting in the studio, and for this type of pose and picture, it is often most convenient to have the model seated. This is because the most pleasing angle for the face is usually obtained when the camera is positioned slightly above the model's eye level. A low stool is a useful item for this purpose because it will allow freedom of movement and will not encroach upon the picture area in the same way that a chair would. Where a less conventional, perhaps reclining, body position is needed, a low platform or even the floor could be used. A more elaborate piece of furniture, such as a sofa, could also be used as an element of the composition rather than simply as a way of supporting the model.

As a general rule it is best to avoid posing your model in a way that presents her too squarely to the camera. This can create a rather static and symmetrical quality and, unless this is the effect you want to achieve, it is more satisfactory to have the model seated one shoulder closer to the camera than the other. Most pictures benefit from having a suggestion of movement and this can often be created by asking your model to lean a little, either forwards or backwards. This could be done, for example, by using an arm on a knee as a support or leaning back onto an elbow. Alternatively you might consider using a prop or an additional piece of furniture to help in this way.

With all but the most close-up portraits it is usually necessary for the model to have something positive to do with her hands and arms, even just folding them in front or placing the hands behind the back of the neck. This too can have a beneficial effect on the way the torso is presented to the camera. A frequent technique of the professional glamour photographer is to ask the model to place her hands in her hair with the elbows raised high. This raises and improves the bustline. With a male model, folding arms can square the shoulders and create a degree of muscular tension which can produce a more pleasing effect. Often a prop or accessory can be used to occupy the model's hands and help to create a more relaxed and natural pose.

Sometimes it can be effective to have the camera at a much lower level. In this case it can be easier to have your model stand, or to place her upon a table or plinth of some sort when shooting in the studio. However with outdoor and location pictures both the position of the model and the camera angle are usually easier to vary because the restrictions of the background are not as limiting. It is also possible to make use of natural features, such as a tree, park bench or a fence, to create a natural support for the model. It is easier for the model in an outdoor situation because she will be able to find ways of posing using the surroundings in a more natural way. This can be very important when working with inexperienced models, when the rather stark and empty nature of a studio setting can be rather inhibiting.

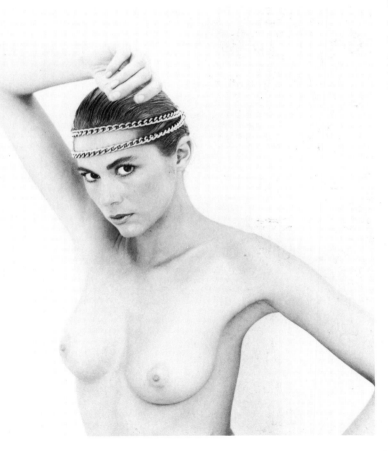

The model was seated in this shot, and the camera placed slightly above her eye level; allowing her to look up into the lens, which emphasises her eyes and produces a pleasing facial angle. *Rolleiflex SLX, 150mm lens, Ilford FP4, 1/125 sec. at f5.6.*

Posing for Full Length Shots

In a studio situation a full length pose without the aid of props or a setting can be quite difficult to achieve, particularly with an inexperienced model. Professional models learn the techniques of creating graceful and natural shapes with their bodies and limbs which introduce a feeling of movement. Glamour photographers often use quite contrived and extreme poses to emphasise the line and shape of the body but this can easily look silly if not done well and is, in any case, often inappropriate for work of a less commercial and more expressive nature. It is sometimes easier to make use of a piece of furniture or other prop to help the model to create a more natural and relaxed pose.

In many situations, however, such items are undesirable in the picture if the image is to be kept simple and uncluttered. A standing pose is probably the most difficult to achieve

naturally and it will help if you ask your model simply to relax as much as possible with her weight more firmly placed on one foot than the other. It can also help to place one leg in front of the other and to bend a knee slightly. The purpose of this is to avoid too static an appearance and to create a pleasing line without having to resort to exaggerated movements. As with a head-and-shoulder shot the position of the arms can also help to create an attractive body shape.

It is also important to consider the pose in the context of the lighting and the effect it has on the body. The composition of the image will be dependent upon the highlights and shadows that are created by the lighting as well as by the shape and form of the body itself. In this respect it can be helpful to ask your model to move around whilst you observe the effects though the viewfinder.

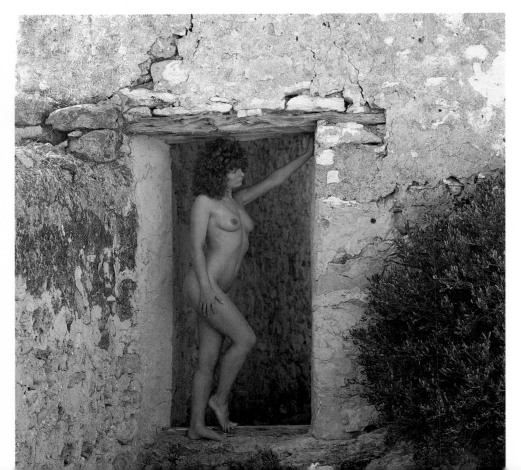

This full length shot, although quite static, has a suggestion of movement created by the model's pose. This helps to give a pleasingly simple outline to the body. *Rolleiflex SLX, 150mm lens, Fujichrome RDP 100, 1/125 sec. at f4.*

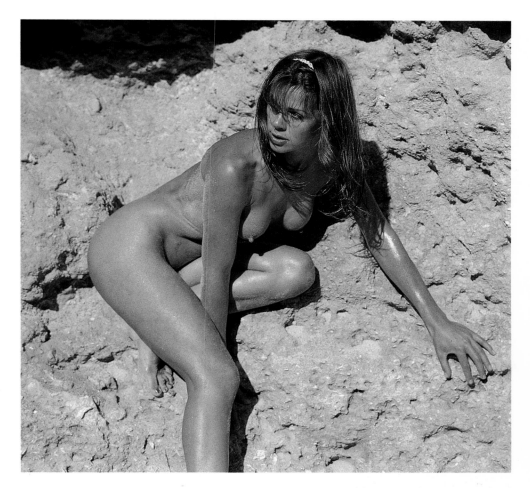

In this shot, although still essentially full length, the model has positioned herself to create a more complex and interesting shape with her limbs. *Rolleiflex SLX, 150mm lens, Kodak Ektachrome EPR, 1/250 sec. at f8.*

This movement will also help to prevent the picture from becoming static. In an outdoor setting there is more scope for varying the pose and body position, making use of the surroundings both as a support and as an additional element of the composition.

Of course a standing position is by no means the only way of posing a model for nude shots. A wide variety of body movements and shapes can be created by having your model sit, kneel and lie down. This can also help to create a wider range of lighting effects. A standing figure is, of necessity, usually lit from the side but with a reclining model both overhead and backlighting can often be used to good effect.

Although the exaggerated movements and poses used by professional glamour models are not usually appropriate for more 'serious' pictures, there is considerable scope for them

when shooting pictures of a more abstract or ambiguous nature. Poses of this type can create pleasing shapes and forms and add impact, movement and excitement to the image. The incongruity of such poses is not so intrusive when the image is no longer simply a photograph of a person. In this type of situation the contours of the body can almost be thought of as a controllable landscape, the movements creating a variety of shape, line and form under your direction. When photographing male models in particular it is also possible to make use of 'athletic' poses in which the limbs and muscles are tensed in order to emphasise this aspect of the body. With fairly close-up pictures in the studio this can be done without aid of props, but there is ample scope in an outdoor setting to use athletic or sporting equipment and situations to give additional interest to the picture.

More Than One Model

In nude and portrait photography the majority of pictures are of a single model. However the opportunities to vary the mood, style and composition of an image are considerably greater with two or more. The main hurdle is that of establishing a relationship between the models in such a picture, in terms of both the composition and the meaning. Two models simply standing side by side would be likely to be boring as an image and rather meaningless. With nude portraits there is also the question of taste to consider. The sexual connotations of a nude photograph are always present and with two models together the potential for creating a suggestive or tasteless picture is considerably greater. This is not to suggest that an erotic quality is undesirable, indeed many of the best nude pictures use this element to great effect, but it does need to be treated with sensitivity to avoid falling into the category of soft porn.

There are a number of ways of approaching this type of picture. The most basic is perhaps a simple double portrait in which the relationship between the models is established as being 'platonic', a couple simply having their photograph taken together, perhaps seated side by side with just a normal and natural contact such as an arm around a shoulder. This type of shot could be done in a

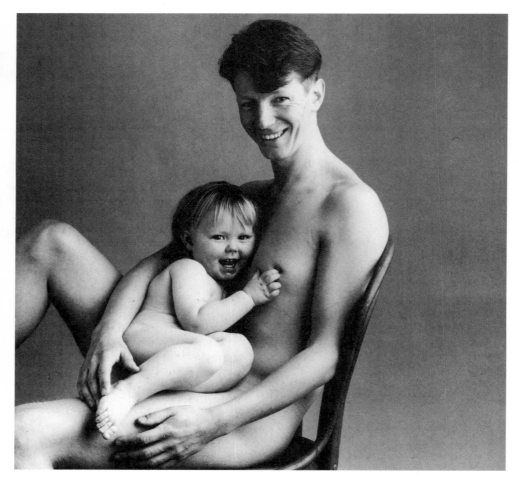

Parent and child invariably make an appealing picture; here, having their eyes looking into the lens gives additional impact, while their heads being at different levels avoids a static composition. *Rolleiflex SLX, 150mm lens, Ilford FP4, studio flash at f16.*

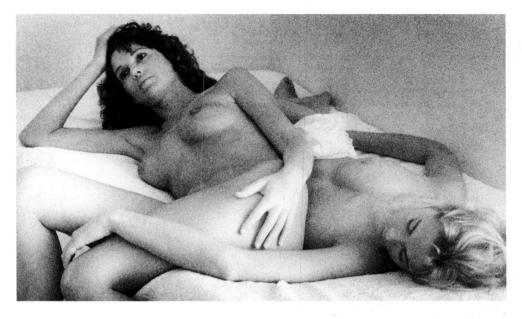

quite relaxed and convincing way with either two girls, two men, a man and woman or even a parent and child.

The essence of such pictures is to create a pleasing balance between the models' faces. In a waist-length shot, for example, the faces will be the focus of attention and it is important that this does not divide and confuse the composition. One way of avoiding this is to ensure that the two heads are not on the same level. One model could be seated on a low stool, for example, with the other kneeling forward onto it so that her head is slightly above and to one side of the seated model's face. It is important, however, to ensure that the two faces are at a similar distance from the camera. If they are at significantly different focussing distances it will not be possible to obtain sharp focus on both. In any case it is best to use a small aperture to ensure adequate depth of field. Another method of creating balance is to vary the angle of the two faces, perhaps one three quarters or in profile, and the other facing the camera.

The directions of the models' eyes will also be important to the balance of the image. The best ways of dealing with this are either to have both models looking in the same direction, or to have one model looking towards the other with perhaps the other looking into the camera. With full length shots balance can

be achieved by having one model closer to the camera than the other, or one model could be seated with the other standing. Another method of arranging the models is to have one facing the camera quite squarely and the other more in profile. The balance and composition can also be controlled by a contrast in types, the muscular body of a man against the softer, gentler contours of a woman's body for example, or dark skin juxtaposed against a light skinned model. In addition both clothes and props can be introduced to help to create a balanced and harmonious image.

The suggestions so far are essentially for a fairly straightforward portrait. However using two models can introduce a number of new possibilities when taking shots of a more abstract or ambiguous nature. It is in this context that it is possible to have much more contact between the models. Limbs intertwined, for example, can create a completely new range of shapes, forms and effects. When pictures of this type are quite tightly framed the personality and identity of the models becomes lost and the emphasis is placed more on the purely photographic qualities of the image. Another way of using more than one model effectively is to suggest a story or meaning within the picture. It does not even have to be explained, the viewers can be left to interpret the elements and mood you have created in their own way.

Using a Male Model

In classical art, painters and sculptors have used the male model as a subject for figure studies at least as frequently as the female model. Photographers however have, to a large extent, concentrated on the female form almost to the exclusion of the male nude. Even in the early days of photography, when most photographers were trying to emulate the work of painters, the male nude was given far less attention. In more recent times photo-

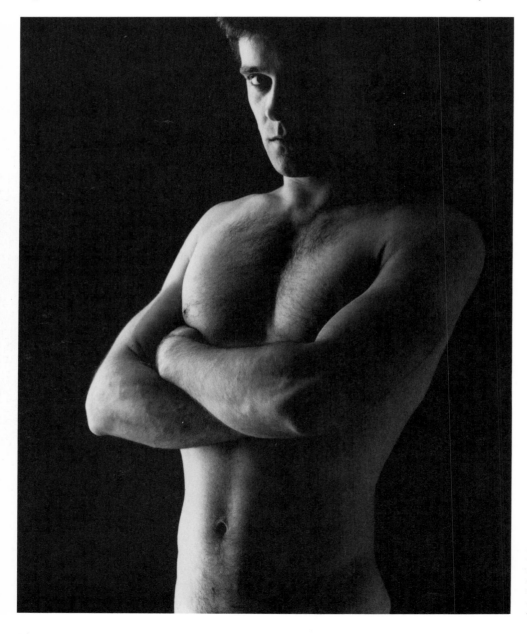

A well built, but not excessively muscular body, is ideal for male nude photography. In this shot, soft but strongly directional lighting has created a bold image and emphasised skin texture. *Rolleiflex SLX, 150mm lens, Ilford FP4, studio flash at f11.*

The model in this shot is a dancer and his finely tuned, lithe body lends itself perfectly to expressing movement and shape. *Rolleiflex SLX, 150mm lens, Ilford FP4, studio flash at f16.*

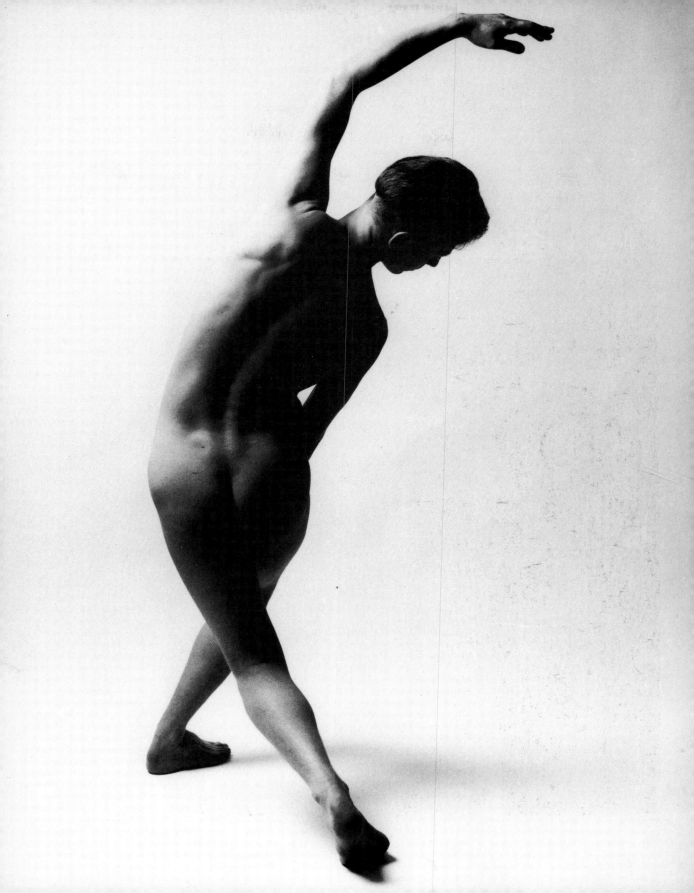

graphers who have specialised in the nude as a subject for their work have worked almost exclusively with women. One reason for this is that in commercial terms there is a much greater demand for nude and glamour images of women than there is for such photographs of men, but this still does not explain why photographers who are taking pictures of a personal and expressive nature still largely prefer to work with a female model.

It is certainly not because the male model is less suitable. Indeed the more defined muscular structure and skin texture of a man's body lends itself very well to the creation of images with a rich range of tones, form and shape – qualities which can be exploited fully in a photograph. In addition there is a tendency when photographing women to flatter and idealise the softer contours of the female form whereas the more angular and assertive nature of a man's body can encourage a more vigorous approach to both the pose, the lighting and indeed the overall mood of the picture.

How best to choose and use a male model? Perhaps the most obvious context in which a

A large, soft, diffused light – directed from almost right angles to the camera position – was used for this portrait. The model's essentially simple, relaxed pose echoes that of a fashion photograph. *Rolleiflex SLX, 150mm lens, Kodak Ektachrome EPR, studio flash at f11.*

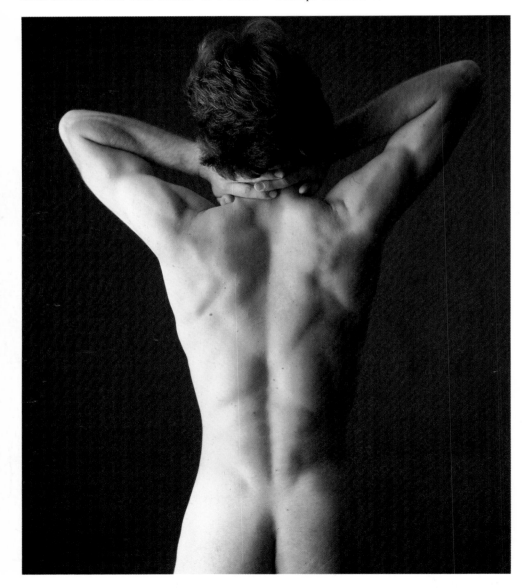

The male body is ideal for bold, abstract images like this, since strongly directional lighting can be used effectively to emphasise muscle tone and skin texture. *Rolleiflex SLX, 150mm lens, Kodak Ektachrome EPR, studio flash at f11.*

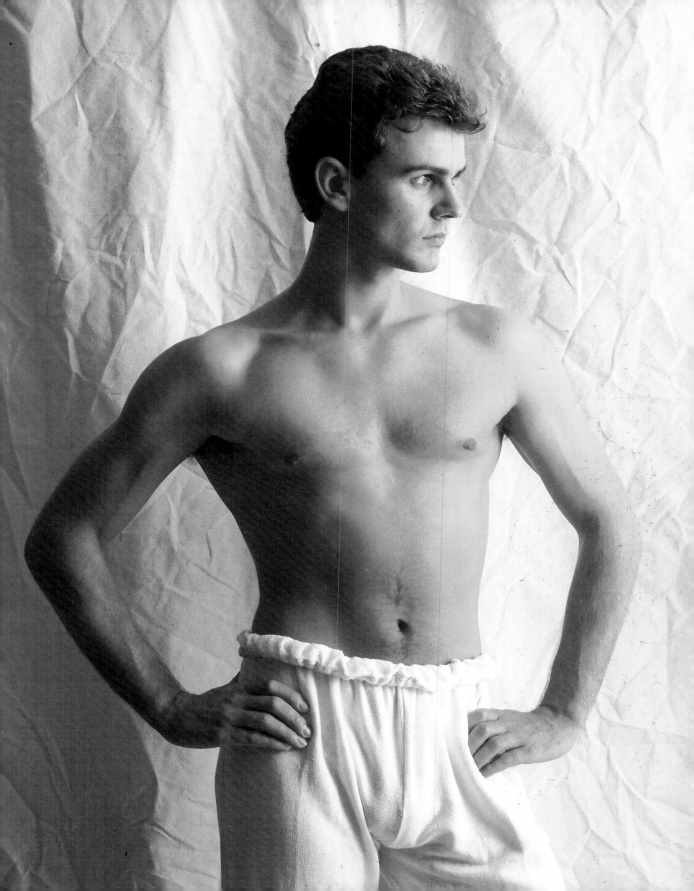

male model can be used is the one just described, for pictures which emphasise the more muscular and athletic qualities of the model. For this type of picture you obviously need a model with a fairly well developed body. Be careful however not to choose someone who has an overdeveloped body, such as a body building enthusiast. Unless you are out to achieve a deliberately exaggerated effect you picture will tend to look rather too much like specialist magazine illustrations just in the same way that it is more difficult to photograph a voluptuous girl model without the results looking like pin up illustrations. A muscular model is not the only type suitable for male nudes. Perhaps for pictures where the body is the main focus of interest, such as with close up or abstract pictures, it is preferable to have a model who is at least quite well built, but for pictures of a

more atmospheric or ambiguous nature the slightly built, or pale and interesting type can be, if anything, even more appropriate.

For pictures which exploit the male physique it can be an advantage to shoot in a studio setting in order to have the maximum control over the quality and direction of the lighting. The limitations of the studio will tend to be less restricting for this type of picture as the image will, in most cases, need to be quite tightly cropped with little of the background or setting shown. Indeed a quite abstract approach is often the most effective. In this way you can isolate quite small areas of the body in order to focus the attention on the shapes, textures and form which are created by the pose and the lighting.

As a general rule, the most suitable basic light source is one that is quite large and diffused, such as an umbrella reflector or a

Beefcake . . . this model possesses the more conventional concept of male attractiveness, looking at home in the beach set-up and creating a more 'glamorous' image. *Nikon F3, 135mm lens, Ilford FP4, 1/250 sec. at f11.*

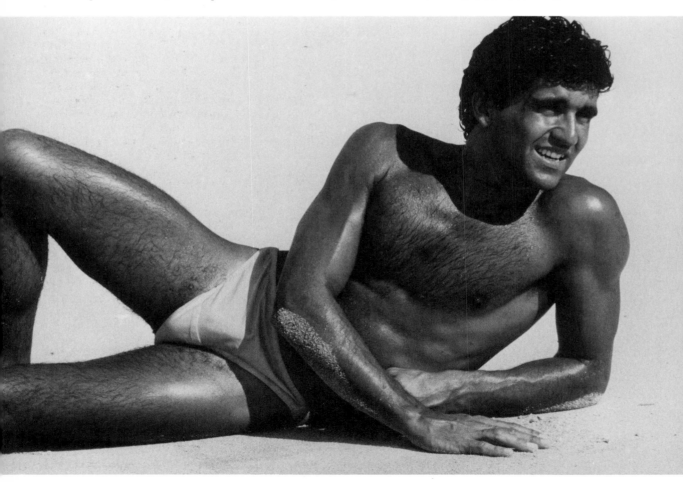

large diffusion screen placed in front of a light. This can be used at quite an oblique angle to the model, in order to create the maximum modelling without producing excessively dense or hard-edged shadows. Such a light can often be used at quite extreme angles to emphasise both the angular quality of the body as well as creating rich tones and shapes within it. One way which can be very effective when the model is in a semi profile position is to use the main light source slightly behind and to one side of him. If you imagine the model to be the centre of a clock face with the camera at six o'clock, the light source would be at about two o'clock or ten o'clock. By asking your model to swing his body a little to each side of his basic position you will be able to adjust and judge the effect of the lighting quite precisely. You may find that you will need to use a reflector close to

the model on the opposite side to reduce the contrast and create some tone in the shadow areas, but in some cases it can be effective simply to let the shadows go quite black in order to create a more dramatic effect. In addition you can use a secondary light source on the opposite side and slightly behind the model to create a degree of rim lighting. This will add further highlights and tones and can help to create a more rounded and three-dimensional effect.

In addition to the lighting, the pose can also be used to emphasise the muscular quality of the body. As a general rule it is best to position your model so there is a degree of muscular tension. Even something as simple as asking him to fold his arms and straighten his back will create a more pleasing shape and give the body more form. When shooting more abstract or tightly framed pictures, quite exaggerated poses can be used effectively to accentuate the muscular and athletic qualities of the body. Simple props can also be used for this purpose and can also help your model to feel more relaxed and natural. Something to hold like a weight or a dumbbell can be used both as an aid to posing and also add visual interest to the picture. Don't be limited by just standing positions for your model. You can experiment with kneeling or reclining poses which will greatly increase the possibilities of both the shapes which can be created and also the angle and direction of the lighting.

Shooting on location will give you less control over the lighting but will provide you with more freedom, in both the way you position your model and the choice of background and use of composition. In addition it will give you the opportunity to use settings and situations to create pictures with a more natural quality. A beach, for example, provides the opportunity to shoot nude or action pictures in a more relaxed and believable way than in the studio. A natural setting can also create more atmosphere and interest in the image and allows you to use the model more as an element of the composition than as the sole focus of interest. The choice of viewpoint is also much greater on location allowing, for example, the use of ground level camera positions or very high viewpoints to exploit the setting and to maximise the use of both backgrounds and foreground interest.

This tightly framed picture was lit to enhance the muscular and textural quality of the model's body by placing a diffused light on each side of, and slightly behind him. A reflector placed close to the camera was used to relieve the shadows, Pentax 6×7, 150mm lens, f16, studio flash.

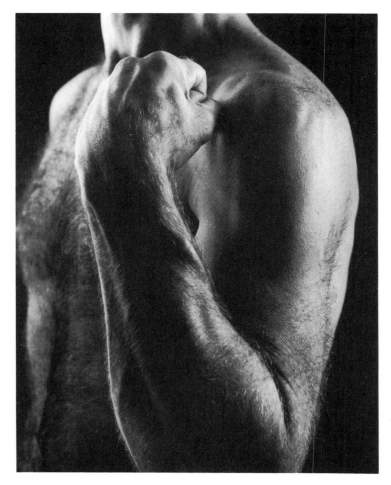

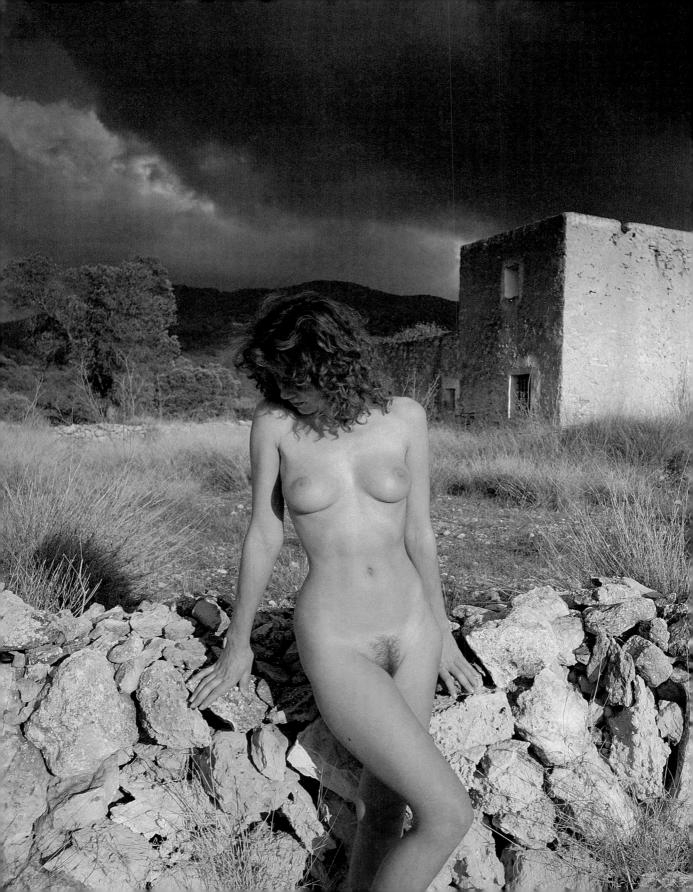

STYLE AND APPROACH

The Natural Approach

There are many approaches to photographing the nude, ranging from the romantic, voyeuristic fantasies of photographers like David Hamilton to the hard and often fetishist images of photographers such as Helmut Newton. All of these types of photograph, however, have one thing in common – they recreate an image which the photographer has in his mind. The models are in fact only a means of embodying the photographer's visualisation.

The alternative to this approach is when the picture is essentially a portrait of an individual. The difference is between a photograph which might be taken of a model to advertise a product, and one taken as a personal memento. The latter is a picture which captures the personality and appearance of the subject – a natural likeness. The difference, in the context of this book, is that we are dealing primarily with the nude, and whereas being naked is quite a natural thing, it is not widely accepted as being entirely normal in portrait photography. Consequently a completely uncontrived and natural portrait of a naked model is perhaps the most difficult to achieve. The result can only too readily look either like an illustration for a naturist magazine or simply selfconscious.

A face seldom looks its most attractive when in a passive state. Most people when not actively registering some emotion by their facial expression look rather dull and gloomy. So too does the body, which requires some activation or suggestion of movement to look appealing. The essence of the natural nude portrait is for a happy balance to be struck between an uncontrived and unselfconscious pose and one which simply looks awkward or inelegant. For this type of picture to succeed it is essential to chose either a quite natural setting or a relaxed and comfortable pose. An indoor setting is perhaps the most happy choice since it suggests an intimate and informal mood, although with careful choice of background and props it is possible to

Left: this shot is the result of the model being unaware of being photographed whilst resting between shots; the result is a relaxed and uncontrived pose and a spontaneous expression. *Nikon F3, 135mm lens, Ilford FP4, 1/250 sec. at f5.6.*

Although having been positioned in readiness for a picture, the two models were photographed while occupied with some spontaneous behaviour between shots, resulting in an unposed and natural photograph. *Rolleiflex SLX, 150mm lens, Ilford FP4, 1/250 sec. at f11.*

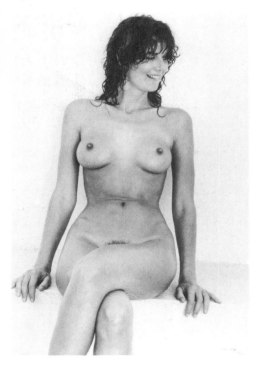

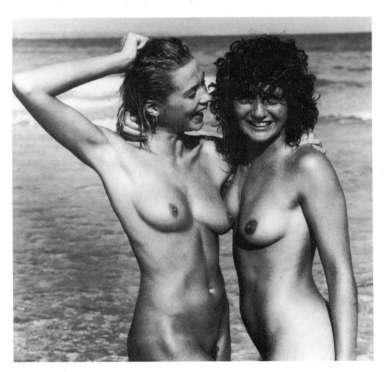

This portrait was the result of simply asking the model to look at the camera a fraction of a second before the exposure was made; rather than by careful posing and a sequence of contrived expressions. *Rolleiflex SLX, 150mm lens, Ilford FP4, 1/250 sec. at f5.6.*

achieve a similar quality in the studio. The naturalness of the image can also be emphasised by the lighting. It is likely to be more convincing if it is not obtrusive, perhaps just a single soft light source placed at an angle which produces a pleasing degree of modelling but without being too dramatic or contrived. Daylight indoors, from a large window or skylight for example, is ideal and in the studio a similar effect can be obtained with the use of a large diffusion screen.

Shooting such pictures successfully out of doors depends a great deal upon the choice of location. For the results to appear natural the setting needs to be appropriate to the model's

nudity. The photographs you see of naturists playing tennis or picnicking are good examples of how the incongruity of the situation can result in the pictures simply looking silly. A garden, for example, or an outdoor pool are places where it should be quite easy to produce a relaxed and natural mood, and a beach is an ideal place for outdoor location. In addition to being a perfectly natural and normal place for the model to be naked a beach is also likely to provide an unobtrusive and uncluttered background, such as the sea or sand, and the wide choice of viewpoints enables the best use to be made of the lighting.

Contrivance and Ambiguity

An improbable pose and an exceptional setting has produced a picture which evokes a positive response – favourable or not! However, the model's position does create an harmonious shape within the composition. *Rolleiflex SLX, 80mm lens, Fujichrome RDP 100, 1/60 sec. at f8 with fill-in flash.*

In complete contrast to the natural, portrait approach to photographing the nude, many photographers choose to use the nude model as a means of creating a mood or of suggesting a story or scenario in their pictures. The nude body is a powerful element in a picture. On an exhibition wall containing fifty prints, a single nude image is most likely to be the immediate focus of attention. Our reactions to such images tend to be both strong and invariably very subjective, and because of this the nude is a tempting source of subject matter for those photographers who wish to create pictures with immediate impact and to make strong personal statements. When the nude is combined with other visually compelling and emotive elements the results can be very powerful indeed. A good example of this is the photograph which John Swannell produced of the nude on a crucifix. It might be argued that even an atheist might find this in doubtful taste, but ignore it he could not. Taste is indeed a dominant factor in this type of picture, because so much is left to the viewer's imagination and interpretation that it would be quite impossible for a photo-

grapher to produce images of this type which someone would not find offensive. One might well question the success of a picture in this genre which disturbed no one.

How then does one go about taking pictures of this type? There are, in fact, a number of ways of approaching this type of photograph. The simplest method, and I suspect one which is used more widely than is realised, is simply to juxtapose elements in an apparently arbitrary and unexpected way, surprise being a key factor. The problem is that many of these initially bizarre juxtapositions have become clichés. Naked girls posed on earth-moving machines are now familiar images on calendars for example, and even the once disturbing pictures of nude models with bandages and surgical appliances draped around them are now rather passé. In truth this type of imagery works effectively only the first time it is done and those that copy or derive are in danger of appearing rather corny. You will need to rely upon your own imagination to succeed in this field. In practice the juxtapositions are not really arbitrary since they are selected in terms of how they relate to each other both psychologically and visually. Contrasting textures of bandage or surgical steel against soft skin, and the vulnerability which it implies, and the opposing shapes of the hard, angular cross and the pliable form of the girl's body with its suggested blasphemy in the John Swannell picture are examples.

Another and perhaps more satisfying approach is to visualise your picture in order to illustrate a theme. This could be something as obvious as a record sleeve or a book jacket – a quite common project given to students at photographic colleges and one which teaches them effectively to translate abstract thoughts into a tangible visual form. You could choose something existing like Vivaldi's *The Four Seasons* or alternatively an imaginary novel. A third method of creating pictures with an ambiguous quality is in the form of a picture story or an essay. In this way you can use a sequence of images to illustrate a theme or a story rather than attempting to achieve the effect in a single picture. A classic example of this, and one which produced some stunning single photographs as well as a witty and inventive narrative, was the book *Cowboy Kate* by Sam Haskins.

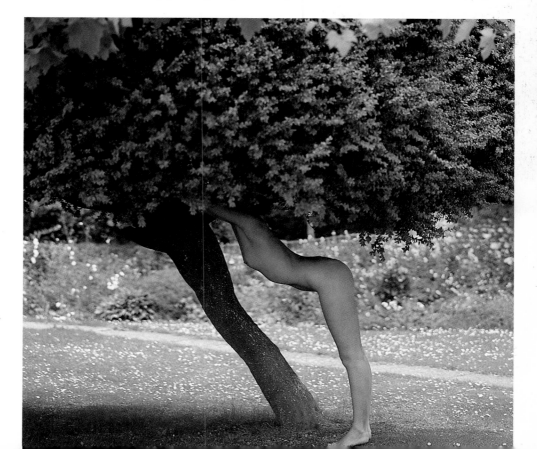

This picture was the result of my saying to a model, 'I like that tree, what can you do with it?' The result, I feel, is both intriguing and amusing. *Rolleiflex SLX, 150mm lens, Kodak Ektachrome EPD, 1/125 sec. at f5.6.*

The Glamour Approach

The most widely practised form of nude photography is that of glamour. It is also the genre with the most obvious commercial applications, pictures of this type being in wide demand for calendars, men's magazines and advertising campaigns. It is also predominantly concerned with the female model although men are sometimes the subject for glamour photography, as in the context of film, music and media personalities. With the exception of specialist magazines, like body building and health and fitness publications, male glamour models generally remain clothed, although there are exceptions.

The essence of glamour photography is that the model represents an idea, a form of perfection which is probably never normally encountered, and the type of model who fulfils this requirement tends to be quite narrowly defined. You have only to look at the pages of the glossy men's magazines and calendars to see that there is a certain look which models working in this field strive to achieve. It quite often has little to do with the way they normally appear. I have quite often had a fright when working with a model for

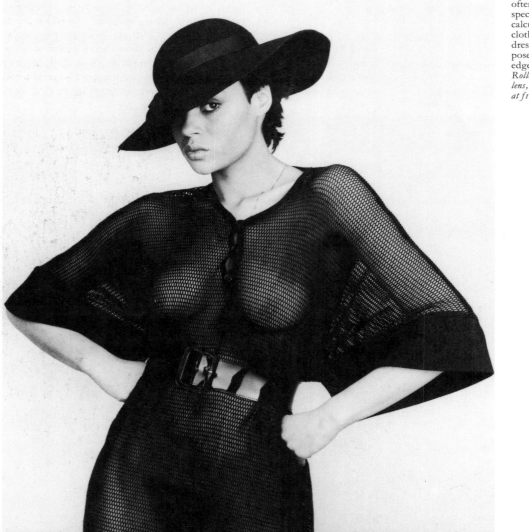

Glamour photography often depends upon a specialist wardrobe of calculatingly revealing clothes, like this model's dress. The fashion-style pose adds an ambiguous edge to the image. *Rolleiflex SLX, 150mm lens, Ilford FP4, studio flash at f11.*

the first time to have her arrive at the studio without make-up, hair a mess, and dressed in baggy dungarees, and have wondered how she will ever look the way I saw her in her portfolio. However an hour later, with the help of a stylist, hairdresser and make-up artist, she is transformed into the glamorous stereotype with which we are all familiar.

The model is, however, only the starting point of the image making. Lighting, props, backgrounds and clothes are all selected to create the illusion of glamour. Lighting is, of course, crucial and unlike in normal nude photography, it is not designed to emphasise texture and form but to soften and flatter the body and skin. The model's face is an important element in pictures of this type and in the studio a soft, diffused frontal light close to the camera is usually used to eliminate skin texture and to avoid unflattering shadows under the eyes and chin. For this reason a reflector is used close to, and underneath the model's face to direct light into these areas, eliminating any slight shadows that may remain. A top light is also commonly used to create highlights on the model's hair and make it shine. This is usually a spotlight or a snoot suspended from a boom arm directly

above the model's head but slightly to the back to avoid light spilling onto her face. A light is also often directed at the background to create a degree of separation and to introduce some tonal variation into the plain colour papers which are often used. The colour can be selected from a wide range to complement or contrast with the hair, make-up and clothes that the model is wearing.

When shooting on location the same control over the lighting is also essential and an assortment of large reflector boards and diffusers are used to ensure that the light is soft and flattering. Quite often pictures of this type are taken in open shade on a sunny day or shot into the light to keep the lighting soft and the contrast low.

Glamour models are seldom photographed completely nude. Some clothing or props are used for partial concealment, making the images a little more teasing and titillating. Most professional glamour models have an extensive wardrobe full of specially selected clothes and props which can be used to reveal parts of the body in a 'not too obvious' way. She will also have a selection of lingerie which is chosen to complement her figure and create the maximum glamour effect.

Right : the model's pose in this shot is designed to present the body in the most flattering, glamorous way – with the back slightly arched, to thrust breasts forwards and upwards, and stomach pulled to create an attractive, if unnatural body shape. *Rolleiflex SLX, 150mm lens, Ilford FP4, 1/250 sec. at f11.*

Left : this photograph combines pose, lighting and clothes to emphasise and idealise the model's body ; the apparent unawareness of the model to the camera lends a slightly voyeuristic quality to the picture. *Rolleiflex SLX, 150mm lens, Ilford FP4, 1/250 sec. at f8.*

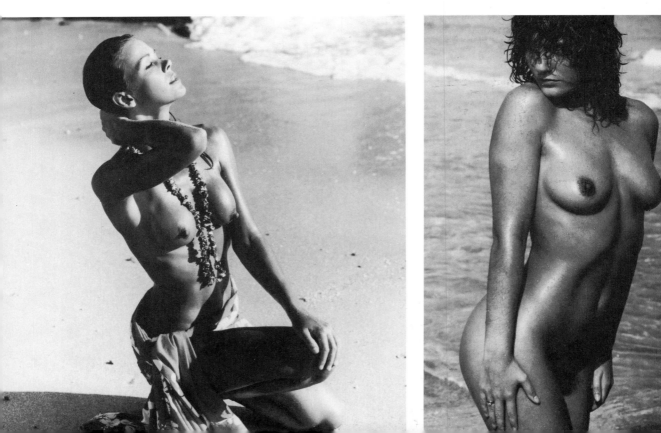

Creating Abstract Images

When photographing models under normal circumstances the resulting pictures are, to some extent, essentially representations of the person being photographed. In glamour photography, for example, the personality of the model is invariably a vital part of the picture and the viewer is invited to relate to the model, or the image which the model represents, in a quite personal way. However, when shooting pictures which have a more expressive and creative purpose it can often be a considerable advantage to minimise or even eliminate this aspect of the image and to create a picture with a more abstract or ambiguous quality. This approach can also be a help when photographing amateur models who perhaps lack the experience or the ability to project themselves as individuals, or indeed are simply unwilling to be photographed in this way.

There are a number of ways of creating this quality in a picture. The most simple and straightforward method is simply to avoid showing the model's face, either by having her turn her head away from the camera so that the features are largely concealed, or by cropping the image more tightly and eliminating the model's head altogether. The most important consideration with this approach is to ensure that the results do not appear coy or contrived. Remember that in some circumstances a degree of depersonalisation can even be created by simply not having the model looking into the lens. Even a profile or downturned head can be used to produce a quite abstract quality. Lighting too can be used to conceal the model's identity, leaving the face in shadow for example.

In some pictures, cropping the image so that the model's head is excluded from the frame can be quite effective. However in general the effect will be even more telling if the image is framed quite tightly in other respects, excluding parts of the limbs for

This studio shot was lit with a large, diffused light source placed slightly behind and to the left of the model. A black screen was placed on the opposite side of the model to make the shadows go completely black. *Rolleiflex SLX, 150mm. lens, Kodak Ektachrome EPR, studio flash at f11.*

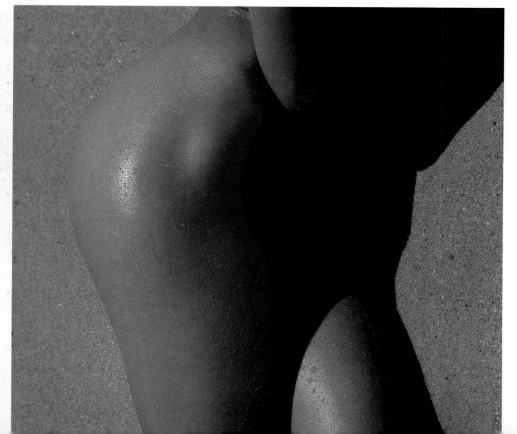

This picture of a girl's hip has an abstract quality to the extent that it almost requires a second look in order to identify it. The composition relies upon simple shapes, limited colour and texture for its effect. *Rolleiflex SLX, 150mm lens, Kodak Ektachrome EPR, 1/250 sec. at f8.*

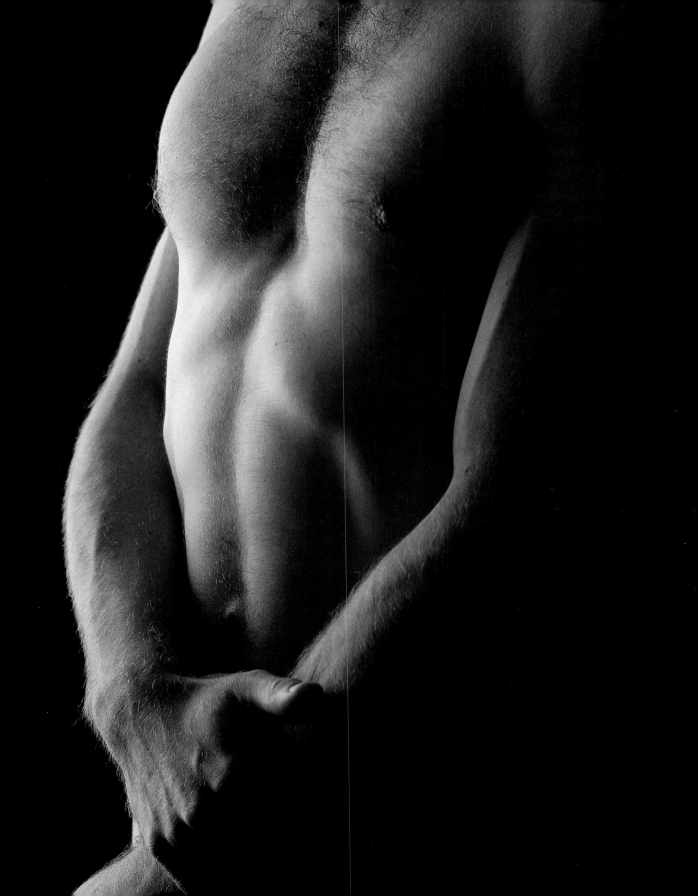

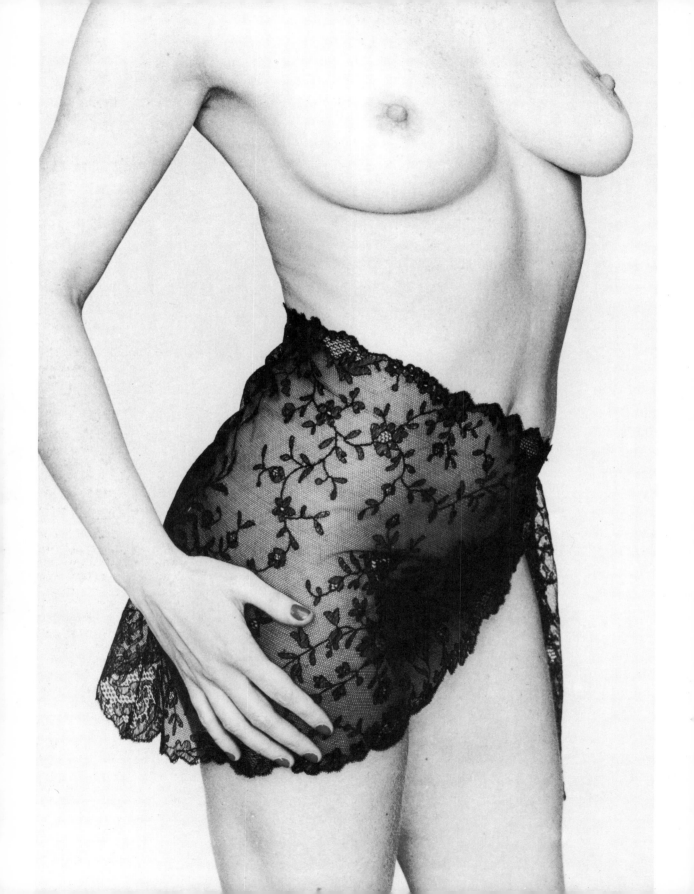

example. When doing this, however, you must be aware of the effect that this creates. Cropping into an arm or a leg can produce a somewhat amputated appearance if the point at which the limb is framed is not carefully considered. A long focus lens will be helpful for this type of shot as it will allow you to frame the image tightly without having to move the camera too close to the subject. Otherwise there can be an exaggeration of perspective which can be unattractive if created accidentally.

Very tight framing which isolates small areas of the model's body is an approach which has considerable potential in terms of expressive imagery. In this way it is even possible to produce pictures where it is not immediately apparent that the subject is a person. This allows the image to be seen purely in terms of its visual and photographic qualities, the model's body being simply a means of creating tones and shapes. Pictures of this type allow the photographer to experiment with a variety of factors – the position of the model's body, the camera viewpoint, the angle and direction of the lighting and the choice of lens and use of perspective. The potential permutations of all of these factors mean that it is possible to create a virtually limitless range of images and effects, particularly when working in the studio where the lighting can be controlled and varied at will.

This type of picture provides an excellent way of learning both lighting techniques and the skills of composition, since the image is very dependent upon the purely photographic qualities of the image. Elements such as texture, form, shape and line can be exploited to the full, and black and white photography in particular can yield images with a rich tonal quality. A tripod is an invaluable aid to such pictures because it will help to frame and focus the image very precisely and will also allow you to eliminate the possibility of camera shake and use a small aperture to obtain maximum depth of field. This can be very important when the camera is quite close to the subject. At wider apertures the depth of field will be quite shallow and it is usually important to have the subject as sharp as possible. A long focus lens will also help with tightly framed images of this type as you will be able to keep the camera at a workable distance from the model and still obtain a close-up image. A zoom lens will also allow you to adjust the framing without the need for moving the camera position.

With this type of picture is it also possible to experiment with more unusual viewpoints and body positions. In this way the subject can be presented in less familiar ways and different juxtapositions of limbs and torso can be achieved. Lenses of different focal lengths can also be used to add to this effect. A long focus lens for instance can be used with a more distant viewpoint to reduce the impression of perspective, producing images with a more two dimensional quality, and a wide angle lens with a close camera viewpoint can be used to emphasise and exaggerate the effect of perspective, creating pictures with a strong impression of depth. Deliberate distortion of perspective can also be used to create quite dramatic and unusual images. Using a very wide angle lens such as a 20mm with a 35mm camera and a very close camera viewpoint can produce extremely exaggerated effects. The famous series of nudes by Bill Brandt were a result of using this technique.

Lighting techniques can also be used to create a degree of abstraction. Strong directional lighting, for example, can be employed to create large areas of shadow or brilliant highlights, and this can be further emphasised by using hard, undiffused lighting. In outdoor situations this can be achieved by using direct sunlight and choosing camera viewpoints and poses which create the desired lighting effects. In the studio, back lighting and rim lighting can also be used effectively to create dramatic effects and also to emphasise elements such as texture which can add considerably to the impact of the picture. With colour photographs it is possible to use colour filters over both the camera and the light sources to produce a 'less real' quality. When shooting in black and white, control of the print can also be used to further these effects, either by shading and printing in or by increasing the contrast. Using a hard grade of paper, for example, or making lith negatives or solarised prints (see pages 186–7) could achieve this effect. Other techniques which can be used to produce a more abstract quality include using a very fast film in order to create a very grainy image, or by using special films such as infra-red which distort the tonal range of the subject (see pages 174–5).

The Erotic Element

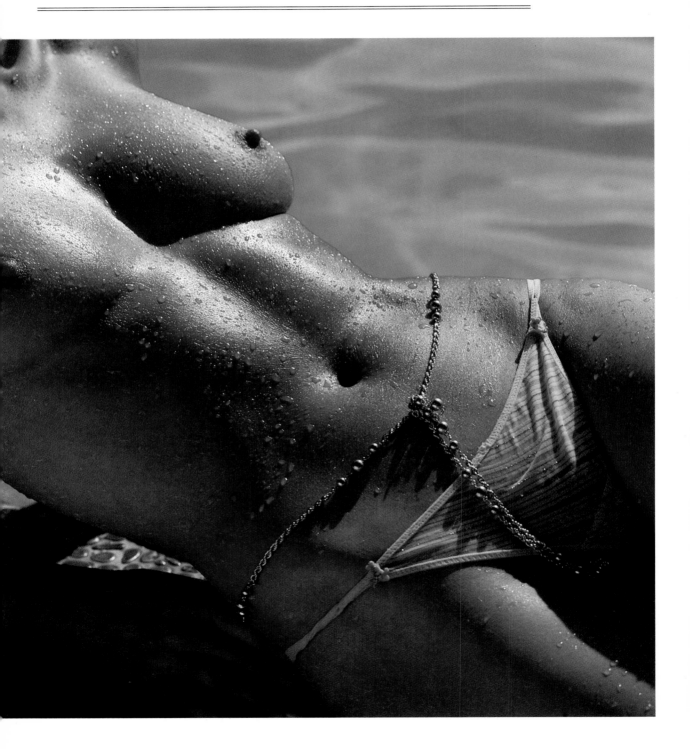

The small figure of a girl spreadeagled against the stark white wall helps to create a charged atmosphere, while the unlikely black lingerie introduces an erotic note. *Rolleiflex SLX, 50mm lens, Fujichrome RDP 100, 1/125 sec. at f8 with a polarising filter to darken the sky.*

Texture is the dominant element in this picture, and the viewpoint was chosen to create lighting which would emphasise this. A polarising filter was used to reduce the brilliance of the highlights on both the skin and droplets of water. *Rolleiflex SLX, 150mm lens, Fujichrome RDP 100, 1/125 sec. at f8.*

It is inevitable that most nude pictures – male or female – will have a sexual connotation. Even the most innocent and deliberately untitillating photograph will be sexually stimulating to someone. Beauty is said to be in the eye of the beholder – it may well be said that eroticism is in the mind of those who find it so. However while a great many pictures may have this quality in an accidental or incidental way it is also frequently deliberately contrived. As the media and advertising industry are only too well aware, sex is a powerful motivating force and a considerable amount of skill and ingenuity is used by photographers to create this quality in their pictures.

Because the erotic content of a picture is largely dependent on a subjective reaction it is difficult or even impossible to produce an image which everyone will find erotic. However there are certain guidelines which can be followed which will be more likely to produce this element in an image. 'Erotic' implies rather more than simply sexually stimulating. In photography in particular a certain degree of subtlety is an essential ingredient of the truly erotic image. The blatant and sexually provocative pictures used by the men's maga-

zines are not only lacking in taste but also in style and photographic merit. They can not be considered to be erotic in the true sense of the word.

Upon what, then, does this quality rely? Largely, it requires something to be left to the viewer's imagination, it is what the picture implies which creates an erotic quality rather than what is actually revealed. The imagination is a much more powerful force than reality, especially when sexual stimulation is involved. For this reason techniques which only partially reveal the model's nudity are more likely to be successful than pictures in which all is displayed clearly. Indeed clothing can play an essential role in creating an erotic quality, whether it is something quite obvious like black, filmy lingerie or something quite subtle such as a piece of draped fabric.

Texture is also often an important ingredient in pictures of this type. It is a quality which the photographic process can record with unerring accuracy and it can create a strong tactile element in an image, giving the viewer a sense of how the subject would feel to the touch as well as simply how it looks. The textural quality of a picture is often enhanced when different textures are juxtaposed – each heightens the effect of the other. For this reason images where skin is seen in contact with lace, fur, leather or water can have a very powerful tactile quality. Pictures of this type must have an excellent technical quality, being very sharp, beautifully lit and correctly exposed to create a full range of tones.

In the opposite way, pictures that are atmospheric can also create an erotic quality. Soft focus or grainy images, for example, which create an impression more to do with fantasy than reality can be very erotic as can those using lighting techniques which leave areas of shadow and mystery within the image. Fetishism too is a quality which many erotic photographs exploit and this element is often introduced into pictures in the form of symbols or props. One only has to look at the work of photographers like Helmut Newton, David Bailey and Bob Carlos Clark to see how frequently this element is used in nude photography. Objects like stiletto-heeled shoes, masks, uniforms, rubber and leather clothes are all very much a part of the stock in trade of the erotic image maker.

The Commercial Approach

Photography in general can be a quite expensive hobby and nude photography particularly so, unless you are fortunate enough to find all your models among friends and acquaintances. One way of offsetting some of the costs of producing your work is, of course, to sell your services. In addition to financial considerations it is very satisfying to have your pictures reproduced and seen by a wider audience than just your immediate friends.

There are a number of ways in which you can earn money through your photography, and a number of special factors must be taken into consideration if this is what you have in mind. Firstly it is important that any pictures you take of people which are intended for reproduction should be covered by the signing of a model release form. This is a simple letter of agreement whereby the model gives her consent for you to reproduce the photographs.

There are three basic ways of selling your

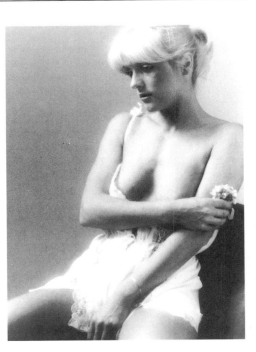

A partially clothed, but revealing, model like the girl in this picture is more likely to have a wide market in terms of picture library sales than a complete nude. *Nikon F3, 105mm lens, Ilford FP4, f11 with studio flash.*

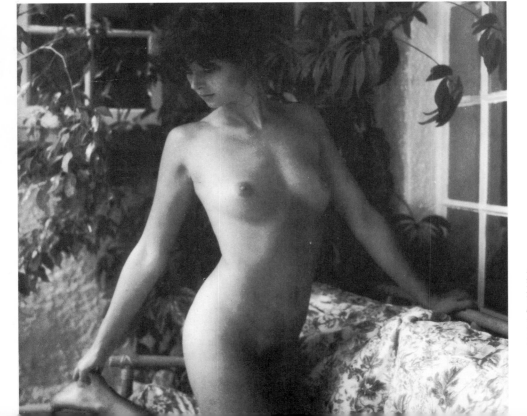

A square image is often favoured by both picture libraries and publishers because this can be more easily cropped to fit a variety of layouts. *Rolleiflex SLX, 80mm lens, Ilford FP4, 1/60 sec. at f5.6.*

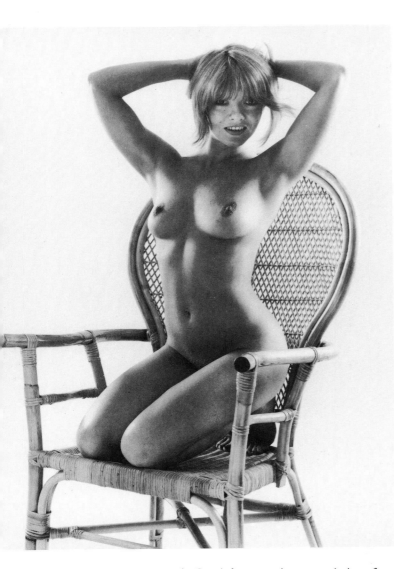

For publication in all but girlie magazines, it is best to be discreet with pubic hair since this can limit a picture's sales in many markets. Note the fine detail obtained by using slow film. *Rolleiflex SLX, 150mm lens, Ilford FP4, f11 with studio flash.*

advantage that the photographer retains the copyright of the pictures and can sell them a number of times, unlike commissioned work where the copyright and the transparencies belong to the person or company who pays the fee.

For this approach it is essential that you study the market well before you submit your pictures. Look at several copies of the magazine or other publications you intend to approach to see exactly what type of picture they use, the type of models they prefer and the situations or settings they favour. It is also necessary to consider the type of film and camera used. Publishers generally prefer roll film transparencies such as 6 × 6cm but good 35mm work is also widely acceptable. However whilst 10 × 8in. black and white prints are commonly used few publishers will accept colour prints, transparencies being largely obligatory. The type of picture too is important. It is worth remembering that pubic hair is not widely acceptable in anything other than girlie magazines and even then not for cover use. Many countries will not accept it at all. As a general rule partially clothed pictures are likely to have a wider market than straightforward nudes. When shooting on 35mm remember to vary the picture shape with both landscape format and uprights. The latter are ideal for covers and full pages but a landscape format picture has to be exceptional to merit a double page. Remember to leave space at the top of a potential cover picture for titles and headlines. The square format has an advantage in this respect since it allows the designer to crop the image in a variety of ways to suit page layouts.

The third, and possibly the simplest, method of selling your work is through a photo library. They hold a stock of your pictures, usually requiring at least several hundred transparencies. They take, on average, a commission of about 50 per cent. This may seem high but you must remember that they carry all the costs of administration, postage, delivery charges, duplicate transparencies and so on, and in addition they are in a position to syndicate your pictures all over the world. In this way an outstanding picture can earn a great deal of money over a period of time. Finally, a library can leave you free to concentrate all your time on actually taking photographs.

work. One is by accepting commissions from clients, such as magazines, advertising agencies and publishers. This is undoubtedly the most competitive field of work and the one in which the beginner will find most difficulty in getting started. For this it is essential that you have an excellent portfolio of your work and the ability to sell yourself as well. It is also not really a suitable way of working on a part time basis.

A more convenient way for the amateur or semi-professional to sell his work is by shooting pictures speculatively and then submitting them to potential clients who will pay the photographer a reproduction fee. This has the

Presentation and Display

A photograph is not really an end in itself. It is something that needs to be seen in the context of a presentation in order for its qualities to be fully appreciated. In some cases this may be the printed page of a book or magazine, as part of a design or layout. In other cases it will be part of a portfolio, or in a frame and displayed on a wall. The manner in which it is presented can have a considerable effect upon how it is perceived by others. No matter how good it is, a poorly presented photograph will lose impact and effectiveness.

The way in which a picture is presented will, to a large extent, depend upon its prime purpose. Transparencies, for example, when submitted to a publisher or client should be mounted in card frames, not glass, inserted in a protective sleeve and clearly captioned or identified. They should also have your name and address included. The most effective way of displaying colour transparencies is undoubtedly to project them in a darkened room onto a screen. The impact of an image shown in this way cannot be bettered but this is not always a practical method. A photographer who wishes to show his work to prospective clients, for example, might not have the opportunity for such an elaborate presentation. Instead it is possible to buy large black mounts which have a number of apertures cut out allowing twenty 35mm transparencies, twelve 6 × 6cm or smaller numbers of larger formats, to be displayed together. The mount is then slipped into a protective sleeve with a frosted backing which allows the pictures to be viewed against any convenient light source. Whichever method of presenting transparencies is used it is essential to ensure that they are well edited. Choose only the best frames, rejecting any similar images from the same sequence, and any which are substandard technically.

Next to projection, a well made print is hard to beat for impact, and making a print from either a colour transparency or a colour or black and white negative gives you the opportunity to exercise a fine degree of control over the quality and tonal range of the finished image. A print should be carefully retouched to remove any small blemishes like dust spots and ideally should be dry mounted onto exhibition board or card. This gives a superior and superbly flat finish. For portfolio presentations these can be placed into acetate sleeves and contained in an album which offers some protection. Some photographers like to have their prints laminated, encapsulated in a thin, clear plastic sheet. This not only protects them but also makes them much lighter to carry around.

When prints are to be used for a permanent display, such as part of home or office decor or an exhibition, there is no doubt that a frame offers the most pleasing finish to a photograph. There are a wide variety of do-it-yourself frames available, ranging upwards from simple clip mounts where the print is

Neatly matted and framed pictures can be used to make an effective contribution to the decoration of a room. A group of small prints can sometimes be more pleasing than a single large one.

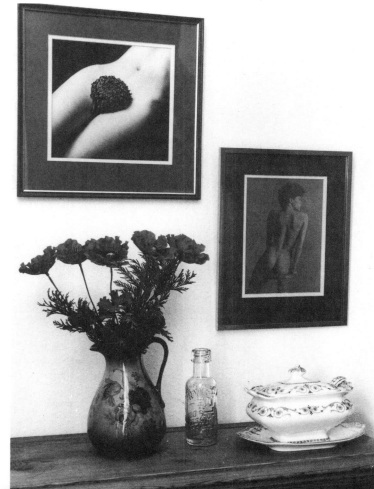

46

This picture shows 6 × 6cm transparencies mounted in a card mask for presentation purposes. The mask is then placed in a plastic sleeve for protection.

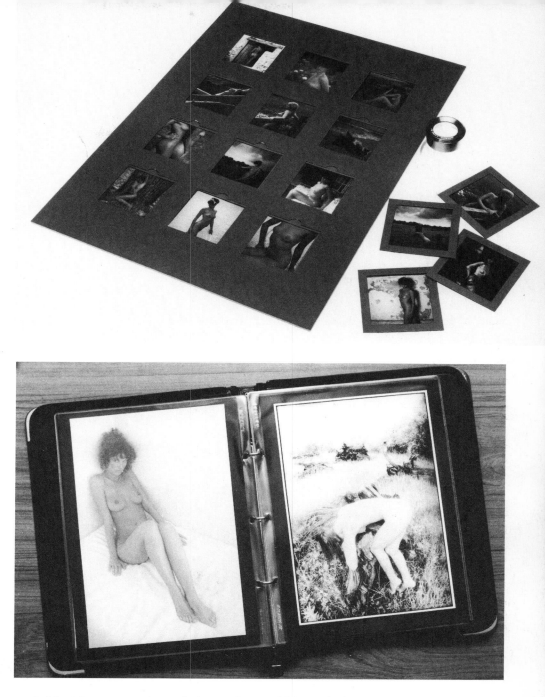

Large prints like these can be both protected and neatly presented in a portfolio with loose, plastic sleeves: this also enables the prints to be readily changed.

sandwiched between a piece of glass and a hardboard backing and held together with small chrome clips. Another simple and inexpensive method is block mountaing, in which the print is mounted directly onto a thick fibre or expanded polystyrene board which holds the image away from the wall with the contrasting edge of the board acting as a frame. Aluminium or metallic frames which can be bought in kit form are a more expensive form of presentation but one which can be particularly effective with photographic images. A final touch, and one that can add a little finesse, is to place a bevelled or cut-out mount over the print before framing to provide a surround. A colour or tint can be selected to complement individual photographs.

47

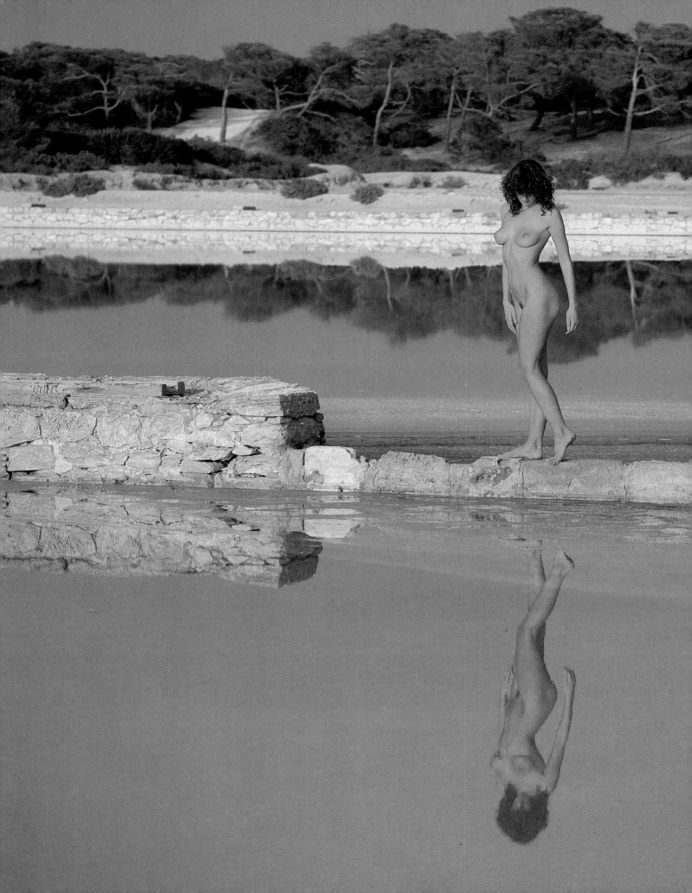

EQUIPMENT AND MATERIALS

35mm Cameras

The 35mm camera has become the standard tool of the serious amateur photographer and one that is also widely used by professionals. The format provides a good compromise between camera size, cost of equipment and image quality. The wide range of films that are available in this size also make it suitable for a wide range of applications.

Although there is no reason why the more simple and less expensive compact cameras cannot be used effectively for some nude work they do have limitations. The SLR camera offers far greater flexibility, and the ability to use different lenses. Most direct vision cameras do not have this facility, with the exception of a small minority of cameras such as the Leica or Minolta.

However the viewing and focusing method of the SLR also provides a positive advantage over the rangefinder type of camera in that the image can be seen on the viewfinder screen in exactly the same way that it appears on film. This is because it is created by the same lens which actually takes the picture, unlike the direct vision viewfinder which uses a quite separate optical system. The SLR camera viewfinder indicates the actual *effect* of focusing with both sharp and out of focus areas of the image shown clearly, whereas the compact type camera shows the whole image equally sharp in the viewfinder regardless of how the lens is focused. In addition the effect of filters and lens attachments, such as starbursts and soft focus, can also be seen with an SLR camera whereas this is not possible with compact cameras.

The SLR cameras have a wide range of accessories available, making them adaptable for a wide range of subjects and conditions. The leading makes of SLR cameras like Nikon, Canon and Olympus are very much modular systems which can be extended as and when required for changing needs. In addition it is easy to hire the specialist lenses

SLR cameras allow very precise focusing, making them ideal for close-up pictures. They also have the facility to change lenses swiftly and often. This picture was taken on a long focus lens. *Nikon F3, 150mm lens, Ilford FP4, 1/250 sec. at f11.*

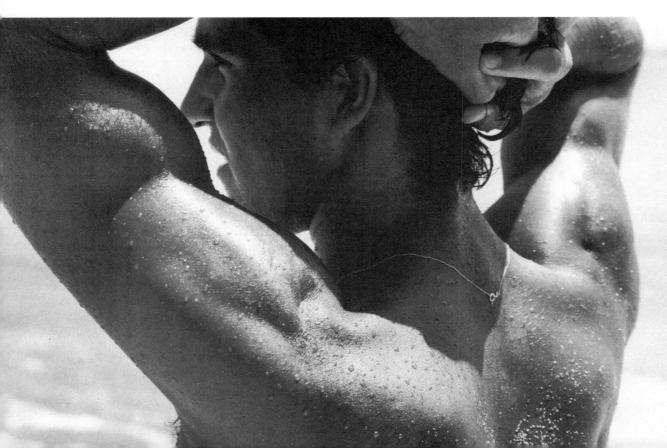

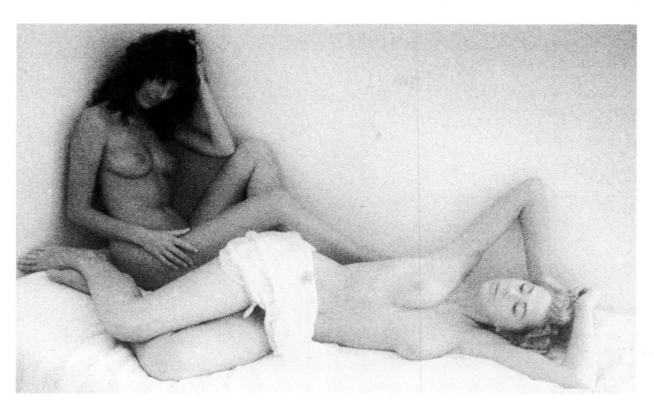

35mm cameras tend to encourage a more flexible approach than larger formats, and are easier to use in low light, allowing a reportage style to be used for both nude and portrait work, as with this shot of two girls. *Nikon FE2, 50mm lens, Kodak 2475 Recording film, 1/60 sec. at f4.*

and accessories, which may be needed only on odd occasions, for these cameras.

The possible disadvantage of the 35mm format compared with larger film sizes, such as roll film, is that the potential image quality is not quite as high. This can be readily understood when you consider that a 10 × 8in. print from a 35mm negative requires a six times enlargement whereas a 6 × 7cm negative needs to be enlarged only a little more than three times. The difference in print quality in a print of this size will not be very apparent, especially if the 35mm negative is made on a slow, fine grained film, but at large print sizes, 16 × 20in. for example, the difference can be very noticeable, particularly if a fast film is used.

On the positive side, however, the 35mm camera offers the advantage of being quick and flexible in use and can more readily be hand held if required. Larger cameras, such as for roll film, are more easily handled when mounted on a tripod. In addition the range of lenses and other accessories tends to be much greater with 35mm cameras. Ultra wide angle lenses or very long telephoto lenses for

example are readily available for 35mm cameras but the choice is much more limited with larger format cameras. Although many roll film cameras can be fitted with a motor drive these are not capable of such rapid exposure rates as those available for 35mm cameras and consequently they are not as suitable for action or rapid sequence shooting.

The 35mm format is also more suitable for slide shows than roll film. The range of projectors is much wider for 35mm slides, and photographers involved in audio-visual presentations usually prefer 35mm for this reason. The choice of film also tends to be wider with 35mm cameras. Some films such as infrared, ultra-fast films and high contrast emulsions are simply not made in the roll film format.

Last, the style and approach of a photographer will often be influenced by the choice of camera format. The 35mm camera tends to introduce a freer, more reportage-orientated quality into the image than larger format cameras, and this can also be an important consideration when choosing a camera.

Medium and Large Format Cameras

The roll film camera tends to be the instrument most widely used by professional photographers for nude and portrait work. There are a number of reasons for this.

Firstly the larger film size offers a significant improvement in image quality. It is possible to make much bigger enlargements without grain or lack of definition becoming a problem. This is important when a picture is used for a double page spread or a poster.

Secondly, both the image in the viewfinder and that on the film can be easier to assess than when using the 35mm format. This can be an important factor when a client or art director is involved, and it is necessary to consider the photograph in terms of a layout with text or other illustrations being combined with it as part of a design. Most roll film and large format cameras will accept a polaroid back which can also be of positive advantage, not only when working with a client or art director but also to check lighting set-ups or

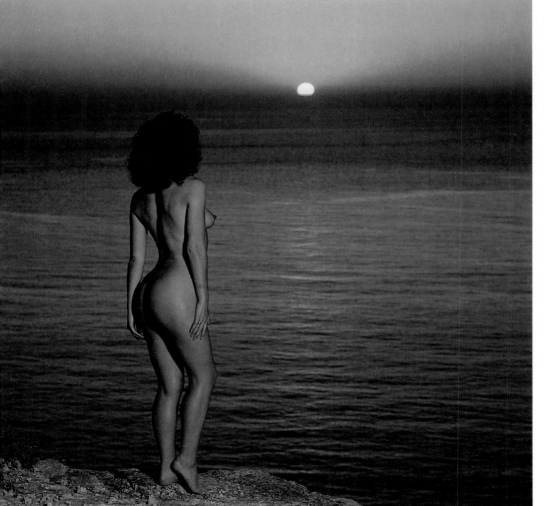

The 6 × 6cm square format is ideal for commercial work as it allows the central image to be selected, either as an upright or as a landscape shape, after it has been taken. *Rolleiflex SLX, 80mm lens, Fujichrome RDP 100, 1/60 sec. at f8 with fill-in flash.*

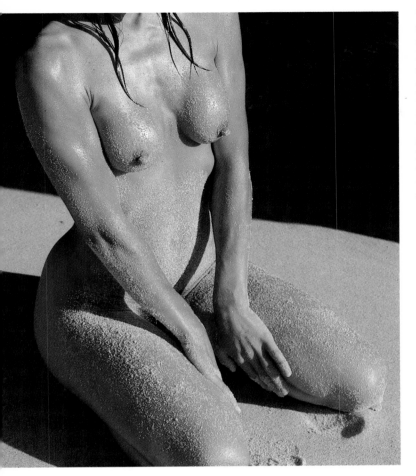

Larger format cameras are an advantage for pictures such as this, which depend upon the rendition of fine detail; large format transparencies are also easier to assess. *Rolleiflex SLX, Kodak Ektachrome EPR, 1/250 sec. at f8.*

twice as much as its 35mm equivalent. Lenses and accessories are correspondingly more expensive and are also more limited in choice. In addition the film is more expensive. A roll of 120 film costs almost as much as a 36 exposure casette of 35mm film and gives only half of a third of the number of pictures. This is partly offset, however, by the fact that the very nature of the roll film camera tends to induce a more selective and controlled approach with a correspondingly lower rate of frames per session, compared with the more extravagant use of film that the 35mm camera encourages.

The range of roll film cameras available is quite wide, and includes viewfinder and rangefinder types. However, as with 35mm cameras the SLR is the most popular, with cameras like the Hasselblad, Rolleiflex 6006, Mamiya RZ and Pentax 6 × 7 offering much the same flexibility as the 35mm SLR systems. There is also a choice of formats, ranging from eight 6 × 9cm images on a roll of 120 film to ten 6 × 7cm, twelve 6 × 6cm and fifteen 6 × 4.5cm pictures. It is also possible to buy double length film rolls called 220, giving twice these numbers of exposures without reloading.

View cameras, using 5 × 4in. or 10 × 8in. film, are perhaps the least frequently used cameras for nude and portrait work since they are somewhat slow and cumbersome to operate. It is necessary to frame and focus the image, which is seen upside down on the screen, with the aid of a dark cloth, and the film, which must be preloaded in a darkroom into dark slides, cannot be placed into position before this is done. This means that after focusing, the shutter must be closed and the lens stopped down before the film can be loaded and the dark slide sheath withdrawn ready for the exposure. Because of this a tripod must be used and the subject must be relatively static, since last minute alterations to the focusing and framing cannot be made. The main advantage of these formats is that superb image quality is possible with fine detail and a tonal range that cannot be matched by the smaller formats. For this reason view cameras are often used by photographers producing fine art images for exhibition, and by advertising photographers producing pictures for posters and large displays.

the model's make-up for example.

The larger prints and transparencies can also be more readily cropped and enlarged without loss of quality, to suit a layout for example. The 6 × 6cm square format is particularly popular because it can even allow the decision of whether the image should be upright or horizontal to be made after the picture has been taken. Another advantage of many medium and large format cameras is that, with the aid of interchangeable magazines and dark slides, it is possible to switch between different types of film in the middle of the roll using the same camera. For example the switch can be made from colour to black and white or from transparency to negative.

What then are the disadvantages of the larger formats? Firstly they are more expensive. A roll film SLR camera costs at least

Wide Angle Lenses

A large proportion of nude and portrait photographs can be, and are, taken satisfactorily with a standard lens. This is a lens which has a focal length approximately equivalent to the diagonal measurement of the film format with which it is used. In the case of a 35mm camera, for example, this would be about 50mm focal length, with a 6×6cm camera about 80mm, a 6×7cm camera 105mm, and a 5×4 camera about 150mm. In each case it will produce a field of view of about 45 degrees giving a similar effect in the camera to the way we see a subject visually.

A lens with a short focal length will produce a wide field of view, the shorter the focal length the wider the field of view. With a 35mm camera a lens of 35mm focal length will give a field of view of 62 degrees, whereas a 20mm lens will give a field of view of 94 degrees. The obvious effect of using a wide angle lens is that you simply get more of the subject into the picture, without having to move further back. This is very useful when working in a confined space like a small room. Another effect is that the objects within the image are smaller than when using a standard lens.

However there are many other advantages to using a wide angle lens. One is that it will give you a much greater effective depth of field. When you want to include close foreground details together with a more distant subject it is possible to get both equally sharp using a wide angle lens and a small aperture. Pictures of this type need to be carefully composed, ensuring that the model is placed in a strong position within the frame and is well separated from the background, otherwise the image can become cluttered and confused.

Another way of using a wide angle lens effectively is when you want to include a large area of background together with a large, close-up image of the model. It is important, however, to be careful that by using a close camera viewpoint you do not get unwanted perspective distortion. If some parts of the model's body are closer to the camera than others they will appear disproportionately larger. In the same way it is also possible to include larger areas of foreground detail in the image when using a wide angle lens, and this can greatly enhance the impression of depth and perspective in the picture.

However, perhaps the most useful quality of a wide angle lens is that it enables you to control the effect of perspective in the image. The impression of depth and distance in a flat photographic print is largely created by the fact that objects of a similar size appear to become smaller the further they are from the camera. With a model close to the camera, a distant tree would appear to be much smaller. The effect is increased when the camera is moved closer to the model, and decreased when it is moved further away. A wide angle lens allows you to photograph the model from a much closer viewpoint than a standard or long focus lens and in this way creates a much stronger impression of depth and dis-

A wide angle lens was used for this shot to emphasise the effect of a higher viewpoint and also to exaggerate the perspective. *Rolleiflex SLX, 50mm lens, Ilford FP4, 1/250 sec. at f11.*

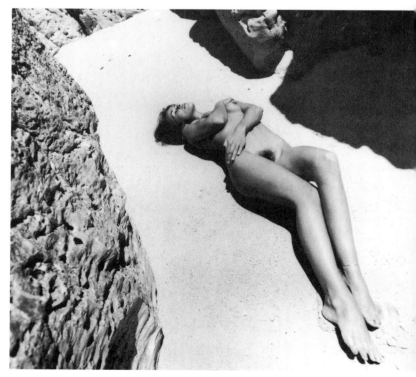

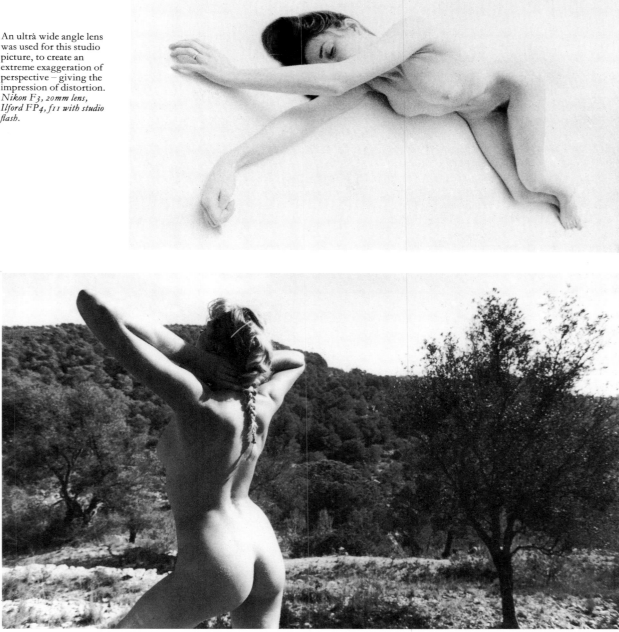

An ultra wide angle lens was used for this studio picture, to create an extreme exaggeration of perspective – giving the impression of distortion. *Nikon F3, 20mm lens, Ilford FP4, f11 with studio flash.*

The use of a wide angle lens in this location shot has enabled a close viewpoint of the off-centre model to be combined with a large area of background, while still providing considerable depth of field. *Nikon F3, 20mm lens, Ilford FP4, 1/250 sec. at f8.*

tance. The shorter the focal length of lens, and correspondingly the wider the field of view, the greater this effect will be. A 35mm lens for example on a 35mm camera will create a slightly more accentuated perspective effect than a standard lens, but a very wide angle lens such as a 24mm or a 20mm will produce a quite dramatic increase in the impression of depth and distance.

In a similar way a wide angle lens can be used very effectively to exaggerate perspective deliberately to the point where the image appears to be distorted. This can be a useful means of creating a dramatic or abstract quality in a picture, especially when combined with an unusual viewpoint, such as a very low or very high camera position. Again this type of effect is more readily created with extreme wide angle lenses such as a 20mm lens with a 35mm camera.

Long Focus Lenses

In the same way that a lens with a substantially shorter focal length than the diagonal measurement of the film format will produce a wider field of view, so a lens with a longer focal length will produce a narrower field of view. This allows less of the subject to be included in the frame and at the same time increases the size of objects within the image. A 135mm lens on a 35mm camera, for example, will give a field of view of 18 degrees

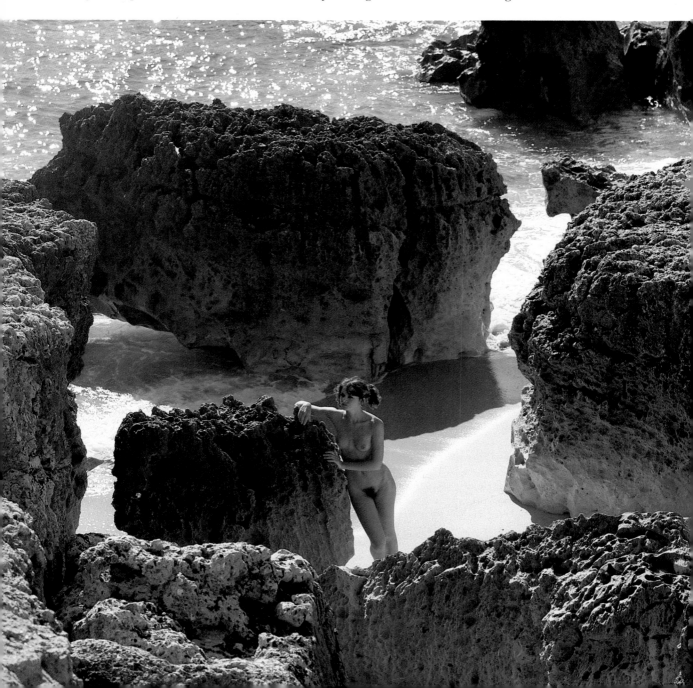

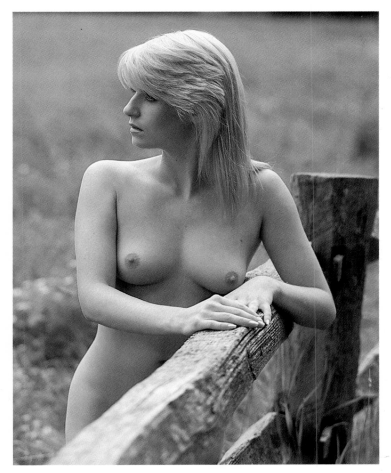

The use of a long focus
lens, combined with a
wide aperture, has
enabled the background
of this picture to be
recorded as a soft blur,
eliminating distracting
detail. *Rolleiflex SLX,
150mm lens, Fujichrome
RDP 100, 1/125 sec. at f5.6.*

A long focus lens was
used for this picture to
isolate a small area of the
scene from a distant
viewpoint. This has
minimised the perspective
effect, intentionally
making the model seem
dwarfed by her
surroundings. *Rolleiflex
SLX, 250mm lens, Kodak
Ektachrome EPR, 1/250
sec. at f5.6.*

and a 400mm lens only 6 degrees. This effect
can be particularly useful with nude and
portrait work since a tightly framed image is
often the most effective way of composing a
picture of this type, and a long focus lens
allows you to do this without having to move
the camera closer to the model.

A long focus lens also has an effectively
shallower depth of field than a standard or
wide angle lens. This too can be a very useful
quality particularly when shooting on loc-
ation outdoors. One of the problems in this
type of situation is that background details
can easily become cluttered and confusing
and a long focus lens, when used with a wide
aperture, will allow you to focus sharply on
the model but will record background details
as a soft, unobtrusive blur. This effect will be
enhanced the greater the distance is between
the model and the background. It will also

increase with the longer the focal length of the
lens and the larger the aperture used. This
technique helps to create considerable impact
in a picture, with a bold separation between
subject and background and can be particu-
larly effective when combined with back-
lighting.

A potential problem when using long focus
lenses is that the risk of camera shake is
considerably increased. With a hand held
camera and a standard lens, it is possible with
care to use shutter speeds of 1/125 sec. or even
1/60sec. and obtain a critically sharp image.
However, with a long focus lens it is far
preferable to use at least 1/250 sec., and with
very long focus lenses, such as a 300mm lens
on a 35mm format camera, 1/500 sec. would
be safer. It is much better however to use a
tripod. Not only will this ensure that the
picture is sharp but it will also enable you to
frame your pictures more accurately – some-
thing which becomes more difficult with a
narrow field of view.

A long focus lens will also allow you to
reduce the effect of perspective. This can be
particularly useful for portraits or close-up
shots when to move the camera very close to
the model can create an impression of distor-
ted features or limbs. With a long focus lens
you can use a more distant viewpoint and still
obtain a large, close-up image of the model. A
zoom lens, such as a 70–210mm for example,
can be especially useful for this type of picture
since it will allow you to adjust the framing of
the image without having to move the camera
position. This can save you much effort –
particularly if you are using a camera
mounted on a tripod.

The control over perspective also allows
you to vary the relationship between the
relative size of objects within the image. With
a model standing in front of a distant tree for
instance, a distant viewpoint and a long focus
lens will enable you to obtain a close-up image
of the model but with the tree shown much
closer in true proportion to the model. This
effect can reduce the impression of depth and
distance in the image. With a very long focus
lens, such as a 400mm on a 35mm camera for
instance, it is possible to obtain the im-
pression of compressed planes, creating
images with a strong graphic quality. This can
be effective in helping to emphasise the
juxtaposition of shapes and colours.

Filters for Black and White

Black and white film 'sees' colours purely in terms of their brightness – the amount of light that they reflect. An image consisting of bright, primary hues – red, green and blue – will record as a bold picture with more than adequate contrast. When photographed in colour, it will be recorded on black and white film as similar tones of grey. A flat, dull image lacking in contrast will result.

To a large extent colour filters can be used to influence the way black and white film responds to the different hues in a subject. This helps to control the contrast of the image. A strongly coloured filter will pass light of its own colour freely but will absorb, or hold back, light of the complementary colours. In this way a green filter will absorb blue and red light, a blue filter will hold back green and red light and a red filter will absorb green and blue light.

This effect can be illustrated by imagining a subject containing contrasting colours of a similar tone, say a girl sitting on a red deck chair, wearing a green hat with a background of blue sea. A picture taken without a filter would record the hat, the sea and the chair as similar tones of grey and the result would not have the same bold and contrasty effect that a colour photograph of the same scene would have. If, however, a strong blue filter were used the blue sea would record as a much lighter tone and the green hat and red chair much darker. With a green filter the effect would be to make the sea and the chair darker and the hat lighter, and with a red filter the chair would record much lighter in tone and the sea and the hat darker.

The extent to which the filters will affect the tone range of the image will depend on the purity of the colours within the subject, and also upon the strength of the filters. With fully saturated colours and strong filters the effect will be dramatic, but when the subject contains hues of mixed colours or if weaker filters are used the result will be more subtle. The exposure will also be influenced by the filters since some of the light being reflected from the subject will not reach the film. Each filter has a filter factor, expressed as $\times 2$, $\times 3$,

$\times 4$ and so on. A $\times 2$ filter requires an exposure increase of one stop, $\times 3$ one and a half stops, $\times 4$ two stops and $\times 8$ three stops. It is not wise to take exposure reading through these filters when using TTL metering as the exposure meter cells can have a different response to light of a dominant

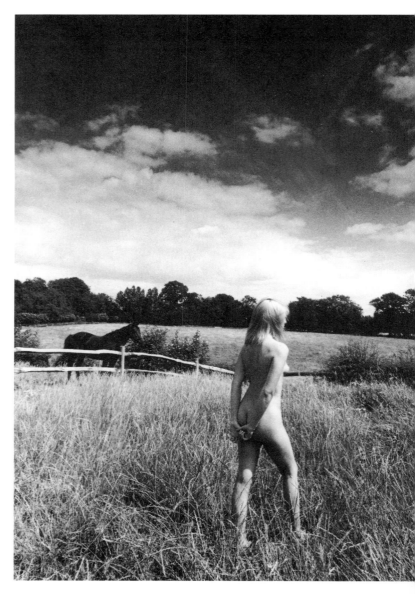

A red filter was used for this landscape picture to make the sky record as a much darker tone of grey, creating a more dramatic effect. *Nikon F3, 20mm lens, Ilford FP4, 1/125 sec. at f5.6.*

colour. It is best to take the reading without the filter and simply increase the indicated exposure according to the filter factor.

The deckchair example used to describe the effect of filters is not frequently encountered, although it helps to explain the principle. In practice filters are normally used in a more subtle way. A red filter can be very effective when shooting pictures with a blue sky, since it will record it as a very dark tone giving the picture a dramatic quality, and if white clouds are present it will throw them into bold relief. An orange or yellow filter will have a progressively less obvious effect. A red filter can

also be used to eliminate skin flaws and blemishes, and record the skin as a lighter tone. However it will also greatly reduce lip colour and when photographing girls with a red filter it would be best to ask them to use a bluish tint of lip colour. A blue filter can be used effectively to accentuate skin texture, something which can be useful for male nudes for example, creating rich tones especially with a tanned body. A green filter is very effective with landscape backgrounds since it will make green foliage lighter in tone and will help to create more detail and a greater tonal range.

These two pictures show the effect of contrast filters. The top one is with a red filter, making the blue water dark and the red fabric light in tone. A blue filter was used for the bottom picture, reversing the effect. *Nikon F3, 105mm lens, Ilford FP4, different exposures.*

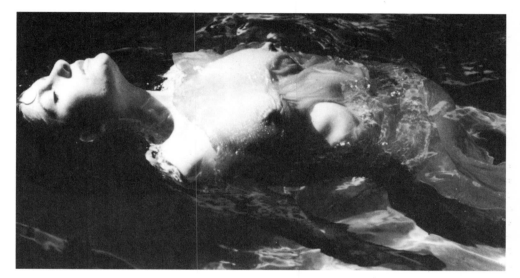

Filters for Colour

Control over the image quality can also be obtained by the use of filters when shooting in colour. However under normal circumstances the filters used are either of a much weaker hue or more neutral in tone than those used for black and white photography.

The most basic, and most widely used, type of filters for colour work are colour correction filters. These are designed to compensate for the difference between the colour quality of the light source and that for which the film is balanced. These filters are seldom needed for use with colour negative films but are essential when shooting colour transparencies.

Colour transparency films are manufactured to give a true rendition of colours only when the subject is illuminated by light of a specific colour temperature. In the case of daylight film this is 5600 degrees Kelvin, and with artificial light film 3200 or 3400 degrees Kelvin. Quite often, however, the light is of a different colour temperature. An overcast day for example will produce light of a higher colour temperature resulting in pictures with a bluish, or cool, colour cast, and late afternoon sunlight has a lower colour temperature resulting in pictures with a reddish, or warm, colour cast. An additional consideration is the presence in daylight of ultra-violet light, which although not visible to the eye will affect the blue sensitive layer of the film creating a bluish colour cast. This occurs at high altitudes, near the sea and on overcast days.

In the same way domestic light bulbs or candles will produce a lower colour temperature than the photofloods or tungsten halogen lamps for which artificial light film is balanced, resulting in pictures with a reddish cast. Other non-photographic light sources, such as fluorescent tubes and sodium vapour lights, will also create colour casts. It is possible to buy a colour temperature meter which works in a similar way to an exposure meter but measures the colour temperature of the light source and indicates the filter required to correct it. However this is seldom necessary for all but the most critical work

and a little experience will normally enable you to judge the filter to use for nude and portrait photography.

The filters most widely used in the nude and portrait field are those which counteract the effect of daylight with its higher colour temperature than that for which the film is balanced. They are the Wratten 81A, 81B and 81C, being progressively stronger in effect. The most commonly encountered situations which require these filters are when shooting on overcast days, by the sea, in mountains and in open shade or against the light. Because skin quality is an essential element of nude and portrait pictures many photographers prefer to use an 81A filter most of the time for outdoor pictures and often with flash. This is because skin tones tend to be more pleasing if they have a slightly warm colour quality and will usually appear unattractive if they have

A Wratten 81A filter was used on an overcast day for this shot, to create a warm and pleasing skin tone. *Rolleiflex SLX, 150mm lens, Fujichrome RDP 100, 1/125 sec. at f5.6.*

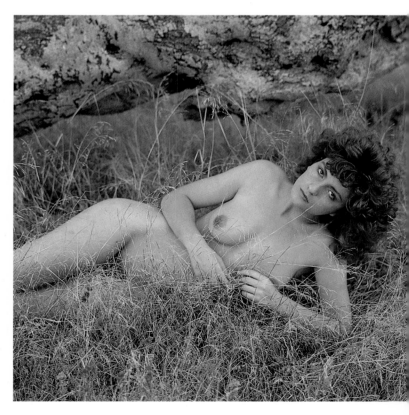

even a slightly bluish colour cast. It is less common to use filters to offset a warm cast when shooting in late afternoon light because this is usually a quality desired under these conditions. However if it is necessary to correct a warm cast the filters needed for this are the Wratten 82A, 82B and 82C, in sequence of strength.

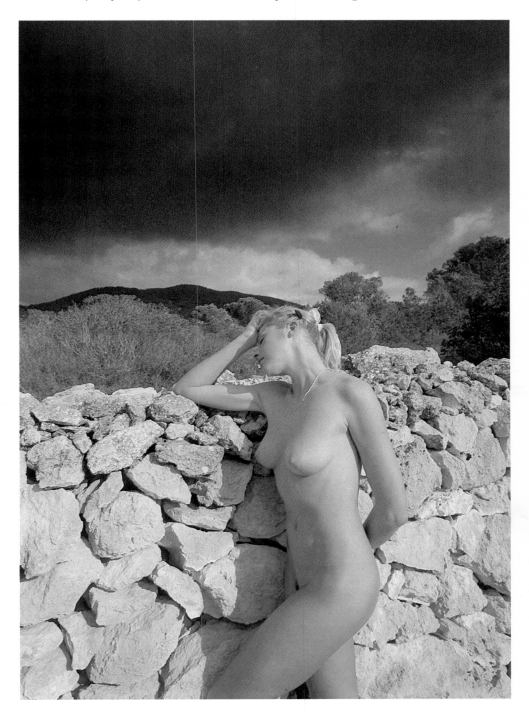

A neutral graduated filter was used for this picture to make the sky a darker tone and give the image a more dramatic quality. *Nikon FE2, 35mm lens, Fujichrome RDP 100, 1/250 sec. at f11.*

It is also possible to buy stronger colour filters to correct major differences between the colour balance of the light source and that for which the film is balanced. An 80A will allow daylight film to be used with artificial light and an 85A must be used when artificial light film is used in tungsten light. It is also possible to buy a filter which will minimise the green cast created when colour photographs are taken using fluorescent light.

Correction filters can be used deliberately to introduce a colour cast for effect. In some situations this can be an effective way of creating atmosphere or a degree of abstraction or drama in a picture. It is worth remembering, however, that the effect of filters used in this way can be greater than appears visually. It is possible to buy gelatin or acetate filters in an extensive range of strengths and in each of the primary and complementary colours enabling a wide range of colour effects to be created.

A filter which can be particularly useful in colour photography is the polarising filter. It is neutral grey in tone, having no effect on the overall colour quality of the image. It requires an increase in exposure of between $1\frac{1}{2}$ and 2 stops. Its effect is to eliminate some of the

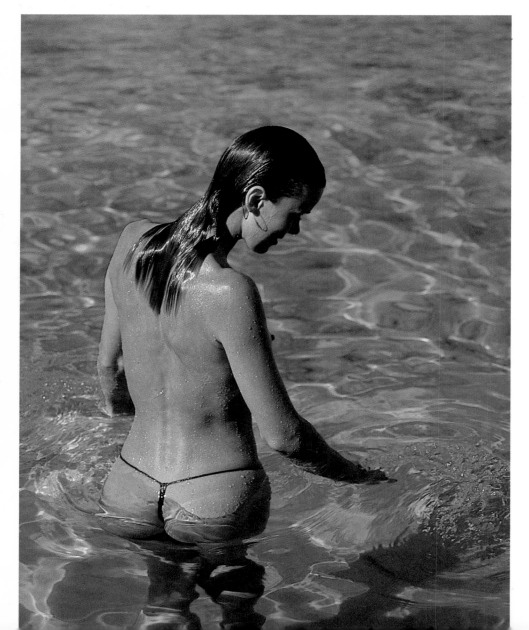

A polarising filter was used in this photograph to make the sea a richer colour and to make it appear more translucent. *Nikon F3, 150mm lens, Kodak Ektachrome EPR, 1/250 sec. at f5.6.*

light reflected from non-metallic surfaces, such as water, foliage, the sky, sand or even skin. It works on the principle that when light is reflected from a surface some of it is polarised, meaning that it is made to radiate along a single plane, rather as if it had been passed through a grid. The polarising filter has the same effect and when it is rotated to a position at right angles to the polarised light from the subject much of the reflected light is eliminated.

This can have a number of useful effects. It can for example make blue skies a much deeper and richer colour, making clouds appear dramatically white. It will also make water appear more translucent and deeper in colour – very useful when shooting by the sea or with a model in the water. It will also make foliage such as leaves and grass much richer when photographing a model with a landscape background, and can also make tanned skin a deeper and browner tone. Another useful application is when shooting a model with wet skin. In bright sunlight this can often create very strong highlights which can 'burn out' and lose detail. By rotating the polarising filter you can tone down these highlights to an acceptable level.

The graduated filter is also very useful for location work, particularly in shots with a landscape background when the sky is important, or with a sunset. It is a filter in which half the glass or plastic is clear but the other half is tinted, with the division between being graduated. It can be used to darken one half of the image without affecting the other, to make the sky a darker and richer colour, for example, but leaving the foreground unaffected. This type of filter can be bought in two strengths and in a variety of colours. The neutral grey is the most useful but the tinted versions, such as tobacco or mauve, can be used to add interest to a colourless sunset. However, unless used carefully or to create a special effect the coloured graduated filters can look unnatural and contrived.

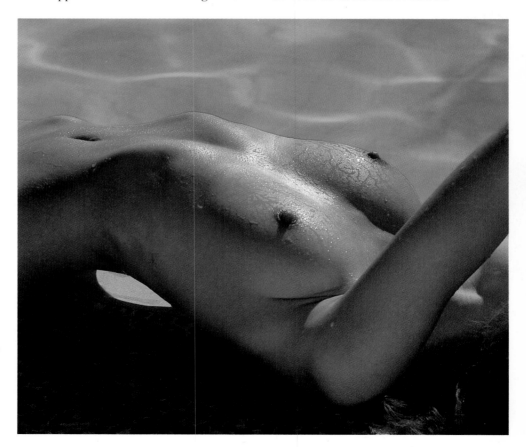

A polarising filter was used for this close-up shot to make the model's tan an even richer colour and to control the brightness of the highlights on the oiled skin.
Rolleiflex SLX, 150mm lens, Fujichrome RDP 100, 1/125 sec. at f8.

Effects Filters and Lens Attachments

Often a photograph is taken in such a way that the result is a fairly accurate record of the subject, the colours appearing quite natural and the image uncontrived. There are occasions, however, when it is desirable to introduce an effect in order to add interest to the picture, to create atmosphere or to inject a dramatic or theatrical quality. For these purposes there are a number of filters and attachments which can be used in front of the camera lens to modify or distort the image it creates on the film.

Filters which change the colour have been largely discussed on the previous pages. There are many further versions of these. Centre spot filters have a coloured tint with a clear central portion, allowing the central part of the image to record naturally but creating a ring of colour around the outside of the picture. Black masks with cut-out apertures in a variety of shapes can be used to create a black vignetted frame around the image. The longer the focal length of lens used and the wider the aperture selected the softer and more diffused the vignette will appear.

Another device which can be used to introduce additional colour into the image is the colourburst filter or diffraction grating. This is a clear plastic filter with a fine mesh engraved into its surface. It has the effect of causing streaks of prismatically coloured light to radiate from bright highlights or light sources within the picture area, or if a very bright light is present, from just outside the limit of the picture. It is only worth using when shooting with colour film and is most effective when there is a dark background. This type of filter can be obtained in a variety of configurations, creating streaks of colour in a circular pattern, for example, or radiating

A colorburst, or diffraction filter was used for this picture to create the rainbow streaks of light from highlights on the water. *Nikon F3, 105mm lens, Fujichrome RDP 100, 1/250 sec. at f11.*

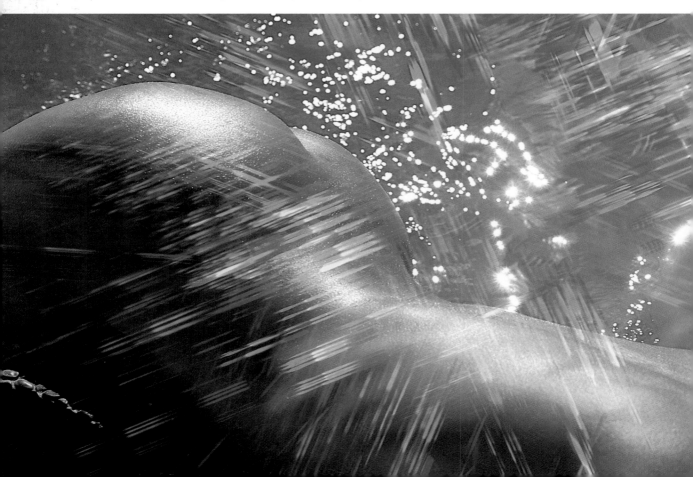

A multiprism was used for this studio abstract shot. It was lit and posed to create a boldly defined shape, which tends to be the most effective type of subject for this treatment. *Rolleiflex SLX, 150mm lens, Fujichrome RDP 100, f16 with studio flash.*

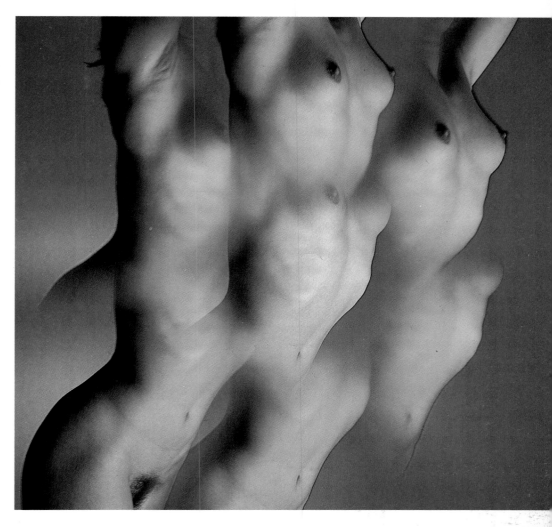

from a central point. The effect will vary according to the focal length of the lens with which it is used and also the aperture selected. The streaks will be more defined and contained with a wide angle lens or a smaller aperture.

An attachment that works on a similar principle, and which can also be used effectively with black and white pictures, is the starburst filter. This causes streaks of light to radiate from bright highlights or light sources within the image and again its effect is more dramatic when the subject has a dark background. The size and intensity of the light streaks will be affected by the type of lens and aperture used. Both the starburst and colour burst filters will tend to reduce the contrast and colour saturation of the image, and so it is preferable in most cases to choose a high contrast subject when using these filters.

Prisms can be used in front of the camera lens to distort the image it creates. A multi prism is an attachment which creates a pattern of repeat images, either around a central image or in parallel. The effect will be governed by the choice of lens and the aperture used. A longer focal length lens or a wide aperture will tend to create a less defined and more abstract image. With most of these attachments it is necessary to use an SLR or view camera so the effect can be seen and controlled on the viewing screen. With a viewfinder camera it is not possible to see how the attachment affects the image at the time.

Lighting Equipment

The variety of conditions under which you can take photographs and the range of effects which you can create will be considerably increased by the use of lighting equipment. The most basic type of lighting, and one of the first accessories that most keen photographers acquire, is a battery powered flash gun. There are a wide variety of types available but for use with nude and portrait photography there are some special points to consider.

It is important that the flash gun you choose has a reasonably high flash output since often you will not want to use it aimed directly at the subject but diffused or reflected. This will considerably reduce the light output and correspondingly the distance at which it can be used from the subjects. In addition the recycling time will tend to be very slow with the lower powered flash guns and this can be very restricting when working with models. It is also an advantage if your flash gun has the facility to run from rechargeable nickel cadmium cells or even from the mains, an important point when it is to be used for a lengthy session. The potential of a flash gun can be greatly increased by the addition of a second gun, to use as a back light or a fill-in. This can be triggered by a slave cell plugged into the synchronisation socket which will pick up the light from the gun fired by the camera and simultaneously fire the second gun.

The main problem with battery powered flash guns is that it is not possible to see and judge the effect of the light and to a large extent this becomes a matter of guesswork. If you contemplate using artificial light for a substantial proportion of your photography, or are interested in studio lighting techniques, then it will be far more satisfactory to obtain mains powered lighting units.

There are several choices, the least expensive being simple tripod stands and reflectors using photoflood bulbs. These are similar to ordinary domestic light bulbs but with a much greater light output and a shorter working life of only a few hours. For this type of lighting it is necessary to use artificial light film when shooting colour transparencies. A more efficient, and more expensive, form of lighting is tungsten halogen – the type used for film and video work. These lamps have a high light output, a long working life and tend to be more constant in terms of colour quality than photoflood bulbs. This type of equipment is both quite light and compact. It is possible to buy a kit of two or three lights

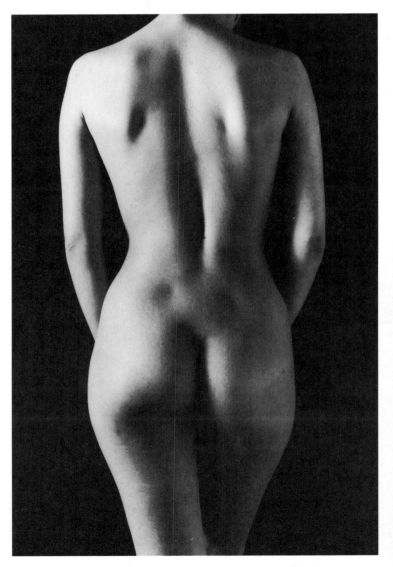

This simple abstract nude was taken using a single tungsten light source, diffused with a tracing paper screen; a reflector was used to add detail and tone to the shadows.
Pentax 6×7, 150mm lens, Ilford FP4, 1/60 sec. at f5.6.

A studio flash unit was used for this picture. The light was aimed at a white background behind the model, and the reflected light created the illumination on her body. A reflector was also used in front of the camera. *Rolleiflex SLX, 150mm lens, Ilford FP4, f8 with studio flash.*

with stands and reflectors which fit into a small case, making it ideal for location work.

Mains powered flash units are, in many ways, the ideal lighting for nude and portrait work. Because the flash has a very short duration it is possible virtually to ignore subject movement. Studio flash units have modelling lights – high powered tungsten bulbs – fitted inside the flash tube so that the exact effect of the lighting can be seen and accurately controlled. A further advantage is that you can use the same film as for your outdoor work when shooting colour transparencies. However you will need to buy a flash exposure meter since a normal exposure meter, such as the TTL meter in the camera, will not be able to read from the very brief flash. The most suitable units for a small studio or the amateur are the monobloc types with combined powerpacks, flash tubes and reflectors. Examples are the Bowens Monolites or the Elinchron 23. These can also be bought in kit form and are easily portable. Larger flash units with a separate powerpack from which a number of flash heads can be fired are considerably more expensive and generally more powerful than is needed for most nude and portrait photography.

Film

It is as important to know and understand the film you use just as well as you do your equipment. The basic film types are black and white, colour negative and colour transparency, but within these categories there are other important differences to consider.

With all types of film the speed is a significant factor in determining the quality of the image. A slow film with an ISO rating of 25 or 50 has finer grain and is capable of recording more detail in the subject than a faster, coarser grained film. It is also possible

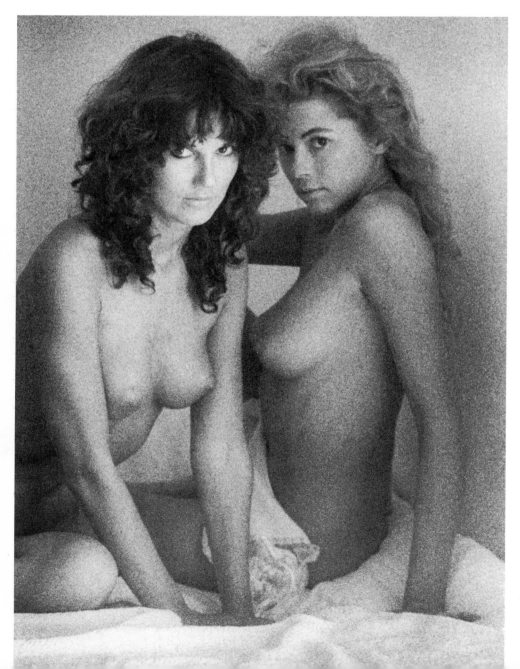

A high speed film was used for this photograph which was taken in very low light. The grainy quality of the image and the lack of fine detail add to the mood of the picture. *Nikon FE2, 85mm lens, Kodak 2475 Recording film, 1/60 sec. at f4.*

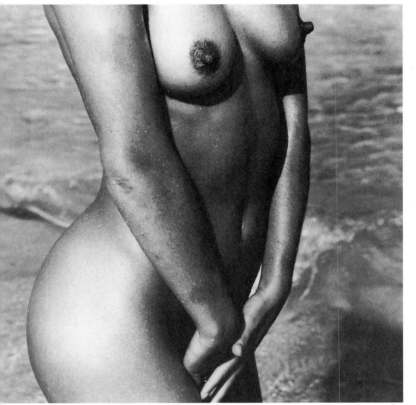

A medium speed film was used for this shot taken in bright sunlight. The fine grained image has recorded sharply defined detail and emphasised skin texture. *Rolleiflex SLX, 150mm lens, Ilford FP4, 1/250 sec. at f11.*

However there are situations when it is necessary or even desirable to use a fast film, such as in low light levels or when photographing a moving subject and a fast enough shutter speed cannot be used. However good image quality does not necessarily mean that grain is always undesirable. Many photographers using 35mm do so because they like the slightly gritty quality which results from seeing the grain structure of the film on the print, and often the grain is deliberately accentuated to create an abstract or atmospheric effect.

Choosing between colour negative film and colour transparency film will be largely dependent upon the purpose of your picture. If, for example, you are taking pictures for your own personal satisfaction and you intend to produce only colour prints, then colour negative film has much to commend it. When making your own prints from colour negatives it is possible to exercise a considerable degree of control over the quality of the finished image. You can alter the density and colour balance, for example, and use shading techniques to emphasise certain parts of the image, and to a large degree it is possible to overcome slight errors in exposure and colour balance at the printing stage.

On the other hand, if your main purpose is to offer your pictures for publication then it is necessary to shoot on transparency film. Few printers or publishers will accept colour prints for reproduction and a photolibrary would certainly not be interested in anything but colour transparencies. Audio/visual or slide-presentation work must also be photographed on transparency film and there is also a case for using transparency film if your ultimate aim is to produce prints. It is generally easier to make prints from *good* transparencies than from negatives. This is because you have the transparency with which to compare and assess your print, whereas with a colour negative a more subjective judgement is necessary. In addition, many photographers producing prints for exhibition and display like to make Cibachrome prints from colour transparencies (it is a positive to positive process) partly because of their excellent fade resistant qualities and also because the process allows much of the brilliant colour quality of a good transparency to be recorded on the print.

to enlarge a negative or transparency made on a slow fine grained film without the image showing signs of deterioration much more than from a faster film. Consequently when large prints are required, or the picture depends upon the rendition of fine detail and a critically sharp image, then it is best to use the slowest film that the lighting conditions will allow.

A medium speed film is one with an ISO rating of between 100 and 200 and offers a good compromise between image quality and film speed. It is fast enough to use comfortably in most outdoor lighting conditions and in reasonably powerful studio lighting, but is also capable of recording fine detail, producing a sharp image and allowing a considerable degree of enlargement.

Fast film is that with an ISO rating of 400 or more. This type of film has a much more defined grain structure which will begin to be visible at quite small degrees of enlargement. High speed films such as those of ISO 800 and 1600 have a very pronounced grain structure.

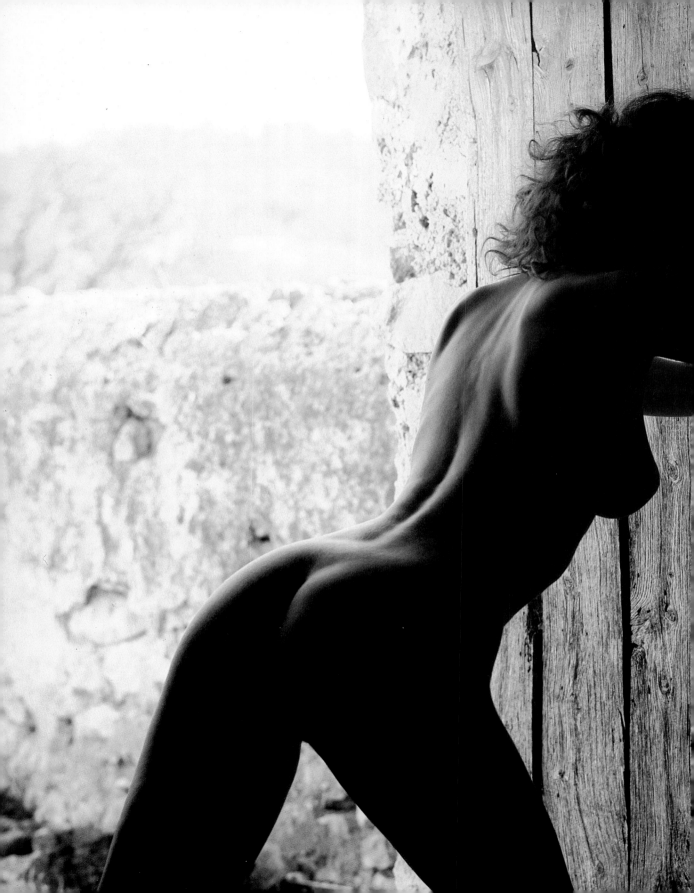

THE
BASIC SKILLS

Aperture and Depth of Field

A camera 'sees' a subject in a way that is very different from the way our eyes perceive it, and part of the skill of photography is in learning to understand and make use of this difference. An important aspect of photographic technique is that of focus and sharpness. When we look at a potential subject our eyes scan it, continuously shifting focus so that everything we see appears to be equally sharp. A camera lens however is quite different, it has to be focused on a particular part of the subject and everything else is either blurred or less sharp.

Control of image sharpness is achieved in a number of ways. Initially the point at which the lens is focused will determine the basic definition of the image. In nude and portrait photography the model is usually the part of the overall scene upon which the lens is focused but the effect of the picture will also be very dependent upon how sharp, or blurred, other parts of the image are.

When a lens is focused at a particular distance from the camera there will be a band in front of and behind the point of focus in which objects will be acceptably sharp. This is known as the depth of field. The depth of field depends upon three factors – the distance at which the lens is focused, the aperture used and the focal length of the lens. Greater depth of field will be obtained when the lens is focused at a point further from the camera, when the aperture selected is small and when a wide angle lens is used. With a long focus lens, when using a wide aperture and when the lens is focused close to the camera, the depth of field will be shallower. It is also important to know that the depth of field extends about twice as far behind the point of focus than it does in front.

How then to use this control creatively? With portrait and nude photography in particular it can be effective to allow the background to become quite blurred. In this way the sharply focused subject will be clearly separated from other elements of the image and the effect will be to create quite bold, well composed pictures with a high degree of impact. This technique is particularly useful

When the subject is close to the camera and a long focus lens is used – as in this shot – a very small aperture is needed to produce adequate depth of field. *Rolleiflex SLX, 150mm lens, Ilford FP4, 1/60 sec. at f22.*

A long focus lens, combined with a wide aperture, has created very shallow depth of field in this picture; throwing both background and foreground details well out of focus. *Rolleiflex SLX, 250mm. lens, Ilford FP4, 1/500 sec. at f4.*

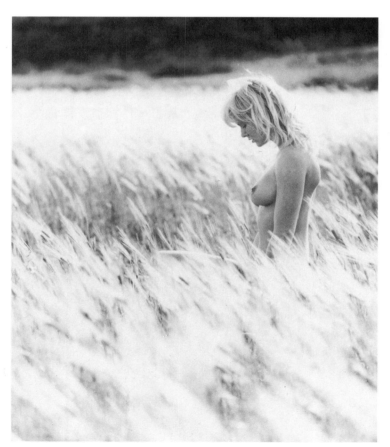

when shooting outdoors in situations when background and settings can easily become distracting if the focus is not controlled. To make the most of this effect a long focus lens is a positive asset, since when combined with a wide aperture the depth of field can be very shallow indeed and the plane of sharp focus very tightly controlled. The same technique can be applied when you want to include foreground details, but you don't want them to be too clearly defined. The degree of sharpness in both cases can also be controlled by the distance between the model and the background or foreground.

There are occasions, however, when it is important that a larger area of the subject is in sharp focus. When the model is quite close to the camera, such as an abstract nude, the result can be distracting and unattractive if only part of her body is in sharp focus. Even when using a standard or wide angle lens a small aperture will be needed to obtain good definition across the image, particularly if the model is close to, and at an angle to the camera. It can also be important sometimes to get both the foreground and background sharp as well. In these instances it is best to select the smallest practicable aperture, and, when extreme depth of field is needed, to use a wide angle lens.

In contrast, this picture was taken with a wide angle lens and, although only a medium-sized aperture was used, there is adequate depth of field. *Nikon F3, 20mm lens, Ilford FP4, 1/250 sec. at f8.*

Using Shutter Speeds

The choice of a shutter speed is governed partly by the exposure required. However, since the shutter speed can affect both the definition and quality of an image, it is important to understand how to select the best shutter speed according to the circumstances and the effect required.

One of the most common reasons for a photograph being unsharp is simply that of camera shake. This occurs when the camera is allowed to move slightly as the exposure is made. It can be overcome to a degree by selecting a fast shutter speed when hand holding the camera, but even a shutter speed of 1/250 sec. can allow camera shake to occur if the camera is handled carelessly. This risk is considerably increased when a long focus lens is used and also when the camera is close to the subject. A lens of more than, say, 200mm on a 35mm camera needs at least 1/250 sec. to ensure a sharp image, and preferably faster still. The difficulty is that a fast shutter speed often means a wide aperture and this can limit the depth of field. The ideal solution is to use a tripod whenever possible. In this way you can select a slower shutter speed with little or no risk of camera shake, and also use smaller apertures for greater depth of field. Image sharpness can be considerably improved by the use of a tripod even with standard and wide angle lenses, and when using long focus lenses it should be considered essential.

Subject movement also affects image sharpness and this is also an important consideration when selecting a shutter speed. Although nude and portrait photography usually deals with a relatively static subject the problem of model movement can require the use of reasonably fast shutter speeds even when a tripod is used. 1/125 sec. is a good basic shutter speed which will be fast enough to prevent movement when a model is standing quite still or seated. If you are shooting while the model is moving, a faster shutter speed will be needed to prevent blur.

It is not easy to predict the shutter speed at which a particular movement will be 'frozen' since it depends upon a number of variable factors. Obviously the speed of the move-

ment is the most crucial but the distance between the camera and the model can also be significant, and a faster shutter speed will be needed when the camera is close to the model. The direction of the movement will also affect the shutter speed. If the model is moving across the camera's view a faster shutter speed will be needed to record the image sharply than when she is moving towards the camera. The moment at which the exposure is made can also be used to control blur. If you wait until the model reaches the peak of a movement a slower shutter speed can often be used safely. Imagine a situation in which your model is jumping out of the sea. If you wait until she reaches the summit of the jump before making the exposure the actual speed of the movement will be much slower at that moment.

Blur caused by movement can be effective however. In some cases it can heighten the impression of speed and movement, and in others create an abstract quality in an image. Using a slower shutter speed and panning the

A shutter speed of 1/500 sec. was used for this picture. Even so, there is a small degree of blur which helps to enhance the impression of movement. *Rolleiflex SLX, 150mm lens, Kodak Ektachrome EPD, 1/500 sec. at f5.6.*

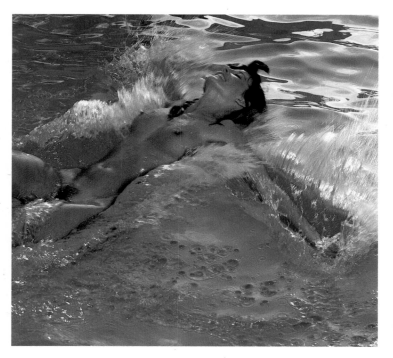

camera with a model who is moving across the camera can create an effectively blurred background but still record the model quite sharply and at the same time enhance the impression of speed. It can be effective to use a slow shutter speed and allow the model to move and create a degree of blur with the remainder of the image recorded sharply. You can also photograph a static model using a slow shutter speed and allow a movement in the background such as waves by the seashore to create blur.

This studio shot was taken using both flash – to freeze part of the model's movement – and tungsten light combined with slow shutter speed to create the blur. *Rolleiflex SLX, 80mm lens, Fujichrome RDP 100, 1 sec. at f5.6.*

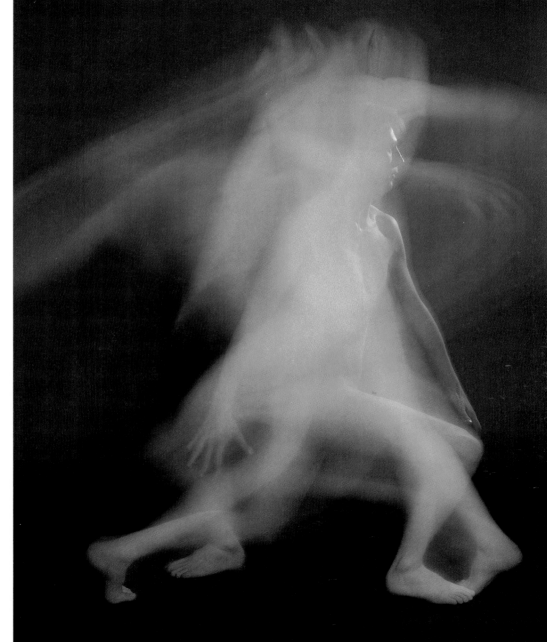

Understanding Exposure

Determining the correct exposure for a photograph is one of the most important factors involved in creating the quality and mood of the image. When shooting either colour or black and white negatives a small degree of exposure error can be corrected when making the print, but with colour transparencies it is essential to ensure that the exposure is exactly right. In a purely technical sense, a correct exposure is one which records the subject most accurately in terms of colours and tones. With a subject of normal contrast and tonal balance it should record detail in both the lightest areas of the subject and the darkest.

Not all subjects, however, have a normal contrast range or tonal balance and under these circumstances the correct exposure is a matter of interpretation, subjective judgement and experience. With a high contrast subject, for example, the exposure which records the middle tones most accurately will cause the darker areas of the subject to be underexposed and the lighter tones to be overexposed. In this situation it may be necessary to give less exposure than is strictly correct in order to record important highlight details, or more exposure if the darker areas of the subject are most important. Both underexposure and overexposure may also be used to create a particular effect or image quality, and subjects which are abnormally light or dark will also need special consideration.

It is important to understand how exposure meters work, since blindly following the reading that an exposure meter gives, or using an automatic camera, will not allow enough control over this element of picture taking. The reading on an exposure meter is simply a measurement of the light reflected from the subject at which it is aimed. In order to translate this measurement into an exposure indication the meter is calibrated on the assumption that the subject is of normal tone and contrast. It is assumed that it contains a full range of tones from white to black, which, if blended like different cooking ingredients in a liquidiser, would produce a medium tone of grey.

However if there is anything within the subject that will alter the balance of tones and create a blend which is lighter or darker than the medium grey tone, the exposure which the meter indicates will be inaccurate. For example if you were photographing a model against a large area of black background, the mixture of tones would be much darker than the standard grey and the meter would indicate more exposure than was needed, producing an overexposed negative or transparency. In the same way, if the model were standing in front of a large area of white

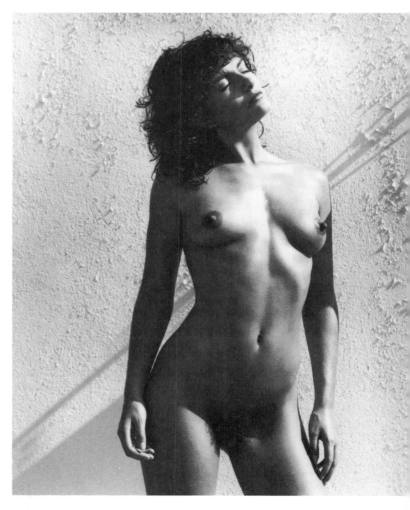

The large area of white wall in this shot made it vital to take a close-up exposure reading from the model to avoid underexposure. *Rolleiflex SLX, 150mm lens, Ilford FP4, 1/250 sec. at f8.*

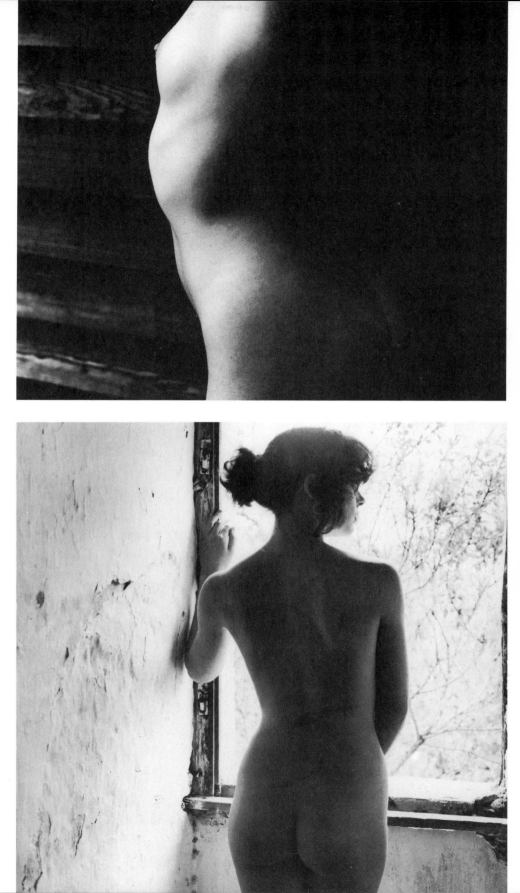

The dark background of this shot would have caused overexposure with an exposure reading taken in the normal way, so an incident light reading was used.
Rolleiflex SLX, 150mm lens, Ilford FP4, 1/60 sec. at f5.6.

Shooting into the light, as in this situation, causes underexposure when a normal averaging exposure reading is taken. A close-up reading was made for this picture.
Rolleiflex SLX, 150mm lens, Ilford FP4, 1/125 sec. at f5.6.

background the balance of tone would be too light and the meter would cause underexposure. In addition to the inherent tones of the subject, the lighting can affect the tonal balance. Backlighting for example can create brilliant highlights which will cause a normal meter reading to indicate underexposure, and strong side lighting can create large areas of dense shadow causing overexposure.

The best solution to these problems is to take selective exposure readings. This means taking the camera, or exposure meter, close to the subject and taking a reading from a small, important area which has a medium tone, and to ensure that this reading is not influenced by area of very light or dark tones, light sources, or by dense shadows or highlights. An alternative method, and one favoured by many professional photographers, is to take an incident light reading. This means measuring the light falling on the subject rather than that reflected from it. This requires the use of a separate hand meter with an incident light attachment. The meter is placed in front of the model and aimed towards the camera while the reading is made. Most flash meters work on this principle.

It is also important to understand the effects of exposure on the image and how it can be controlled to create the quality and mood of a picture. Overexposure has a number of effects. It will make the colours and tones of the subject lighter, it will increase detail in the shadow areas and lose detail in the highlight areas of the subject, and it will reduce the contrast of the image. Underexposure has the opposite effect. It makes colours and tones darker and richer, increases detail in highlights, loses shadow detail and increases contrast. It can often be used to emphasise such qualities as texture and form, to produce bold, assertive colours and to create pictures with a more dramatic quality or sombre mood. Overexposure is a technique used to make pictures softer and more delicate. The loss of highlight details tends to flatter skin tones, making faces paler and minimising skin texture; the colours within the subject lose saturation, becoming more pastel in quality. It is a method often used by photographers shooting beauty pictures for cosmetic or skin care advertisements.

One stop more exposure was given than was strictly correct for this picture to produce a high key image with very pale skin tones. *Rolleiflex SLX, 150mm lens, Kodak Ektachrome EPD, 1/125 sec. at f5.6.*

This picture was underexposed by one stop to create rich, dark skin tones and to emphasise the textural quality of the subject. *Nikon F3, 150mm lens, Fujichrome RDP 100, 1/500 sec. at f11.*

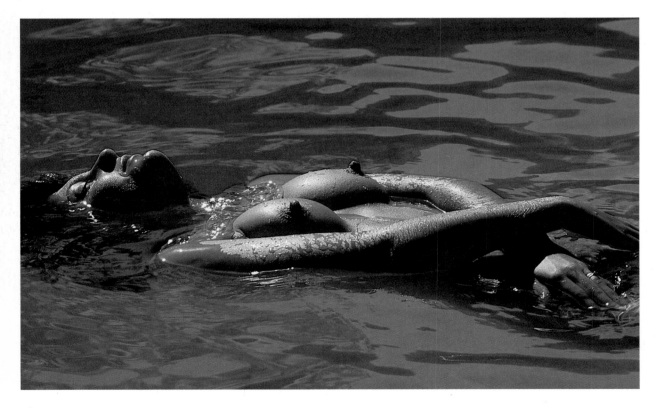

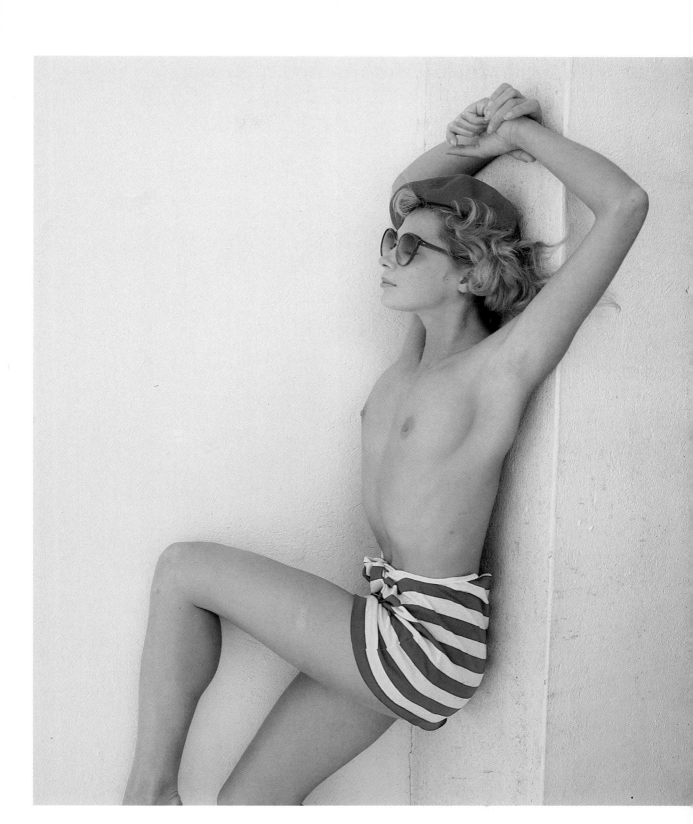

Framing the Image

Composition is very much a question of personal taste, experience and the effect you wish to achieve. However there are two basic factors upon which good composition depends – the way the image is framed and the choice of viewpoint. These are crucial to the techniques of composition and they should be considered as part of a photographer's basic method of approach.

Inexperienced photographers simply centre the subject in the viewfinder rather like using a gunsight or telescope, with little attention paid towards the other elements of the scene and how they relate to each other.

A long focus lens was used to produce this tightly framed picture. Rolleiflex SLX, 150mm lens, Ilford FP4, 1/250 sec. at f8.

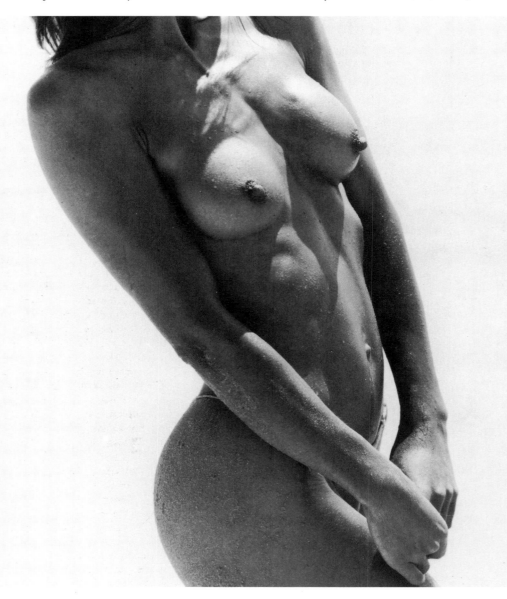

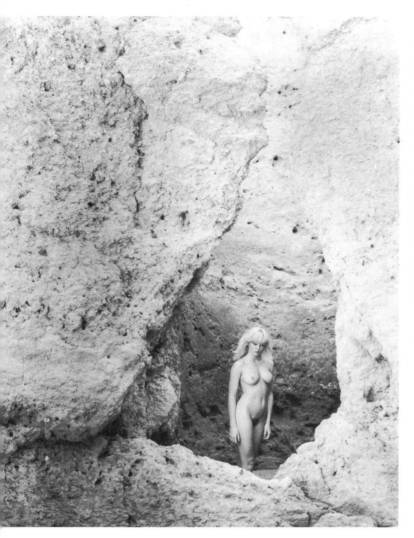

A large area of background has been included in this shot, yet the model has remained the focus of attention and the picture well balanced because she has been placed in a strong position within the frame. *Rolleiflex SLX, 150mm lens, Ilford FP4, 1/125 sec. at f8.*

picture you get is improved by doing this.

With nude and portrait subjects it is often best to frame the image quite tightly so the full focus of attention is given to the model's face or body, and distracting or unnecessary elements are either completely excluded or given much less emphasis. This can have considerable impact and will accentuate features such as the model's expression and the texture of skin, clothes or props. The most basic way of doing this is simply to move closer to your subject. However this can produce an unwanted exaggeration of perspective and cause distortion, particularly if the camera is moved very close to the model. Because of this it is often preferable to use a long focus lens, especially when a very tightly framed shot is wanted. A zoom lens is ideal for this since it will enable you to adjust the framing quite precisely without having to move the camera.

Even with a tightly framed picture it is seldom best to centre the subject in the viewfinder. It is better to decide what part of the face or body is the most important and to adjust the camera angle so this element of the image occupies the strongest position within the frame. As a general rule this is about half way between the centre of the frame and one of the corners. The rules of composition state that the main point of interest should be at the meeting point of imaginary vertical and horizontal lines which divide the image into thirds. However this is only a guide and should not be followed slavishly.

Many pictures will benefit from having much more than just the subject included within the frame, for example when you wish to include more of the background or setting in order to create atmosphere, to establish a scenario or when there are other important elements in the scene. The important thing to consider in this situation is that there should be a sense of balance between the main point of interest, usually the model in nude or portrait shots, and the other elements which are to be included. This is largely a matter of personal judgement, but you should frame the picture in such a way that there is always a clearly definable centre of interest with the other elements playing a secondary role, harmonising with the subject rather than competing for attention and creating a division of interest.

This is almost guaranteed to produce either static and uninteresting pictures or ones that are cluttered and confused. It is essential to use the viewfinder in a very selective and considered way, ensuring that you know exactly what is being included in the picture and consciously deciding what elements of the scene should be emphasised and what should be left out. You should develop the habit of carefully scanning the viewfinder and becoming aware of everything within it, not just as objects but also in terms of their shape, colour and tone. Study the effects that these elements have upon each other and try altering the framing either to exclude some or to alter the balance between them, and see if the

Choosing a Viewpoint

Compared to a painter or a sculptor, a photographer has only a small degree of control over the way the different elements of a subject are composed within the borders of his photographs. He cannot, for example, simply move things around at will in order to improve the balance and harmony of his pictures. He can, however, move his camera, and his camera position is one of the most important choices he makes in terms of the composition and balance of his images.

Unlike a landscape photographer, the nude and portrait photographer is at least able to move one of the elements of his pictures, the model. However the choice of viewpoint is nevertheless an important means of controlling the composition, the perspective and the framing of the picture. The relationship between a model in the foreground and more distant objects or details in the background is one that can be varied perhaps more than is realised by the choice of viewpoint. How many pictures have you seen spoiled by an awkward juxtaposition, like a tree appearing to grow from the top of the model's head for example, or a distracting highlight or object in the background? This sort of thing is simply the result of a bad choice of viewpoint, and the failure to study the contents of the viewfinder carefully.

The background is an essential part of outdoor nude and portrait shots and it is with this in mind that the choice of viewpoint should primarily be made. Make sure that there are no unsightly objects, jarring splashes of colour or distracting shadows or highlights. These will be more noticeable in the finished picture than they are through the viewfinder, and if you are using an SLR camera with open aperture viewing remember that the background details will be sharper and more defined when the lens is stopped down to a smaller aperture.

The choice of viewpoint will also affect the inclusion and use of foreground details. Quite often by moving the camera back, to one side, higher or lower, effective use can be made of objects between the model and the camera. In the majority of pictures the camera is used at a comfortable viewing height – about five feet or so from ground level. A quite dramatic effect can be achieved when the camera is used from a very low or much higher viewpoint.

Low angle shots for example can create dramatic perspectives, especially when the camera is close to the model and a wide angle lens is used. Be careful however to avoid unwanted and accidental distortions when

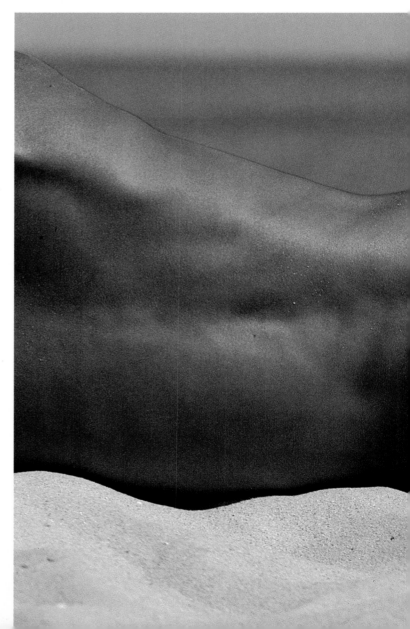

The use of a low
viewpoint has created a
quite different image in
this abstract nude,
enabling the distant sea
and sky to be used as a
background. *Rolleiflex
SLX, 250mm lens, Kodak
Ektachrome EPR, 1/125
sec. at f8 with a polarising
filter.*

using this type of viewpoint. A camera close
to ground level will allow you to make use of
the sky, a useful point to remember when the
other surroundings create a cluttered or
distracting background.

High level viewpoints can also help to
improve composition. Even just standing up
on a chair or an equipment box can make a
significant difference to the composition and
effect of a picture. A lightweight aluminium
step ladder can give, quite literally, a com-
pletely different perspective to your pictures,
when shooting down on a reclining figure for
example.

Remember, too, when shooting outdoors
the choice of viewpoint will be the most
dominant factor controlling the lighting of
your model, particularly when working in
sunlight. By moving the camera around the
model you are, in effect, also moving the light
source, the sun, around and this will in turn
have a dramatic effect on both the quality and
mood of a picture. By moving from one side
of the model to a position at 90 degrees, for
example, you can change from a flat, frontal
light to strong, cross lighting, and a further
move to the opposite side will enable you to
shoot into the light.

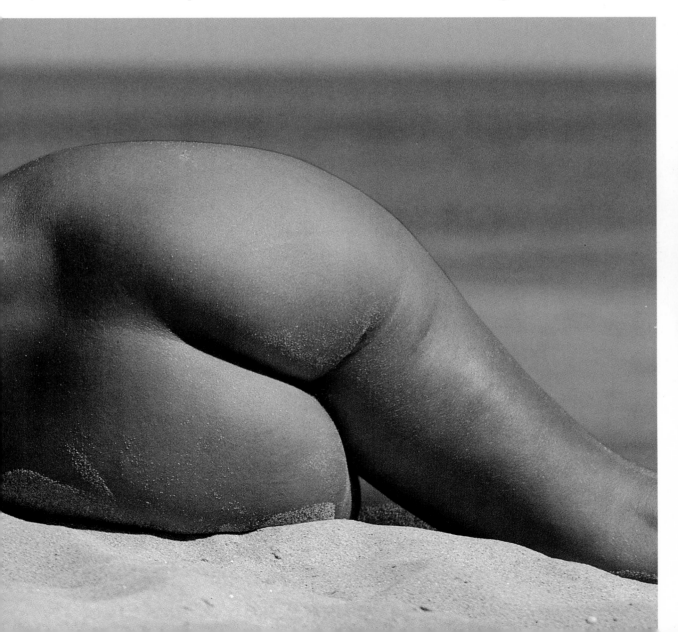

Using a Flash Gun

A battery-powered flash gun is one of a photographer's most basic accessories and is an invaluable aid to many lighting problems. However, used without care and thought it can easily produce uninteresting and poor quality results.

The most commonly encountered fault with flash lighting arises from its use when attached to the camera and aimed directly at the model. Firstly, this will produce a very flat frontal light with no modelling, or form, in the model's face or body. This is not necessarily a fault in itself, since such lighting can create interesting and flattering effects if used in a considered and controlled way. The second hazard occurs when the model is some distance from the background. This will result in the more distant details becoming considerably underexposed, and either flat and lacking in detail or completely black. When combined with the flat frontal lighting this can produce pictures of very poor quality.

It is important to appreciate that the light from a small source, such as a flash gun, diminishes in brightness in inverse ratio to the square of its distance from the subject. Because of this an object at twenty feet from the camera, for example, will receive only a quarter of the light received by objects at only ten feet. This means that if the exposure is calculated for the closer distance the background will be two stops underexposed. For this reason it is best to ensure that the distance between the model and the background is never more than about a quarter of the distance between the camera and the background, particularly when it is inherently dark in tone.

If more modelling is required, the simplest method of lighting is to use a long synch lead to enable the flash gun to be held slightly to one side and above the camera. The exact distance will depend upon how far the flash is from the model, her position, and the effect you want to create. Consequently the result will be, to some extent, a matter of guesswork. Remember too that the flash light will cast a shadow of the model onto the background and this can be unsightly if you allow it to happen indiscriminately. Unless you are shooting in a fairly small, light-toned room you may also need to use a reflector board to fill in the shadows created by the flash. It is possible to use a torch or table lamp from the selected flash position to get some impression of the effect of the flash.

Another method of creating more modelling and also to produce a softer light is either to diffuse or to reflect the light from the flash gun. The most simple method is simply to 'bounce' the flash light from a white wall or ceiling. This will obviously require an increase in exposure to allow for the extra distance the light must travel before reaching

This portrait was lit from an angle of ninety degrees to the camera, with a diffusing screen placed between the model and the flash. *Nikon F3, 105mm lens, Ilford FP4, f5.6 with flash.*

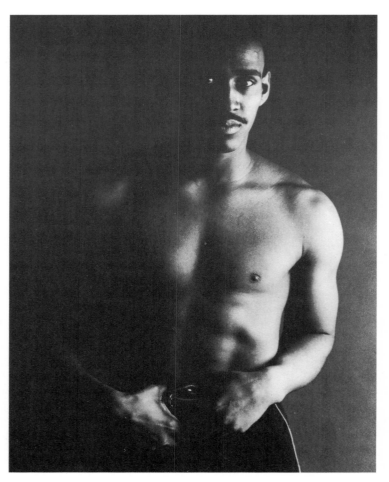

Direct flash from close to the camera lens has produced this flatly lit image with very little modelling. The background has recorded as white because it was very close to the model. *Nikon F3, 150mm lens, Ilford FP4, f8 with flash.*

This softly lit, abstract figure was lit by bouncing the light of the flash gun from a white ceiling, creating an almost shadowless effect. *Nikon F2, 35mm lens, Kodak Tri X, f8 with flash.*

the model and also for some absorption from the reflective surface. It is possible to estimate the exposure but for accurate results you should use either a dedicated flash gun which is controlled by the camera's exposure system, or a flash meter. The light from the flash can also be diffused by placing a diffusion screen in front of it or bouncing it from a reflector board or an umbrella reflector.

Although a small battery flash gun can be useful as a sole light source in an emergency, it is perhaps most useful in nude and portrait work as a supplement to the ambient light. When used as a sole source the choice of shutter speed is largely irrelevant and most photographers simply set the shutter to the flash setting, usually about 1/125 sec. However, by selecting a shutter speed which will give a correct exposure for the ambient light at the aperture required for the flash exposure it is possible to combine both effects. In this way you can record the effect of light sources, such as table lamps or windows, when shooting indoors. A similar technique can be applied to flash as a means of controlling contrast or supplementing sunlight when shooting outdoors. This is described in detail on pages 158–9.

Using Available Light

Although flash is a useful means of overcoming the problems of low light levels there are occasions when it is best to avoid it. In some instances this may be because the use of flash could be intrusive. However in nude and portrait photography it is most likely to be because the existing light creates a particular mood which the addition of flash would diminish or destroy.

Shooting in low levels of light creates some special problems which require a change in the normal methods and techniques of photography. The most basic of these is simply that of exposure. In outdoor lighting situations, or when using flash or studio lighting, it is possible to use both fast shutter speeds and reasonably small apertures, but when shooting in an interior with only minimal daylight or normal domestic lighting the choice of film, shutter speed and aperture will be much more restricted.

Slower shutter speeds mean that the risk of

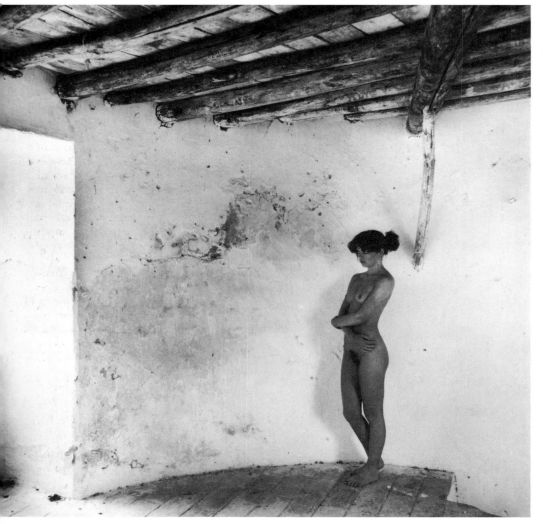

A tripod was used for this shot to allow a slow shutter speed to be used, so avoiding the use of a fast, more grainy, film. *Rolleiflex SLX, 80mm lens, Ilford FP4, 1/30 sec. at f4.*

86

both camera shake and subject movement are considerably greater. The first, and most important, solution to this problem is the use of a tripod. Shutter speeds below 1/60 sec. should not be attempted without the use of a tripod if critically sharp results are to be obtained with any degree of certainty. With a tripod, exposures of even 1 second or more are possible providing the model is quite static. It follows, therefore, that pictures requiring this type of exposure should be limited to poses in which the model is either seated, reclining or supported in some way.

Of course the shutter speed can be increased if a wider aperture is used. Many lenses for 35mm cameras have maximum apertures of f2 or f1.4 but at this setting the depth of field will be very shallow indeed. When the model is close to the camera it is quite likely that the depth of field will be insufficient to obtain adequate sharpness in all the most important areas of the image. If a very wide aperture must be used, it is essential to ensure that the most important elements of the image are primarily on one plane, by arranging for the model to be positioned quite square to the camera for example.

Switching to a faster film is usually an essential requirement of low light level photography. While you may normally use an ISO 100 film for outdoor or studio photography, in poor light it may well be necessary to use ISO 400, 800 or even faster. Remember too that the speed of most medium and fast black and white and colour transparency films can be increased in processing. This however will produce an image in which the grain of the emulsion is much more evident. This can often contribute to the mood and effect of available light pictures, but if you wish to minimise the effect of the grain then it is necessary to reduce the degree to which the image is enlarged. Changing to a larger format camera is the most effective way of doing this.

Another problem with available light photography is that the subject contrast is often quite high, especially if light sources are included within the picture area. This requires special consideration. When framing your picture it is essential to do so in a way that excludes or minimises the extreme ends of the brightness range of the subject. A picture which includes both large areas of deep shadow and bright highlights will inevitably produce an image which is too contrasty. Exposure readings on a high contrast subject can be misleading. It is best to take a close-up exposure reading from a mid tone in the most important part of the subject and to ensure that this reading is not influenced by either very bright highlights or areas of deep shadow.

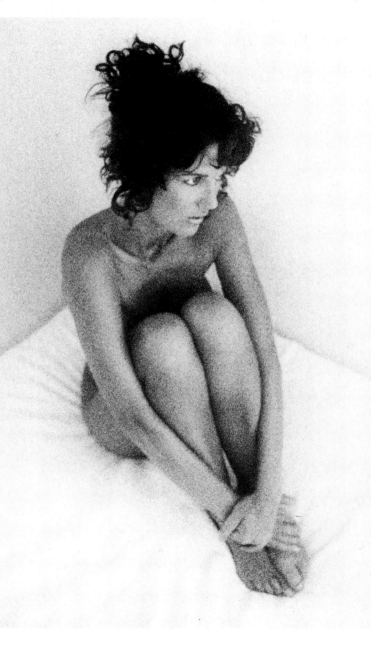

A high speed film was used for this indoor nude, which was taken in very low light. The grainy image contributes to the required mood of the picture. *Nikon F3, 50mm lens, Kodak 2475 Recording film, 1/30 sec. at f2.8.*

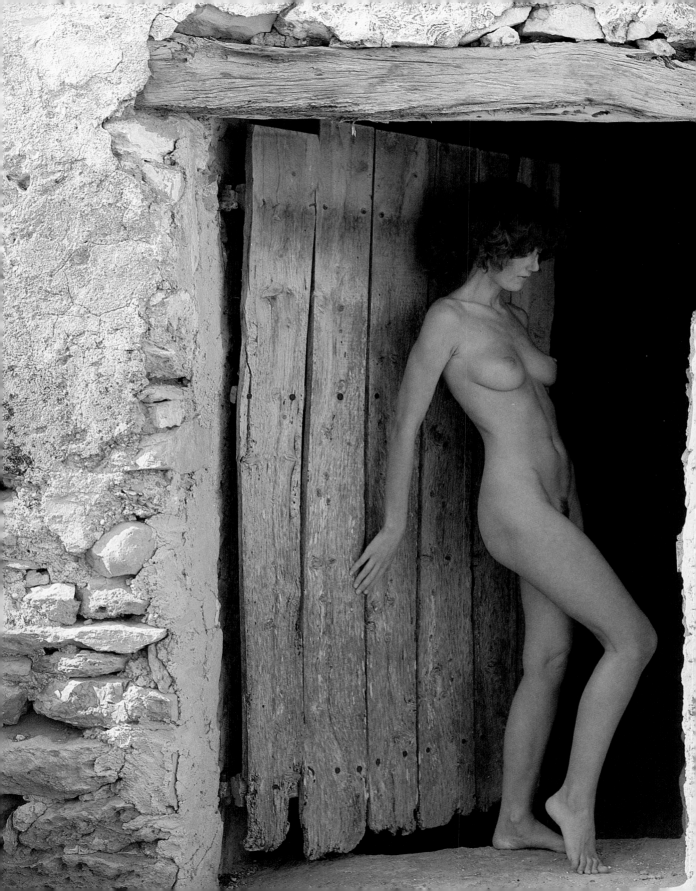

COMPOSITION
AND COLOUR

Using Shape and Line

The most basic way of identifying anything is by its shape. Indeed most everyday objects and even individual people can be recognised by their silhouette alone. The shape of a subject can be one of the most dominant elements of a photograph and one of the major factors in creating the basic structure of an image.

In nude and portrait photography in particular, shape is an element which can be fully exploited since not only is it a basic means of identification but also the outlines and contours of the human face and body are, in themselves, capable of creating beautiful and compelling images. Even a pure silhouette can be effective, and shooting a subject in this way can be a useful and constructive exercise in basic composition. One way of shooting a silhouette is to use studio lighting. By placing your model some distance in front of a white background and illuminating it as evenly as possible, and ensuring that no light spills onto the model, it is possible to obtain a solid black image of the model against a pure white background. When printing the black and

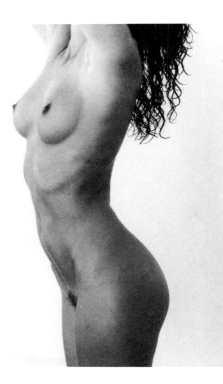

Although there is not a bold contrast between model and background in this picture, her exaggerated pose creates a strong and pleasing shape. *Nikon F3, 150mm lens, Ilford FP4, 1/250 sec. at f5.6.*

white negative any tone that may remain can be eliminated by printing onto a hard grade of paper. It is also a simple matter to obtain a silhouette without studio lighting, by placing your model against a window for example, or by shooting from the interior of a room with the model framed in a doorway.

In most cases, however, you will not want to produce a pure silhouette and it is only necessary to emphasise the outline of the model but still retain detail within the shape of the body or face. This can be done by ensuring that there is a strong tonal or colour contrast between the model and the background. A light skinned model posed against a dark toned wall for example, or a tanned body juxtaposed against a blue sea, will create a bold shape in which the outline of the model will be a dominant element of the image.

Lighting, too, can be used to emphasise the shape of the subject. You can, for example, choose a viewpoint which enables a brightly lit area of background to be positioned

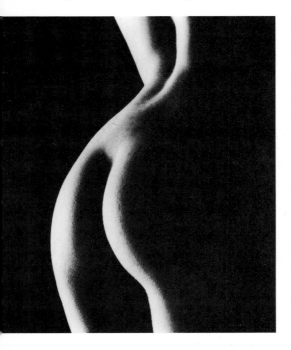

Rim lighting from above and behind the model, and the use of a black background, has emphasised the strong line created by back and buttocks. *Pentax 6×7, 150mm lens, Ilford FP4, f11 with studio flash.*

behind your model, or a different viewpoint may enable you to backlight the model, creating a rim of highlight around her body isolating it from a darker toned background. In the studio, of course, there are endless possibilities in both the use of lighting and the choice of backgrounds to accentuate the shape of the image.

So far we have only considered the basic shape of the subject, the model, but all of the shapes within the picture create a series of lines and these, too, are important to the way in which the composition of a photograph is created. The effect of perspective also tends to create lines and shapes which can be powerful elements in the composition – the converging lines created by a road leading away into the distance for example. If you take any good photograph, cover it with tracing paper and pencil in the main outlines, the resulting image will invariably have a pleasing and balanced quality and it is this which you must learn to identify in the subject when viewing it through the camera. In nude and portrait photography in particular you have many things under your control. The position and pose of the model, the use of props, clothes and accessories and the choice of background and camera viewpoint are all things that can be used to create an image in which the lines and shapes create a balanced and coherent effect.

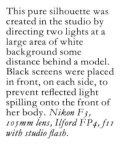

This pure silhouette was created in the studio by directing two lights at a large area of white background some distance behind a model. Black screens were placed in front, on each side, to prevent reflected light spilling onto the front of her body. *Nikon F3, 105mm lens, Ilford FP4, f11 with studio flash.*

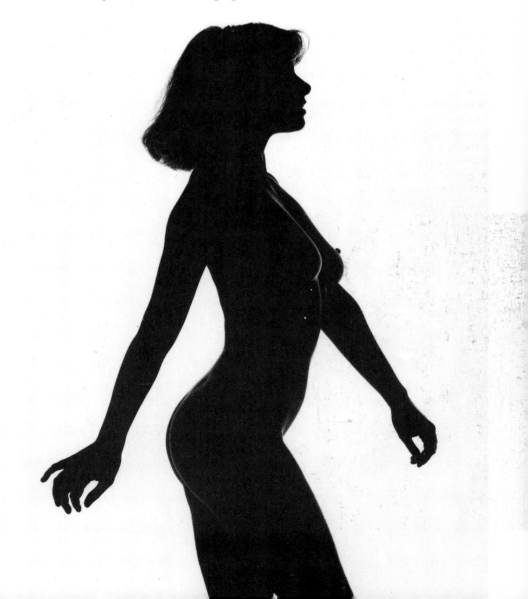

Revealing Form

While shape defines the outline of an object or person, form is the quality which gives it solidity and weight. In nude and portrait photography it is perhaps the most important element of the image. Revealing the form of the subject is one of the ways in which a flat image on a photograph can create the illusion of three dimensions and a sense of realism. This can be an important aspect of producing pictures with impact and sensuality.

Light is the crucial element in revealing form. It is the effect of the lighting which creates the range of tones within the subject – the transition from highlight to shadow, from white to black and all the subtle grades of tone between. It is this which gives the photographic image the ability to record the im-

pression of depth in a subject as well as just its shape. If a model is illuminated by a frontal light, one close to the camera like a flash gun for example, it will not create any shadows within the model's outline, and the different planes of the face and body, the contours, will not be revealed. If, however, the light is moved to one side it will begin to create shadows from the higher planes of the body or face. The further to the side the light is moved the larger and more pronounced will be the shadows and the more the model's form will be emphasised.

The nature of the shadows created is also important. The transition of tone from white to black, through the range of grey tones, creates the impression of form. A hard light,

This studio shot shows the male form revealed as a series of half shadows and curves. A reflector was used to relieve slightly the strength of the shadows. *Rolleiflex SLX, 150mm lens, Kodak Ektachrome EPR, f11 with studio flash.*

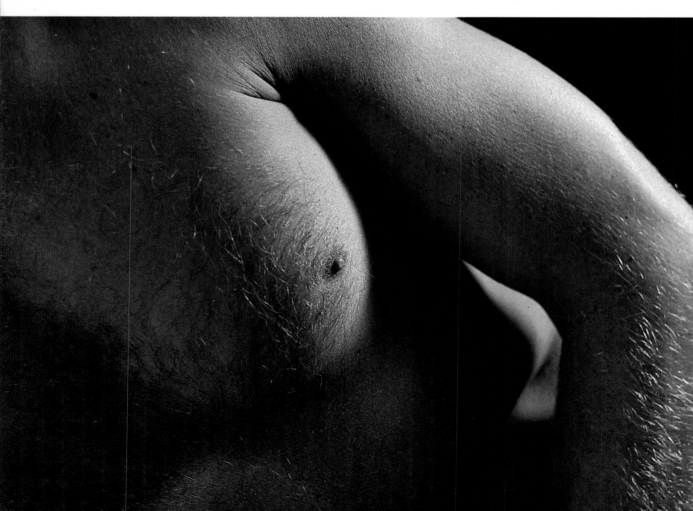

The strong modelling in this outdoor nude was created by a soft light from the doorway. The model was positioned so that the light was directed at almost right angles to her body. *Rolleiflex SLX, 150mm lens, Fujichrome RDP 100, 1/125 sec. at f5.6.*

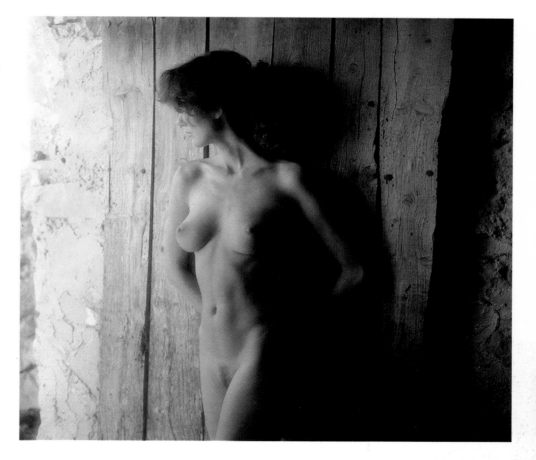

such as an undiffused studio light or direct sunlight, creates a hard edged, sharply defined shadow which will produce little intermediate tone, going straight from highlight to shadow. For this reason the lighting which is most likely to create the strongest impression of form is a soft, diffused light. The shadows it produces will have a blurred, indeterminate edge creating a wide range of tones between white and black.

The direction of the light source is also crucial. If it is too close to the camera few shadows will be produced, and if it is at too great an angle the shadows will be too large and dominant. The exact position will depend on a number of factors – the angle at which the model is placed in relation to the camera, the position of his or her body and of course the inherent nature of the contours of the body itself or those created by the pose. It is essential to learn to study the effect of the shadows as the lighting angle changes and as

the model moves. There are infinite variations and one of the pleasures of nude photography is of exploring the constantly changing and controllable effects of light and shade.

A further degree of control over the tonal range of the image can be exercised by using additional light sources and reflectors. The density of the shadows created by the main light can be varied, for example by the use of a reflector placed close to the model on the shadow side and angled towards the light. By moving this closer to, or further from the model, the shadows can be made either lighter or darker and the overall contrast of the image can be controlled. A second or third light source can also be used to create additional highlights and a further range of tones within the subject. A backlight, for example, can be placed behind and to one side of the model to create a rim of highlight on the shadow side of her body, and this can further enhance the impression of form and depth.

Using Perspective

Like form, perspective is an important element in the creation of depth in a photograph. The effect of perspective is created by the way in which objects of a similar size appear to become smaller the further they are from the camera. The more pronounced the perspective effect becomes the greater is the impression of depth and distance and the three dimensional quality of the image.

Perspective is controlled by the camera viewpoint. The closer this is to an object or person the larger the subject will appear in relation to more distant objects. This effect can be readily understood by simply holding your hand close to your eye. At this distance it will appear to be considerably larger than a distant tree, creating a greatly exaggerated impression of perspective. If you now move your hand slowly towards arm's length you will see that it rapidly diminishes in size reducing the effect of perspective. The effect of perspective is important when taking a portrait. From a very close camera viewpoint a model's face can appear almost distorted with the nose and chin seeming much larger in proportion to the rest of the face. As the

A distant viewpoint and a long focus lens have been used in this picture to produce intentionally an image with little impression of depth or perspective. *Rolleiflex SLX, 250mm lens, Ilford FP4, 1/250 sec. at f5.6.*

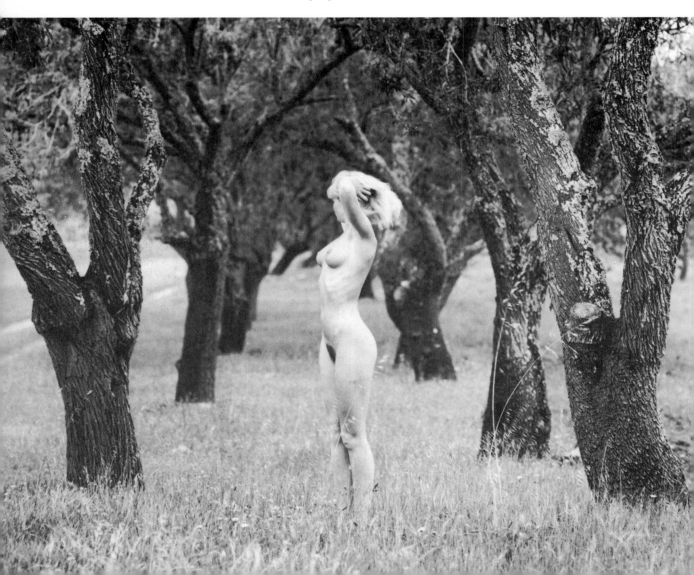

camera is moved further away so the features are shown more in their true proportion. This is the reason why close-up portraits are best taken using a long focus lens and a more distant viewpoint.

It can be effective, however, to exaggerate perspective deliberately, especially when an unusual or abstract effect is wanted. Many successful nude photographs have been taken where a close viewpoint has been used to make the body appear to be distorted. The famous series of nudes by Bill Brandt is a good example, with a wide angle lens used to further accentuate the effects of a close viewpoint. The use of perspective effects, however, is not limited just to the model's appearance but also the backgrounds and foregrounds of the shots. Very interesting images can be created by having the model very close to the camera and juxtaposed with background details in a way that makes them appear to be much smaller and much further away than they really are. Again the use of a wide angle lens will further enhance this effect. In the same way, very close foreground details can be included with the model at a greater distance so that the model appears

much smaller in proportion. These techniques will create the impression of bold, converging lines in the image, which, as we discussed on the previous pages, can help to produce strong and compelling images. Quite often the use of higher or lower than normal viewpoints will also help to create unusual or dramatic perspective effects.

Minimising the effect of perspective can also help to produce unusual and interesting pictures. For this it is necessary to use more distant viewpoints so that both model and background, together with any foreground objects, are all at a distance from the camera. In this type of picture a long focus lens can be used to create a close-up image of the model from the more distant viewpoint. If a very long focus lens is used, such as a 300mm or 400mm lens with a 35mm camera, it is possible to produce an effect in which the planes of the photograph appear to be compressed and the impression of depth and distance is almost eliminated. This technique allows you to juxtapose your model with more distant background details or objects in a way that makes them appear to dwarf the model or appear disproportionately large.

Here a very close viewpoint and the use of a wide angle lens has created an exaggerated perspective. *Rolleiflex SLX, 50mm lens, Ilford FP4, 1/250 sec. at f11.*

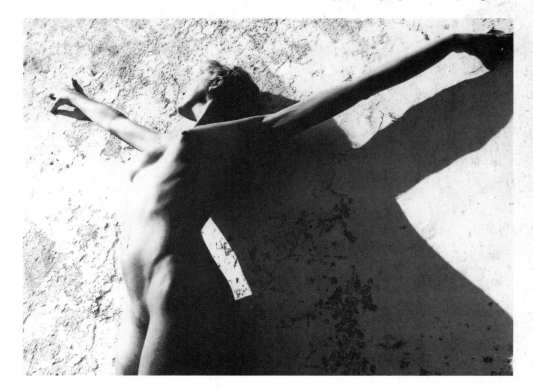

Introducing Pattern

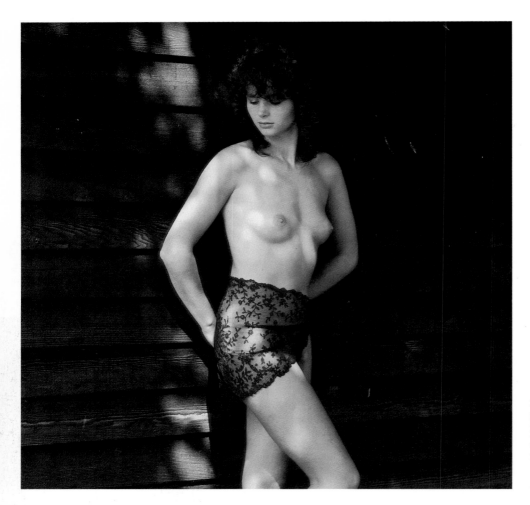

In this picture both the piece of fabric and the light filtering through the leaves of a tree have added to the sense of pattern. *Rolleiflex SLX, 150mm lens, Kodak Ektachrome EPD, 1/125 sec. at f8.*

Pattern is the repetition of shapes, lines or colours within the image. Its presence tends to create a harmonising effect giving the picture a feeling of coherence. In photographic terms a pattern does not necessarily have to be symmetrically ordered, as long as there is an impression of repetition it will have the same effect. Often something as random as a series of similar highlights, shadows or colours within the picture can create a pattern effect.

The effectiveness of an element of pattern in a picture is usually greatest when there is some object or detail which breaks it, creat-ing, in a way, an element of surprise and making it the focus of attention. For this reason, in nude and portrait photography, the most useful place for a pattern to be used is often in the background or setting. In this way the model becomes the feature which breaks the pattern and as a result is given further emphasis. There are many ways of finding and using patterns, particularly in outdoor location photography where both manmade and natural features invariably have a strong pattern element. Even something as mundane as a brick or stone wall can create an effective background especially when the

pattern fills the frame and the model is placed in a dominant position within it.

Patterns on a larger scale can also be found in landscape settings, such as a hillside planted with trees or the ripples on wet sand after the tide has gone out. Beach and seaside locations are often ideal for this type of shot as there are many objects which can be used to create patterns – rows of beach umbrellas, for example, or deck chairs. The impression of pattern in settings like this is often the result of a carefully chosen viewpoint. A long focus lens can also help because it will diminish the effect of perspective and help to make the image more graphic in quality and enable you to keep it tightly framed.

Lighting can also create pattern both outdoors on location and in the studio. Highlights and shadows can easily be used to create the effect of a pattern, and on a sunny day outdoors the hard edged shadows created by features like fences and trees can often create bold pattern effects for the background of a picture. Even the highlights on backlit water can produce a quite compelling pattern. In some instances the pattern created by highlights and shadows can be used effectively to illuminate the model. Sunlight filtering through leaves, or perhaps a venetian blind, can be used to cast a shadow pattern over the model. Be careful, however, that this type of effect does not create too much contrast since an exposure which accurately records the shadowed skin tones can leave the highlight tones bleached out and lacking in detail. This can be avoided by using a reflector to fill in the shadows and reduce the contrast, or to use fill-in flash – described on pages 158–9.

In the studio, patterns can often be used effectively to add interest to the background. Shapes cut out of black card can be placed a few feet in front of a spotlight aimed at the background. It is important, however, to ensure that the light used to illuminate the model does not spill onto the background and degrade the light pattern. A similar and more controlled effect can be created by making a slide of a suitable pattern and projecting it, with the aid of a slide projector, onto the model or background, or both.

The highlights on the rippled water of a swimming pool have created a patterned background and provided an effective contrast to this abstract nude. *Nikon F3, 150mm lens, Fujichrome RDP 100, 1/250 sec. at f11.*

Emphasising Texture

The camera has an almost uncanny ability to record the texture of surfaces so accurately that a colour photograph can give the viewer a very strong impression of the tactile qualities of the original object. It is partly this quality which enables a photograph to convey such a strong sense of realism, and in nude and portrait photography it can be a vital element in the ability to create images with a bold visual impact as well as helping to create sensual and erotic pictures.

Like form, the element of texture is largely dependent upon lighting. In many ways they are similar – texture is in fact the form of a surface. Because most textures encountered in the field of nude and portrait photography, such as skin, fabric and hair, have quite a subtle relief the type of lighting which is usually needed to emphasise it is more directional and often harder than that which is needed to reveal form. The light source needs to be positioned so that the light literally skims across the surface it is illuminating. In the studio this can be accurately controlled by the use of an undiffused light or a spotlight.

It is important to appreciate, however, that this type of lighting can be rather unflattering and care must be taken to ensure that unwanted effects, such as harsh lighting and skin blemishes, are not accentuated along with the textural quality. Backlighting is often an effective way of emphasising texture. By placing a light source slightly behind and to one side of the model light can be directed to create bold textural effects around the rim of the model's body or face. Be sure, however, that this light does not spill into the camera lens and also that it does not create excessive contrast. A reflector may be needed to bounce some of this light back into the shadows to control the brightness range.

In outdoor photography the lighting angle must be controlled by the choice of camera viewpoint and the pose and position of the

The texture of the rough stone walls, the grass and weathered wood provide an effective contrast to the soft skin of the body. *Nikon FE2, 85mm lens, Ilford FP4, 1/125 sec. at f8.*

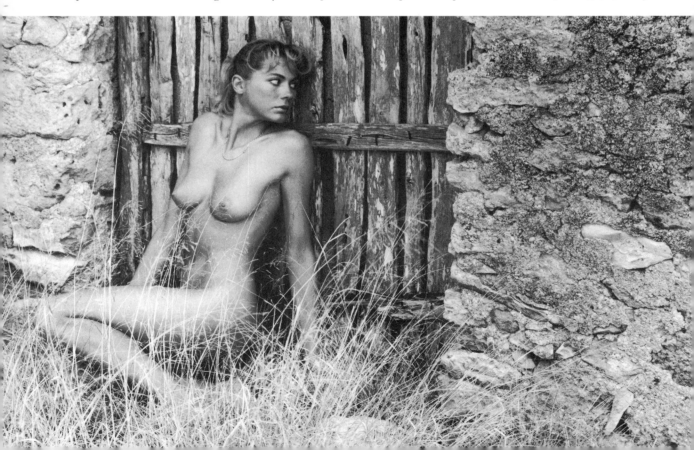

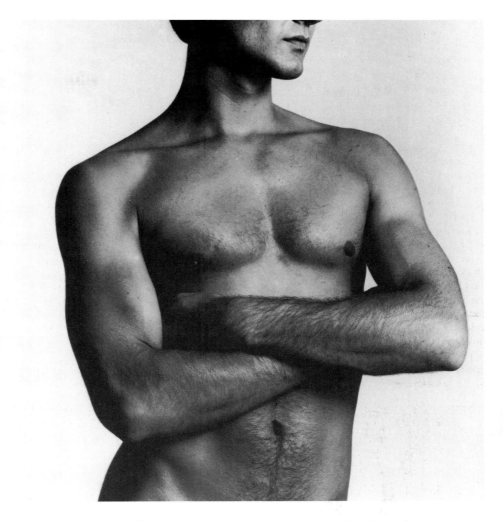

A diffused light source placed at almost right angles to the model's body has emphasised the skin texture in this male nude. *Rolleiflex SLX, 150mm lens, Ilford FP4, f11 with studio flash.*

model. Direct sunlight will give the most pronounced effect but any quite strong directional light, if angled correctly, will enhance the textural quality of skin and fabric. As with studio lighting it is important to avoid excessive contrast since this will tend to lose the highlight detail which is crucial to creating a strong textural effect. Exposure is also important and any degree of overexposure will diminish highlight detail and reduce the quality of texture. As a general rule it is best to underexpose slightly, by say 1/3 to 1/2 stop. For really dramatic effects even greater degrees of underexposure can be used.

Image sharpness is also essential to the quality of texture. It is important that the lens is focused accurately, that there is no possibility of camera shake and that there is

adequate depth of field, particularly when close-up shots are taken. For these reasons it is best to use a tripod for this type of shot. A slow fine grained film will also help to retain the fine detail of subtly textured surfaces and when, in addition, small apertures are used for maximum depth of field, shutter speeds will tend to be longer than can be safely used with a hand held camera.

The effect of a textured surface is often heightened when it is juxtaposed with a different texture – silk or leather against skin, for example, or sand or water on skin. Juxtapositions of this type are widely used when a sense of realism and eroticism is important, and the images created can have a powerful impact as well as producing pictures of superb photographic quality.

99

Composition and Style

There are many different qualities which contribute towards a successful photograph, but the final effect is dependent upon how the elements of the image are organised within the borders of the picture. The basic technique of framing the image was discussed on pages 80–1, but there are many refinements and visual techniques which can be learnt in order to perfect the art of composition.

It is important to learn how to see your subject in terms of its visual elements – shape, line, form, texture, pattern, perspective and colour. These are the building blocks from which you can construct your images. By becoming aware of these inherent qualities of the subject you can see how best to organise them within the borders of the picture in order to create the most telling result. As a general rule one of these qualities tends to dominate in a good photograph. You can learn a great deal by studying the work of successful photographers, and your own best pictures, and recognising exactly which is the visual quality in a particular photograph that provides the nucleus of the image. This is not to suggest that only one of these qualities is necessary to create an interesting picture. On the contrary a photograph with an unrelieved pattern, or a close-up of skin texture alone may have an initial impact but its interest would not be sustained. It is the successful combination and balance of these elements which creates a completely satisfying photograph.

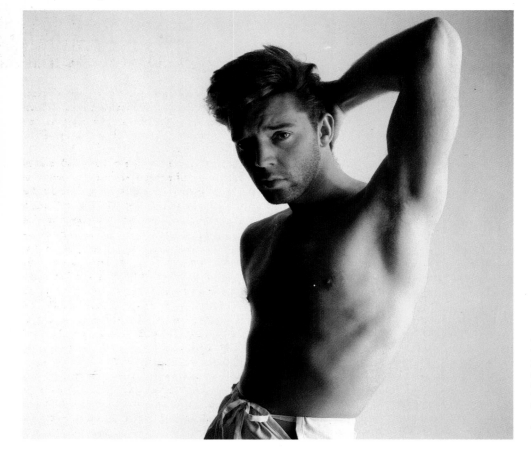

The choice of background, strong side lighting and angular pose of the model have been combined in this portrait to produce a picture with a strong visual impact. *Rolleiflex SLX, 150mm lens, Kodak Ektachrome EPR, f11 with studio flash.*

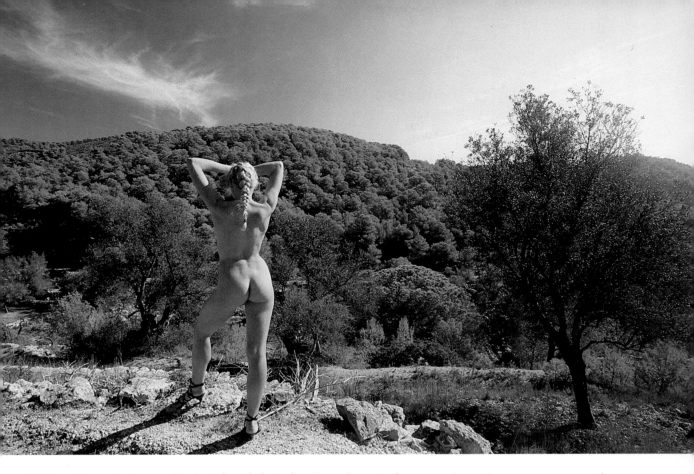

In this outdoor nude, the setting has been used in a dominant way and directional lighting has emphasised the statuesque pose of the model; combining to produce a bold image against a bold background. *Nikon F3, 20mm lens, Fujichrome RPD 100, 1/250 sec. at f11.*

Having identified the dominant element of your picture, how then should you proceed to construct the image around it? The first consideration is to choose a viewpoint and to frame the picture in such a way that the main point of interest is shown in the best way possible. If it is, for example, the shape of a girl's body, juxtapose it against a background which creates the maximum emphasis, and if it is the texture of a muscled male torso or the rounded form of an abstract nude, choose a camera angle and model pose which creates the most effective lighting. Once this has been done you can then begin to study the other elements of the scene and decide which will contribute to the overall image and which might detract from it.

This could mean that you may need to adjust the framing of the picture or change the viewpoint slightly. Remember, however, there is seldom only one way of approaching and composing a picture of a given situation and it is well worth while exploring all the possibilities before you start to make your exposures. Indeed it may well merit shooting

some alternative arrangements and comparing the results. This is not only an excellent way of learning the art of composition but also of gaining experience and helping to develop a personal style.

There are also a number of basic techniques that photographers use to help to organise and balance their pictures. If you study the work of other photographers you will soon discover that each has his own repertoire of compositional techniques, such as using foreground details and objects to frame the subject, perspective lines to lead the eye into the picture, calculatedly 'off balance' framing or a particular way of lighting or posing the model. Used in different ways, and in different contexts, techniques like these are a crucial part of the experienced photographer's stock in trade. Although you should by no means copy other photographers' work slavishly, there is much to be gained from drawing inspiration and ideas from others, including artists and sculptors for example, and incorporating them into themes and subjects of your own.

Seeing in Black and White

Black and white photography is a medium which is particularly suited to nude and portrait work for a number of reasons. Firstly, it is a stage removed from the realism of colour and this can make it easier to create more personal and interpretive images and also to avoid the more glamorous, commercial quality which colour photographs can easily impress on a subject. In addition many of the visual qualities which help to create rich black and white images are particularly abundant in nude and portrait subjects. Tex-

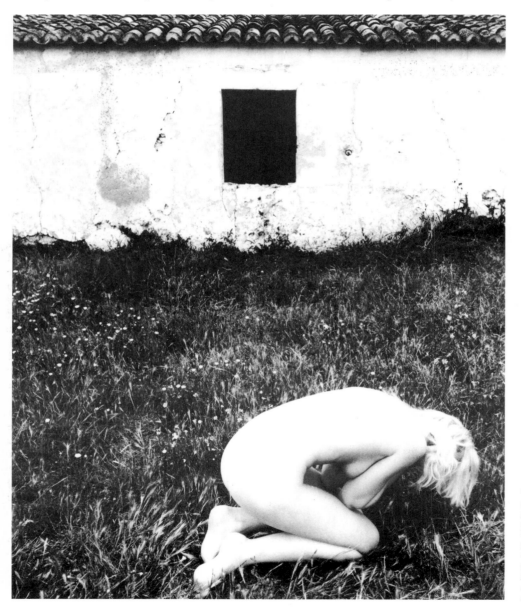

The bold shapes, textures and tones of this outdoor nude lend themselves perfectly to black and white photography. The introduction of colour would have detracted from the effect of the image. *Rolleiflex SLX, 150mm lens, Agfa Isopan, 1/125 sec. at f5.6.*

ture, form, shape and pattern are all elements which can have an even stronger effect on the image when photographed without the distraction of colour to diminish them. Finally the image control which is available to the photographer who makes his own black and white prints is so great that it offers an almost unlimited potential for innovative and individual work.

However, it is true to say that the vast majority of photographs taken today are in colour, and the use of black and white materials has become quite limited, certainly as far as the amateur photographer is concerned. This is a complete reversal of the situation a few decades ago when most photographers learned their craft through the medium of black and white, only later extending their skills to the use of colour. It is a fact that the basic approach to a subject and the way in which it is seen and the image is composed is quite different when shooting in black and white. Indeed many photographers prefer not to have to shoot black and white and colour pictures together on the same session because each makes quite different demands.

The main reason for this is that when shooting colour pictures, as a general rule, the colour content of the subject tends to dominate the nature of the image and the way it is composed, and the other elements of the image become of secondary importance. When shooting black and white pictures, however, the roles are reversed. It is no longer the colours within the image which must be considered but the tonal range, and you must learn to see your pictures in shades of grey.

The tonal range of a subject is dependent upon two factors – its inherent tones and the tones created by lighting. A picture of a blonde, fair skinned model and a dark skinned model for example, would, even if lit with a soft shadowless light, display a full range of tones from white to black, but the blonde model alone and lit in the same way would create an image with a much more limited tonal range. Should the lighting be changed to a strong side light casting deep shadows, a further range of tones would be introduced, and if the blonde model were photographed with back or rim lighting the tone of the skin could be made to appear as dark as that of the other model.

This means that you must learn to see your subject in two ways. Firstly look at the colours and see them as shades of grey – a bright red records in colour as a strong tone but in black and white is a quite weak tone of grey. Secondly you must become aware of the tones produced within these areas of colour by the light and shade created by the lighting. Judging tonal values this way can be difficult at first, particularly if you are accustomed to shooting in colour. It can help to see the effects of light and shade more clearly if you view the subject through half closed eyes, or a strong colour filter such as green.

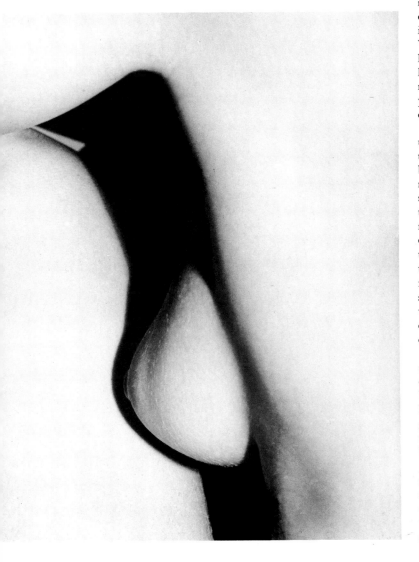

This studio abstract relies solely upon the juxtaposition of tones and the bold shapes this creates: colour would have been irrelevant. *Nikon F3, 150mm lens, Ilford FP4, f11 with studio flash.*

Using Colour Contrast

When shooting colour photographs the inherent colour content of the subject is invariably the most dominent element of the composition and it is essential to be fully aware of the different colours within the image and how they react with each other. The most common fault with colour photographs is that there is usually simply too much *uncontrolled* colour in them. It is necessary to be very selective when choosing a viewpoint and framing the image to ensure that you include only the colours which contribute to the composition and effect of the image.

It is important to understand first how colours react with one another when included in the same image. There are three basic ways – they create a contrast with each other, they harmonise or they clash. The colour spectrum is a guide to the way that this works. It has bands of hues ranging from red through orange, yellow, green, blue to indigo and violet. If two colours come from widely separated bands of the spectrum, such as red and green, they will create a degree of contrast, depending upon how pure and saturated the colours are. If, however, the colours comes from the same or adjacent bands of the spectrum they will tend to harmonise, like, for example, blue and green. Clashing colours are rather more difficult to define since personal taste and fashion can be involved. Indeed clashing colours can be quite stylish and are not necessarily to be avoided, but the success of a picture is more assured if it is dependent upon contrasting or harmonising colours.

In many ways contrasting colours are the most effective and easiest to deal with in terms of composition. A picture with a bold colour contrast will invariably have a powerful visual impact and it is a way of creating a strong focus of attention. The greatest contrast will be created when the colours involved are fully saturated, a primary green with a pillar box red for example. When colours are softer and less saturated the effect will be more subtle. Contrast can also be created when a colour is juxtaposed with a neutral tone, such as white, grey or black.

The essence of pictures of this type is to limit the number of colours within the image and to ensure that one colour dominates and

The vivid contrast between the red fabric and the deep blue water of the pool has created a strong image with considerable colour contrast. *Nikon F3, 150mm lens, Fujichrome RDP 100, 1/250 sec. at f11.*

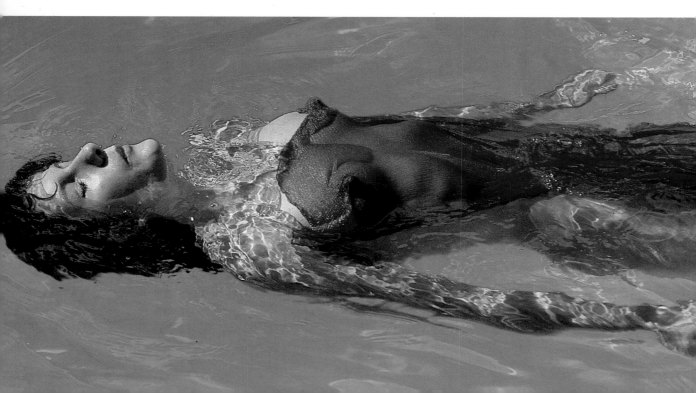

is either part of the centre of interest or very close to it. Colour contrast can be very effective when a small area of a bold colour is juxtaposed with a much larger area of contrasting colour. Imagine, a picture of a nude girl some distance from the camera with a large area of blue sea as a background. A single splash of red, perhaps a scarf in her hair, would have quite a dramatic effect.

The main way of selecting the colours in a picture is by the choice of viewpoint and the way in which the image is framed. A long focus lens is often an asset in this respect because it enables tightly framed pictures to be made and encourages a more selective approach. In nude and portrait photography, however, you have much more under your control than when taking a landscape picture. You can position your model in front of suitable backgrounds, for example, and select props, clothes and accessories in order to create the exact colour effect you want.

The yellow fabric was added in this back lit beach shot to create a colour contrast which would otherwise have been lacking. *Nikon F3, 105mm lens, Kodak Ektachrome EPR, 1/250 sec. at f5.6.*

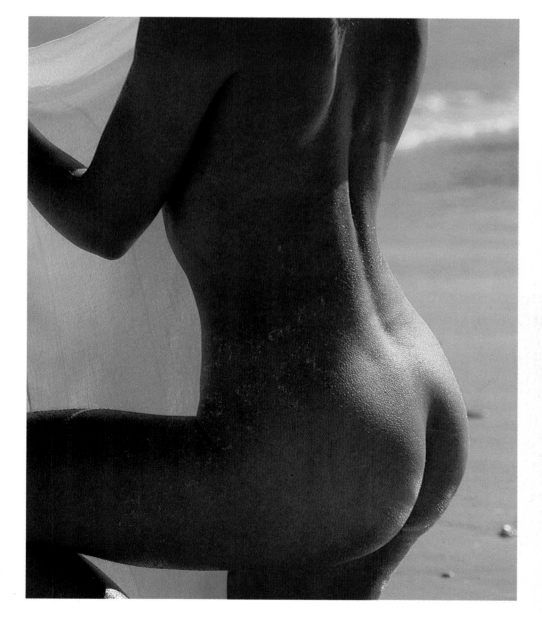

Using Harmonious Colours

While colour contrast creates bold, assertive images it is not always appropriate to the mood or quality of a picture, and quite often a more subtle approach to the use of colour in an image is called for. Colours which harmonise tend to create a soft, gentle mood. They can be suitable for pictures which have strong visual elements, such as a rich textural quality or a dominant pattern, where bold, contrasting colours could be a distraction.

We have already discussed the fact that harmonious colours come from similar areas of the spectrum band. In outdoor locations many colours have a quite natural harmony –

The choice of a dark brown background has produced a picture with harmonious colour quality in this male portrait. *Rolleiflex SLX, 150mm lens, Kodak Ektachrome EPR, f11 with studio flash.*

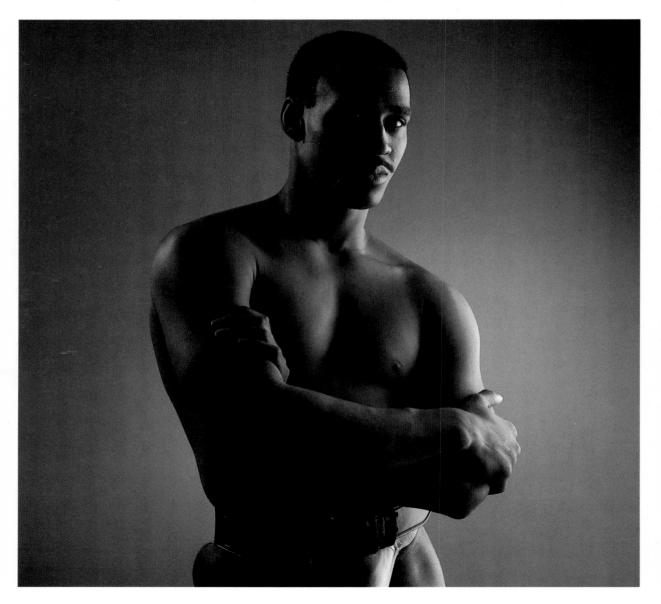

The overcast sky has created a soft and almost monochromatic quality in this beach shot, and this has been emphasised by slight underexposure. *Nikon F3, 20mm lens, Fujichrome RDP 100, 1/250 sec. at f8.*

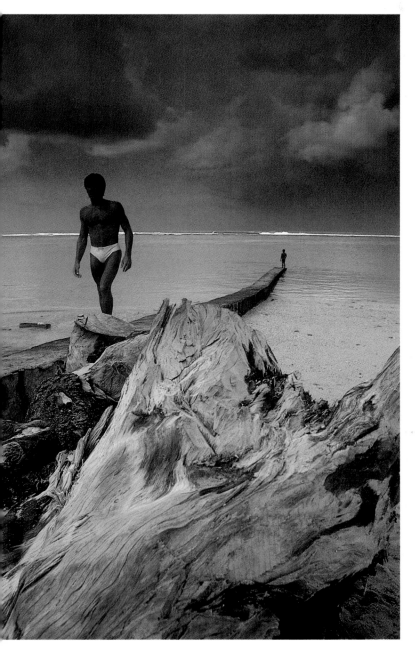

green foliage and blue sky, autumn woodland colours and the mixtures of blue and turquoise found in seaside locations for example. In addition there is the opportunity to combine the colours of props and accessories with those found naturally in the settings. In nude photography skin tones have a quite neutral quality and will harmonise quite readily with most colours with which they are juxtaposed.

One of the most effective ways of using colour harmony is to limit the colours to different shades of the same or similar hues. In the studio for example, a nude body photographed against sepia or brown background papers can create a very harmonious quality which will enhance visual elements like form and texture. Sometimes it can be very effective to use very little colour, with the image virtually monochromatic and only the slightest hint of colour present.

Colour harmony can exist, however, when colours which are more distant from each other in the spectrum are present in the image. This works if they are soft and desaturated, for example like pastel hues, and if they are distributed in a way that does not create bold juxtapositions. There are a number of techniques that can be used to help create an harmonious colour effect. A degree of overexposure, for example, will desaturate colours and the use of soft focus and fog filters will have a similar effect. Even the simple expedient of shooting a strongly coloured background so that it is thrown well out of focus can help to make the colours harmonise. This can be done by using a long focus lens, selecting a wide aperture and ensuring that there is as much distance as possible between the model and the background. Shooting through diffusion media such as an out of focus screen or foliage, for example, or a misty or rain streaked window will also help to soften and degrade the colours.

Lighting and weather conditions can impose a degree of harmony. Mist, fog and even rain can weaken and desaturate quite strong colours. Shooting into the light is also a technique which can produce softer and more pastel hues, particularly if a degree of flare is allowed to occur by letting the light fall onto the camera lens. Lighting conditions which create a colour cast can be used to help the colours within the subject blend and produce a more monochromatic effect. A good example of this is at sunset when everything is basked in a golden light, or at dusk when a soft, bluish cast is created. It is also possible to create this type of effect artificially by using colour correction filters to produce a colour cast, although this must be done discreetly or the results can simply look contrived and gimmicky.

Creating Mood

Colour has a very significant effect on our mood and the choice and use of colour in a photograph will have a corresponding effect on the mood of a picture. In many ways the spectrum can be considered in bands of moods as well as of colours. Red is a very assertive colour and tends to command attention. Orange and yellow have more mellow qualities and are inclined to create a warm and inviting atmosphere. Green and blue are the dominant colours of nature and have a restful, reassuring quality. Indigo and violet have a much more subdued and sombre quality, suggesting dignity and sobriety.

The mood of a picture can be affected by colour in different ways – by the overall colour quality of the image and the way in which the colours react with each other. Colour contrast tends to create a bright, lively and assertive quality, especially when strong saturated colours are present in the image, whereas soft, harmonising colours create a more restful or romantic atmosphere. It is easy to see just how dominant the use of colour can be in this way if your consider the way individual photographers use colour to create their own mood and style. David Hamilton, for example, is a past master of the use of soft pastel colours to produce dreamy, romantic pictures, whereas photographers like David Bailey often use bold primary colours to create more aggressive images.

With nude photography the element of colour must come essentially from the background or setting, and perhaps the choice of props or accessories. To be fully effective it must be sympathetic to both the model's pose and expression. It would, for example, be counterproductive to have a reclining nude with a tranquil or pensive expression photographed in a setting with bold bright colours, just as it would to attempt to create a bright, lively atmosphere with a background of subdued colours.

Mood is a question of tone as well as of colour, and of course in black and white photography this is one of the most effective ways of creating atmosphere in a picture. An image with a bold tonal contrast, bright highlights, rich shadows and a full range of tones between, will tend to create a bright and lively atmosphere. However, a picture with mainly dark and subdued tones will produce a quieter, more restrained mood, and even a sad or sombre one if the model's pose and expression are appropriate. A picture with predominately light tones will produce images with a gentler, more romantic atmosphere.

Image quality in general can also affect mood. In black and white photography, for example, it is possible to create harsh, assertive images from quite normal pictures simply by printing onto a hard grade of paper, and similarly produce photographs with a more brooding atmosphere by making the prints darker and richer in tone. Underexposing colour transparencies can have a similar effect, creating quite rich and dramatic images from a quite normal situation. The use of

This outdoor nude was lit with flash, to allow the background and sky to record with dark and subdued tones, and so create a moody picture. Rolleiflex SLX, 80mm lens, Fujichrome RDP 100, 1/500 sec. at f11 with flash.

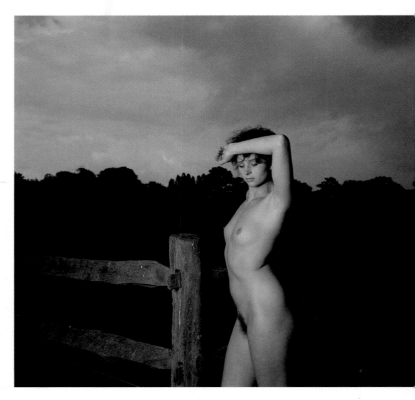

grain and soft focus can also, in some situations, be an effective way of creating mood and often the choice of viewpoint and the way the image is framed and composed can emphasise particular moods. It is important to appreciate, however, that the overall mood of a picture will depend on a successful combination of a number of different elements, together with a clear idea of the effect you wish to create.

The overall bluish quality, combined with the pensive pose of the model, has produced a sombre mood for this indoor nude. *Pentax 6×7, 105mm lens, Kodak Ektachrome EPD, 1/60 sec. at f4.*

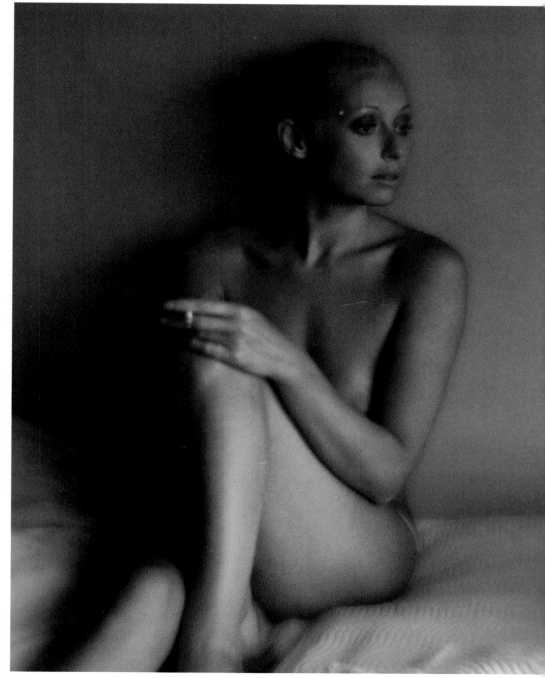

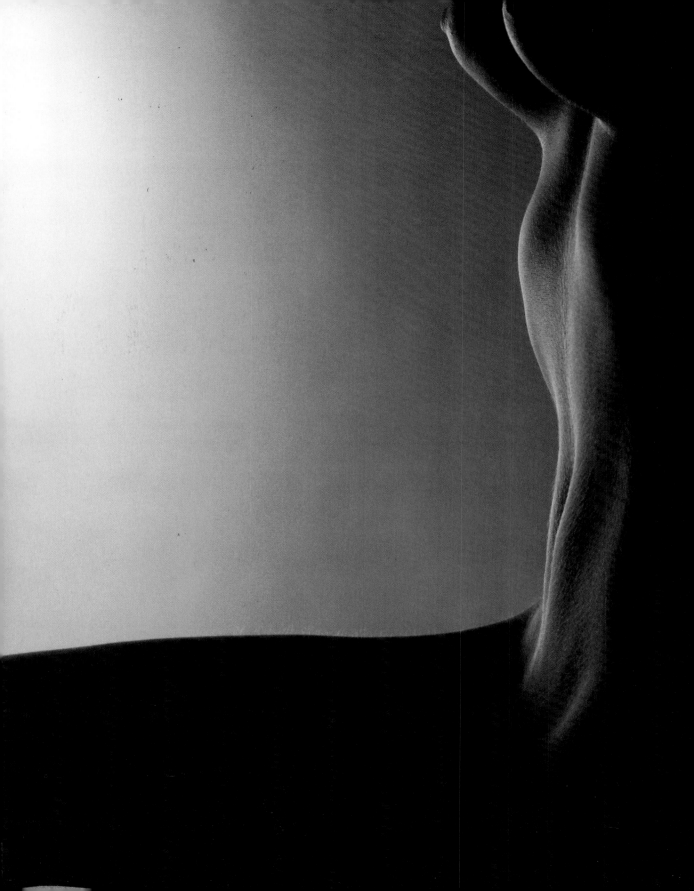

INDOOR PHOTOGRAPHY

Setting up a Makeshift Studio

The range of possibilities available to the photographer concentrating on nude and portrait work will be considerably extended by the use of a studio. For an amateur photographer, or one who only occasionally needs studio facilities, it is quite possible to have a readily arranged temporary setup that will adequately fulfill most requirements.

The first consideration is the space available – obviously the more the better, but it is possible to carry out a wide variety of sessions in a quite limited space. For most people the studio will be a room in their home or perhaps a large garage. Ideally you will need a space at

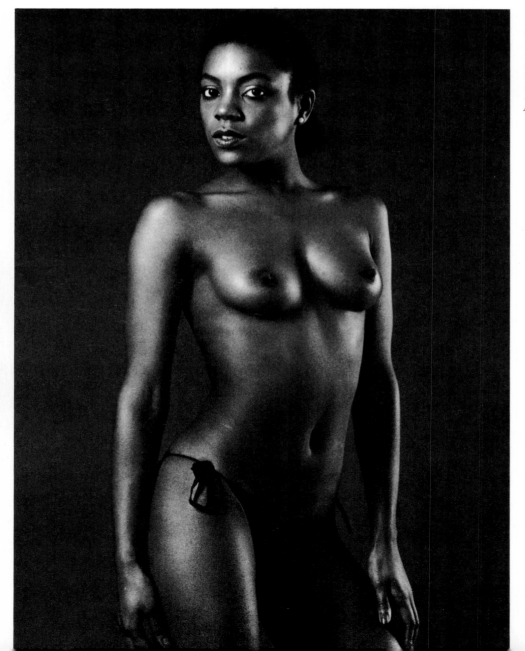

In this picture the model was placed five or six feet in front of the background to avoid shadows. A room at least fifteen feet long is needed for this type of shot. *Nikon F3, 105mm lens, Ilford FP4, f8 with studio flash.*

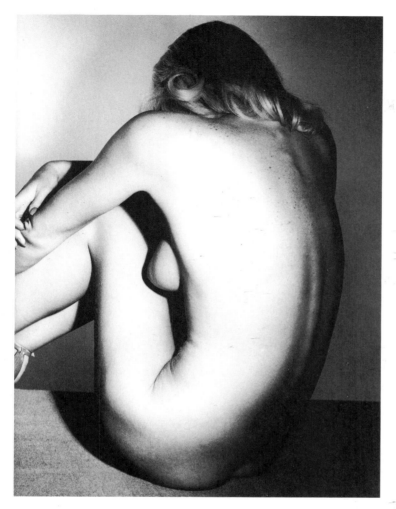

A much more modest space is sufficient to create a picture like this, which was taken on a wide angle lens. *Nikon F3, 35mm lens, Ilford FP4, f11 with studio flash.*

tridge paper and are available in a wide range of colours; they are 9 feet (2.75 metres) wide allowing ample coverage for even two or three models. They are virtually a necessity for full length shots since the paper can be extended onto the floor in a smooth curve which avoids a hard line between floor and wall. They can be supported by simply taping or pinning the end of the paper to the wall and allowing the roll to rest on the floor, but a more convenient and compact means of support is by the specially made background units. These consist of brackets, holding one or more rolls, which sit onto two spring loaded poles held firmly between floor and ceiling. These, unlike tripods, take up virtually no floor space and can also be used advantageously as lighting stands. Fabrics and painted boards can be used as backgrounds for closer shots where the floor is not shown. Extra care should be taken to avoid creases in fabrics. This can be avoided by stretching the pressed fabrics onto a simple wooden frame.

Additional items which will be invaluable are two or three reflector boards, measuring about 6 × 4 feet (1.8 × 1.2 metres). These can be pieces of hardboard painted white, or sheets of rigid white polystyrene which is very light to handle and can easily be propped against a spare light stand or a chair. One of these at least should be painted black on one side to be used as a screen for reducing scattered light. This problem is often encountered when working in a small, light toned room and results in a loss of shadow density. A diffusing screen is also an invaluable and inexpensive accessory, a large softwood frame about the same size covered in tracing paper or white translucent plastic will be ideal. You will also need some posing aids. These could include a stool, or low-backed chair, and some boxes which can be arranged in a variety of ways and covered in cushions or fabrics. A large rigid board which could be placed on these boxes to form a low stage or rostrum would also be useful.

Whatever system of lighting you use you will need at least two or three stands to enable them to be accurately positioned and easily adjusted. Tripod based stands are convenient, and are also portable. One of them should have a boom arm to enable a light to be supported directly above the model.

least 15 × 12 feet (4 × 3.5 metres), especially if you want to shoot full length figures and use standard background rolls. The actual shooting distance can easily be increased by placing the camera outside an open door, but you need to allow for a distance of at least five or six feet (up to about two metres) between the model and the background to avoid problems with shadows. Ceiling height too must be considered. Modern homes often have relatively low ceilings of nine feet or so (less than 3 metres), and this will not allow the use of low viewpoints, particularly with full length shots.

Although it is possible to make use of a plain, painted wall as a background it is much more satisfactory to use standard background rolls. These are made of good quality car-

A Permanent Studio

If you have the opportunity to take over a space as a studio on a permanent basic then it is well worth while planning it so that it is as comfortable and convenient as you can make it. If the room you have has windows then it is a good idea to have them fitted with light-proof blinds since the presence of daylight can often be a nuisance when working with artificial light, and complete darkness is some-times necessary. It is essential that a studio for nude work should be warm and comfortable.

A fan heater is useful to boost the background temperature. There should be a private place for the models to change and do their make-up and hair, and this should be provided with a well illuminated full length mirror, a work bench with a mirror and a garment rail. A small hospitality area should also be pro-vided, screened from the working area, where models can wait or rest and refreshments can be provided. Some sort of sound system is also a good idea, even if it is just a portable

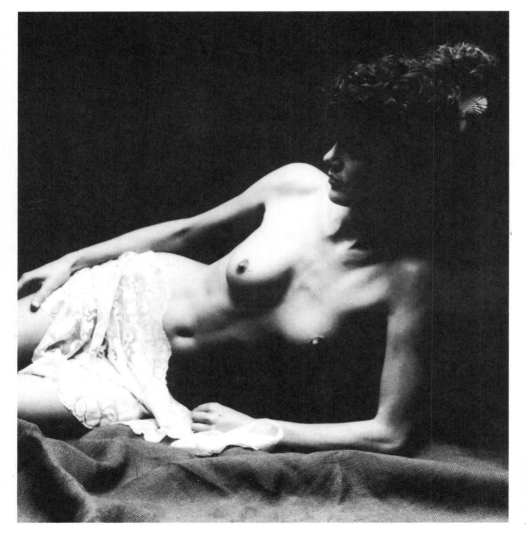

A small platform, about three feet high, was constructed for this reclining nude, making the use of a low camera position far easier. *Rolleiflex SLX, 150mm lens, Polaroid BW Negative film, f8 with studio flash.*

tape player, since sympathetic background music can do much to help create a good rapport and working atmosphere.

Decoration of the shooting area is also an important consideration. Many photographers prefer the walls and ceilings to be painted matt black. In this way the only reflected light is that which is intended and created by the use of reflector boards, but it does make for a rather oppressive atmosphere. The paintwork must, however, be

neutral in colour to prevent the possibility of colour casts. If a white studio is preferred then black screens can be used to shield the model from reflected and scattered light. The working area of the floor should not be carpeted since background paper on the floor will be creased and punctured by people standing on it. Wood block or vinyl flooring is ideal.

In addition to the rolls of coloured background papers you might also consider a permanent cove. This involves covering a wall with hardboard panels which can be curved onto and continued along the floor, and can provide a much wider seam-free background than paper rolls. It can then be painted any colour required, with the advantage that unlike background paper it can be wiped clean of marks. A small platform or rostrum can be very useful, as it enables low viewpoints to be obtained without having to have the camera actually on the floor. This can also be covered with fabric and cushions to create a suitable support for reclining shots. A simple way of constructing one is to use a large sheet of blockboard supported on plastic beer crates. These are very strong and can be built up to any desired height and conveniently stacked away after use.

A cupboard for equipment is also important, not just for security reasons but so that cameras, lenses and accessories can be found quickly in their proper place when needed. A rack for reflectors, flex, light stands and other similar bits and pieces will be very useful. An electrical kit with screwdrivers, fuses and plugs is also invaluable as well as a tool kit, rolls of gaffer tape and packets of blue tack. A cupboard for props is a useful addition to the studio, as most photographers engaged in this type of work accumulate a collection of useful and photogenic bits and pieces which can be drawn upon as needed. I always keep a lookout in junk shops and bric-à-brac sales for items which I think might be useful additions to the props cupboard.

Instead of a tripod, many studio photographers use a single column camera stand on a wheelbase. Although this is not portable it is ideal for studio work since it is rigid and will allow the camera to be moved from near ground level to seven or eight feet or more (up to 2.5 metres) in one quick movement as well as providing support for a boom arm attachment for shooting straight down.

For a picture like this it is necessary to use either a sweep of background paper, or a permanent cove which can be painted. *Rolleiflex SLX, 80mm lens, Ilford FP4, f11 with studio flash.*

Using Indoor Settings

Indoor photography need not, of course, be limited to the studio. Indeed a good indoor location can offer a great deal more in terms of inspiration and interest than the rather sterile studio atmosphere. Finding a suitable house is likely to be the first hurdle unless you are fortunate enough to live in a roomy, photogenic home.

What are the main qualities to look for? Firstly you will need reasonably open, spacy rooms to work in, particularly for full length shots and if you want to include significant areas of background.

Rooms with good windows might enable you to make use of daylight. A conservatory can be ideal, both in terms of lighting and for sympathetic backgrounds. A good sized, nicely decorated bathroom is an ideal location for nude shots with a more natural and less contrived quality, and will also provide the opportunity to do some shots with the model wet. Bedrooms too can provide a plausible setting for nude pictures and a bed of course is the ideal situation for reclining shots, with plenty of space for the model to move and pose.

Naturally the furnishing and decor of a house will have a significant effect on the mood and quality of the pictures. A dark Victorian interior with brocade drapes and leather or velvet upholstery will create a totally different atmosphere from a light airy house with pine or cane furniture and tiled floors. Do not be afraid to move things around, with your host's permission of course, since it is most unlikely that the furniture will be arranged in the best way possible for your shots. Remember it is how it looks in the camera that matters, not how the room itself looks.

Do not allow the settings to become too crowded or fussy. It is better to have too little in the shot rather than too much, and nothing should be included that does not contribute either to the mood or to the composition of the image. Be careful to avoid distracting details in the background, such as pictures on the wall, ornaments on a shelf or folds in a curtain. Even shadows and highlights created

by the lighting can easily become irritating distractions unless noticed and removed before shooting. If you are using artificial lighting such as flash or tungsten it is best to keep it quite simple. A single soft source with perhaps a fill-in reflector will avoid the overlit look where several direct light sources can create a multitude of shadows.

When you wish to include a large area of the background or setting it can help to use a wide angle lens, particularly if the room is not too large. Be careful, however, that this does not cause unwanted perspective effects. This can be particularly noticeable in interior shots because if the camera is tilted up or down it will cause the vertical lines to converge. Unless it is done in a controlled and deliberate

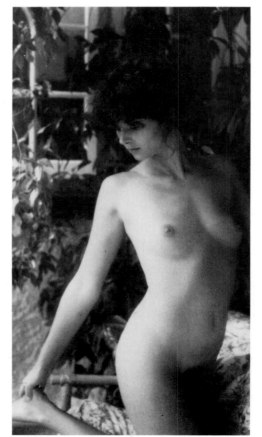

This shot was taken in a conservatory. A large area of window around and above the model has created a quite soft and flattering light without the need for a reflector. *Rolleiflex SLX, 8omm lens, Ilford FP4, 1/60 sec. at f5.6.*

way this will look ugly and awkward and so it is essential to ensure the camera is kept level.

When a large area of the background is included in the frame there is a danger that the model will become lost and not clearly defined. It is important to ensure that there is good separation between her and the background. Choose a viewpoint or position the model in such a way that the area of background immediately behind provides a good tonal or colour contrast. This separation can also be achieved by lighting, using a backlight or rim light for example to create a highlight around the model's profile to isolate her from a darker toned background, or aiming a light source at the background area immediately behind the model to create a pool of lighter tone.

Using Backgrounds, Sets and Props

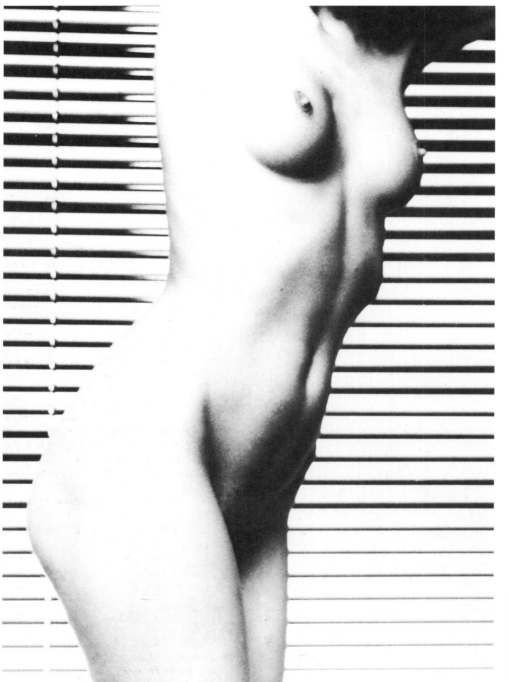

This shot was taken using a venetian blind as a background. Hard lighting was used to create a bold and contrasty effect. *Rolleiflex SLX, 150mm lens, Polaroid BW Negative film, f11 with studio flash.*

One of the difficulties of studio work is that, unlike location photography, there is no possibility of simply discovering interesting backgrounds and settings. What you need you have to provide beforehand. The rolls of background paper which are supplied by professional dealers for studio use are all very well, and for many shots these are all that is needed, but the range of effects you can achieve with them is relatively limited.

Most studio photographers like to experiment with different materials for background use. Almost anything can be used, the main limitation being that not all materials can be swept in a curve onto the floor, as background papers can, for full length shots. There is a current vogue for textured and mottled backgrounds which can be parti-

cularly appropriate to nude and portrait work and there are a number of ways to achieve this effect. One way is simply to use aerosol spray cans to paint a piece of plain background paper, and an old marked piece can often be used up in this way. With the spray can held at some distance and moved gently it is possible to obtain soft swirls of tone, either in a single colour or as a subtle, harmonious mixture of hues. Another solution is to use a heavy, coarse fabric such as canvas and have the folds create the mottled effect. The canvas used for theatre backgrounds is ideal and relatively inexpensive. For a more subtle effect, where the folds are soft and the actual texture of the fabric is not visible, you can simply use a wide aperture and throw the background well out of focus. It is also possible to buy ready painted backgrounds from professional photographic dealers but with these you will be limited to exactly the same background in each picture.

There is a wide range of other fabrics, ideal for background use, which are easily and cheaply available. For slick, graphic style pictures materials like corrugated aluminium and perspex can be used, and fabrics, such as lurex, which have a glittery surface can also be effective in a bright, bold way when lit quite strongly. It is best to stretch materials over a wooden frame to eliminate any unwanted creases. Translucent fabrics used in this way can also be lit from behind for a different effect. Tracing paper for example could be used as a screen on which you could project a shadow pattern or even a colour slide. It is essential, however, when using this technique to prevent the lighting used for the model from spilling onto the background as this will weaken its effect.

An extension of this principle is front projection. This involves the use of a special projector and screen fabric and, with the aid of a beam splitting mirror, enables any colour slide to be projected along the optical axis of the camera onto a highly reflective and directional screen. Used with care it is possible to produce pictures in the studio using slides of landscapes or beach scenes which can pass as location shots. There is also considerable potential for creative and abstract effects using front projection.

Even more elaborate studio backgrounds and settings can be created by the construc-

The background effect in this picture was created simply by painting a piece of dark toned background paper with an aerosol paint spray of a lighter colour. *Rolleiflex SLX, 150mm lens, Polaroid BW Negative film, f11 with studio flash.*

119

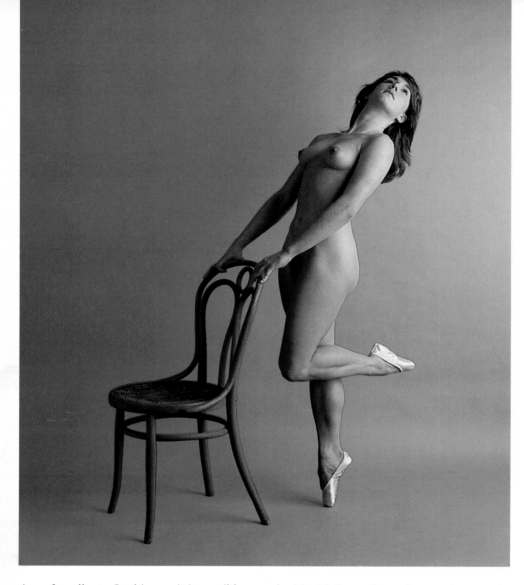

tion of small sets. In this way it is possible to simulate the effect of a room and to create three dimensional backgrounds. The basis of this method is to make a number of wall flats. These are simply wooden frames about 8 × 4 feet (about 2.5 × 1.25 metres) constructed of wood and covered in hardboard or plywood on one side. They can then be clamped together in a variety of configurations with the aid of G clamps to make, say, a corner of a room or angular shapes for a background. Window frames and doors can even be incorporated to create a more elaborate room set and, of course, the structure can be finished by decorating in the normal way. Many short cuts can be taken with finishing, such as using a staple gun to fix curtains and

double sided tape for wallpaper. Inexpensive coloured felt, obtainable in a wide range of colours, can be very effective as a carpet and can be simply stretched and stapled flat to the studio floor.

It does not really matter how well the set is constructed or how it looks close up, as long as there are no flaws visible from the camera position. Much of your handiwork will be obscured by the model or by shadows and will often not be in sharp focus. Indeed it is a good idea to set the camera up and check the appearance through the viewfinder of the set as you construct it. Quite often you will find it is better not to have a corner at a true right angle, or not to have a wall joined up. You can even lean a wall flat back a little to correct

An old, painted chair has provided both a useful prop and additional interest for the composition of this studio nude. *Rolleiflex SLX, 150mm lens, Fujichrome RDP 100, f11 with studio flash.*

A length of inexpensive theatrical canvas, carefully crumpled, was used as the background for this nude. *Rolleiflex SLX, 150mm lens, Kodak Ektachrome EPR, f8 with studio flash.*

converging verticals when the camera is tilted. Another material which is very useful for sets is expanded polystyrene, available in sheets of blocks. It is very light, can be cut easily to size and, provided it does not have to bear any weight, can look just as solid and convincing as hardwood.

The finishing touch to studio shots is often the addition of a suitable prop. Indeed professional photographers often employ a stylist whose job it is to find, hire or buy items which can be used in this way. A prop can be literally anything additional to the model and background, ranging from a piece of furniture such as a sofa to a vase of flowers or something the model might hold, like a hair brush. A suitable prop can fulfil a number of

requirements. It can add interest and authenticity to a set, it can create an additional element in the composition of the image, it can help to establish a mood or add meaning to a picture and it can also simply give the model something to do with her hands. If you look at the work of photographers shooting for magazines and books you will see that very often the nucleus of a good picture is a well chosen prop. It is a good idea to accumulate a collection of useful and photogenic items, or keep an eye open when visiting friends' homes for things you might borrow at later dates. A friendly local antique shop also might be willing to lend the occasional item, and boot and garage sales are always worth looking at for potential props.

Using Daylight Indoors

The very soft, diffused light for this picture was the result of placing the model in a corner away from the direct light of the window. *Nikon FE2, 85mm lens, Kodak 2475 Recording film, 1/30 sec. at f4.*

Indoor photography does not need to be limited to artificial lighting. Daylight is a valuable and very effective means of lighting indoor pictures, particularly for nude and portrait work. Many of the artificial light sources, reflectors and techniques used in studio lighting are in fact designed to simulate the effect of daylight, and a number of well known photographers in this field use daylight in preference, having their studios designed to make the most use of it.

The main requirement is obviously a room with a good sized window or skylight. Two or more on different walls will also give you more flexibility. Artists traditionally prefer a north facing window for the simple reason that the quality of light is more constant and the room will not be exposed to direct sunlight. However it is possible to overcome the problems of harsh sunlight by using translucent screens or even white nylon curtains to diffuse direct sunlight and to control the quality of light from the window.

There are two basic limitations on using daylight indoors. The first is that the light level is substantially lower and exposures will need to be longer than when working outdoors or with studio flash, and this will mean that the choice of aperture and shutter speed will be more limited. A faster film than you would use outdoors will help to overcome this problem. Fast films also have the advantage of having slightly lower image contrast than slower films, and this can be helpful with daylight indoor lighting. The use of a good firm tripod will allow you to use slower shutter speeds, and smaller apertures, without the risk of camera shake. A tripod also allows you to frame and focus the camera more accurately and to leave it set in position while you make adjustments to the set up. It also allows you to concentrate more attention on your model and to communicate more directly by not having to have your eye glued to the viewfinder.

The second limitation is that the light source, the window, is not movable. This can be overcome however by moving the camera or the model or both. If you have the camera and model in a position where the window is parallel to a line drawn between them you will obtain a directional cross lighting which will create pronounced shadows and a high degree of modelling within the subject. By moving the model so that the line between him or her and the camera is at an angle to the window the light will become progressively more frontal with smaller shadows and less modelling. A fully frontal light will be obtained when the model is facing the window with the camera directly in front, and of course back lighting can be obtained by simply reversing these positions. The lighting quality and effect can also be controlled by moving the model laterally along the window. In the centre of the window the light will be at right angles. At one edge, facing towards the centre, the angle will be closer to 45 degrees and this can be adjusted further by moving him or her closer to or further from the window.

In addition to moving the camera and model you might well need to move the background. In many cases a wall of the room can provide a suitable background area, but the ability to vary both the colour or tone and the position will give you much more flexibility. For fairly close-up shots a frame covered with painted hardboard or fabric can be adequate, and it can be supported by simply propping it against a spare light stand or a chair. However, for longer shots and full length pictures, a paper background roll supported on tripod stands or spring loaded poles will be necessary.

It can be seen from this description that there is in fact a wide degree of control over the lighting which can be exercised simply by adjusting the positions of the model and the camera. However further control can be obtained by placing diffusing media between the window and the model. A large wooden frame covered with tracing paper is ideal. An inherent problem with daylight indoor photography is that it tends to create rather higher subject contrast than outdoor lighting and so in addition to controlling the quality and direction of the light source you will also need to vary the density of the shadows and the image contrast with the use of reflector boards. Large sheets of painted hardboard on a frame or sheets of rigid expanded polystyrene are the most convenient way of making reflectors if portability is not a consideration. When a reflector is placed on the opposite side of the model to the window its effect can be varied by moving it closer or further away. A stronger effect can be created

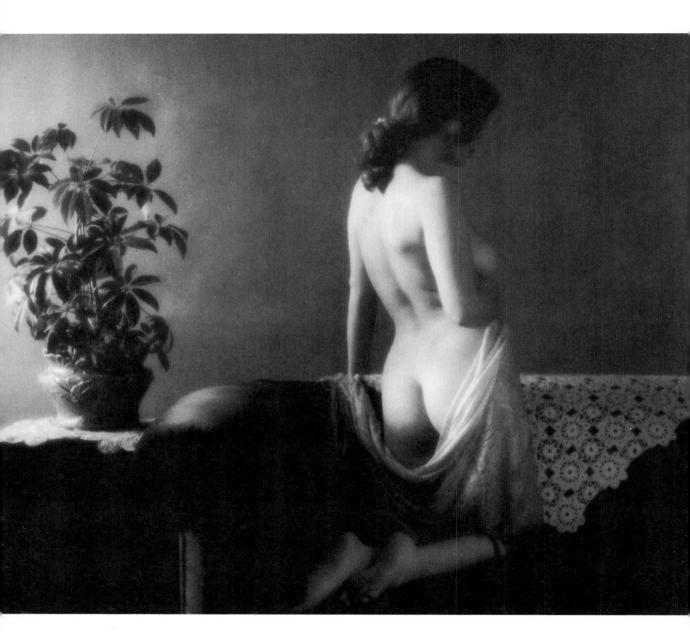

by covering a board in crinkled aluminium foil, and even a large mirror can be used to create additional highlights if required. When taking quite close-up shots of a model's face it can be effective to place a smaller reflector as close as possible under her chin.

Another method of controlling the contrast and shadow density is with fill-in flash using a battery powered flash gun. Because this has the same colour quality as daylight the two sources can be mixed when shooting in colour without creating a colour cast. The technique is described on pages 158–9. If you are shooting in black and white it is also possible to use an ordinary domestic light, such as a table lamp, to fill in the shadows, although you must be careful that it does not create shadows of its own as this can look unattractive and distracting. In colour the use of a tungsten light in this way would create an orange cast. Soft focus and pastel or fog filters can also be used to reduce the contrast of

A large reflector placed quite close to the model on the opposite side to the window has added tone and detail to the shadow areas of this picture. *Rolleiflex SLX, 80mm lens, Kodak Tri X, 1/60 sec. at f5.6.*

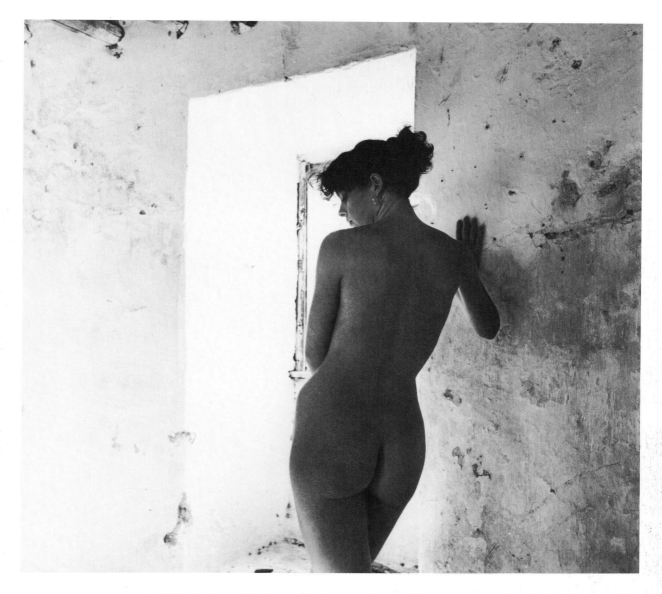

The light walls of this old, empty house and a window on the opposite wall has helped to create a quite soft light for this indoor nude. *Rolleiflex SLX, 150mm lens, Ilford FP4, 1/60 sec. at f5.6.*

daylight indoor lighting and these can be particularly effective in nude and portrait photography. This technique is described on pages 178–9.

Colour temperature is an essential consideration when shooting nudes and portraits since skin tones will register even a slight variation in the colour temperature of the light source. Daylight indoors does tend to have a higher colour temperature than that for which the film is balanced, creating a bluish, cooler quality. This can be particularly evident when the window is illuminated by either an overcast cloudy sky or a deep blue sky. It is generally best to use a warm colour correction filter such as a Wratten 81A or 81B to counteract this. As a general rule a slightly warm cast is quite acceptable with skin tones, whereas a bluish cast can look very unattractive and unflattering, and so if you are in any doubt it is best to use a warm filter when shooting colour transparencies. When shooting colour negatives slight adjustments to the colour quality can be made at the printing stage, and so correction filters are not necessary.

Using Mixed Lighting

For the majority of pictures you take, the lighting used will be of a similar and standard colour quality. However there are occasions when it is necessary, or desirable, to use non-standard or mixed light sources. When shooting in colour it is not possible to mix light sources of a different colour temperature without at least one of them creating a colour cast.

The only way to overcome this problem is to change the colour temperature of one of the light sources so that it matches the other. It is possible to buy sheets of tinted acetate from professional photographic dealers in a range of hues including the most common colour correction values. If you were taking pictures in a room where you wished to use both the domestic room lighting and daylight

The tungsten bulb in the anglepoise lamp has created a warm glow on the model's skin when combined with the daylight type film used in this indoor nude. *Rolleiflex SLX, 150mm lens, Fujichrome RDP 100, 1/60 sec. at f8.*

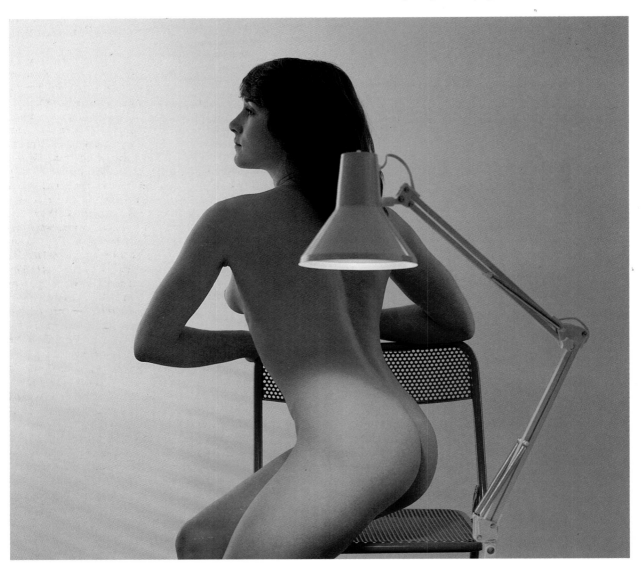

from the window, the simplest solution would be to cover the tungsten bulbs with blue tinted acetate. This would change the colour temperature to match the window light, enabling you to use daylight film without obtaining a colour cast.

A similar technique can also be used to filter the light of a small flash gun to lower its colour temperature when it is used as a fill-in flash in an interior lit by tungsten light, and when using artificial light film. The same principle can also be adopted when using flash in conjunction with fluorescent lighting, which will create a green cast when used with

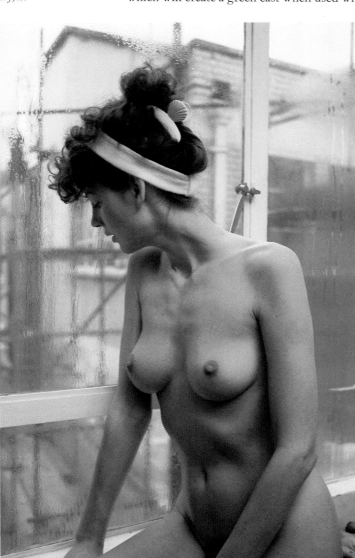

This picture was lit with tungsten light and photographed on artificial light film, which has caused the exterior to be recorded with a strong blue cast. *Nikon FE2, 35mm lens, Kodak Ektachrome EPT, 1/60 sec. at f5.6.*

daylight type film. To counteract this you will need to use a magenta filter over the camera lens. The exact value depends upon the type of fluorescent tube but for daylight tubes a filter of about CC20 Magenta will be adequate. The area illuminated by the flash will now have a magenta cast, but this can be negated by placing a filter of the complementary colour and strength, a CC20 Green, over the flash tube.

It is not always desirable, however, to eliminate the colour casts created by the use of mixed light sources. Small localised areas of colour cast can add both interest and atmosphere to a picture. A shot, for example, in a room lit predominantly by daylight could benefit from small pools of yellowish light created by a table or standard lamp fitted with a tungsten bulb. Conversely in a room lit by tungsten light and photographed on artificial light film the blue cast created by light from a window can produce an effective mood.

This type of effect is likely to be more pleasing and most effective when the film used matches the predominant light source. In this way the most important areas of the image will be recorded accurately with only small, localised areas of colour cast. As a general rule it is best to avoid a colour cast affecting the skin tones, except perhaps for small areas of highlight. It is important to appreciate that the effect of a colour cast on the film will be appreciably stronger than the way it seems when viewing the subject. The effect will also vary according to the type of film in use. As a general rule fast colour transparency films and colour negative films tend to be more tolerant of variations in the colour temperature of light sources than the slower colour transparency films.

While considering the virtues of mixed light sources it is also worth bearing in mind that on occasions it can add interest and mood to a setting if you deliberately introduce areas of colour cast. This can be done in a similar way to the corrective techniques but using filters over the light sources to make the light a different colour temperature from that for which the film is balanced. One or two small flash guns fitted with yellow filters can be positioned in the background of a shot and fired by slave cells to create pools of light and add warmth and atmosphere to an interior setting lit by daylight.

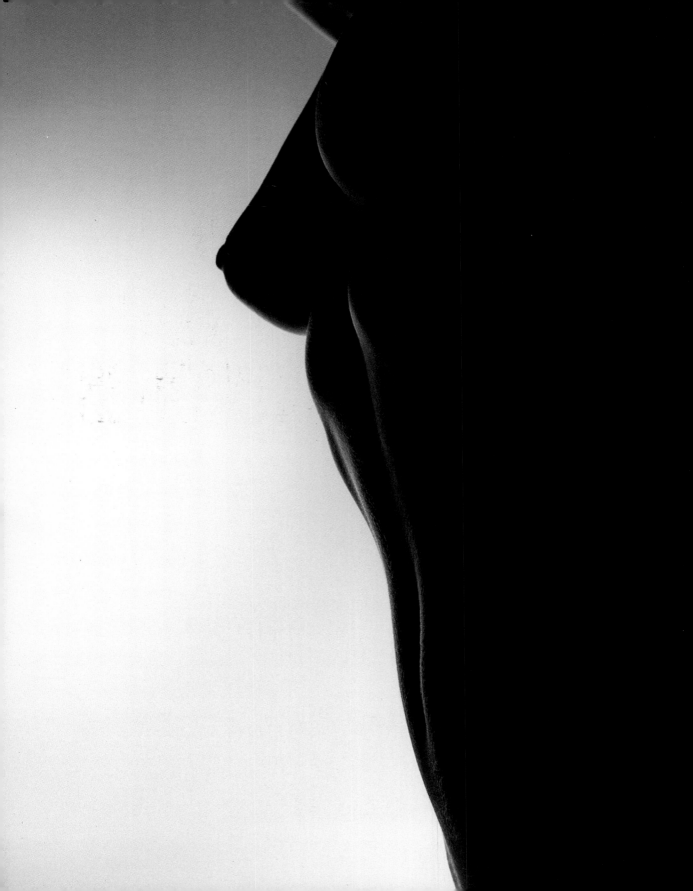

STUDIO LIGHTING TECHNIQUES

Single Source Lighting

Inexperienced photographers often have the misconception that studio work involves numerous lights and complicated setups. The opposite is closer to the truth, particularly in nude and portrait work where a simple, uncontrived lighting quality is often the aim. Indeed much can be achieved with a single light source and the beginner will benefit considerably from learning all that can be achieved in this way before adding extra lights to his arrangements.

Fitted with a normal reflector, a light source, whether flash or tungsten, is effectively a point source, that is to say the rays of light travel directly from the filament or tube to the subject and create quite dense, hard edged shadows, like the sun. Although a softer light is often preferred for nude and portrait work, this type of lighting has its uses, however because it is so directional it must be positioned and aimed with care to avoid unwanted and ugly shadows. It also means that the model's movements and poses are more limited because even a slight change of position can have a significant effect on the direction of the light and the quality it creates.

A direct light source of this type is best used when a hard, dramatic quality is wanted, or when you wish to create a theatrical or shadowy effect or to emphasise skin texture. Unless used with great care it can be unflattering and will tend to emphasise blemishes except when used from close to the camera position. Although as a general rule shadows on the background are to be avoided, a single undiffused light can be used deliberately to cast shadows from the model onto the background in order to create unusual and dramatic effects. The further the light is from the model the more sharply defined the shadows will be.

In most cases, however, you will want your

In this picture a light source, with a diffusing screen in front, was placed at right angles to the model's body. No reflector was used. *Nikon F2, 105mm lens, Ilford FP4, f11 with studio flash.*

This abstract nude was lit with a single diffused light; and a reflector was used to relieve the shadows and reduce the contrast. *Pentax 6×7, 150mm lens, Ilford FP4, f11 with studio flash.*

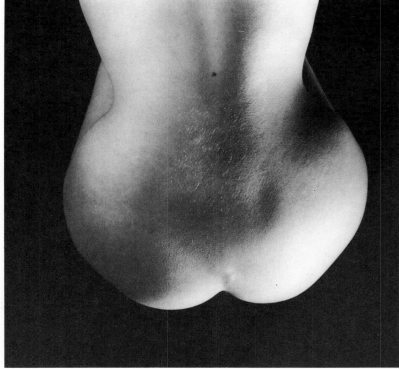

main source of light to be softer and diffused. This will create weaker shadows with blurred or even indefinable edges. It will tend to be more flattering with less emphasis on skin texture, but will still create a high degree of modelling. There are several ways to diffuse a single light source, one of the simplest and most widely used being with the aid of an umbrella reflector. With this the light is aimed away from the subject into a large white umbrella which reflects and diffuses the light back onto the subject. It is important to appreciate that the softness of a light is essentially dependent upon the relative size of the source compared with the subject. Used close up, an umbrella is quite a large source and will produce quite a soft light. When it is moved back to say eight or ten feet (about three metres) to cover a full length figure it will become relatively small again and give a correspondingly harder light.

A more satisfactory way of creating a large diffused light source for full length figures is to cover a large softwood frame, about 6 × 4 feet (1.8 × 1.2 metres) is ideal, with tracing paper or white frosted plastic film. This should be placed in front of the light source and quite close to the model. Its size will provide an even light coverage at only a few feet, and the light can be moved closer to make the effect harder and further away to make it softer. An alternative method is to bounce the light from a large white reflector board placed at the desired angle to the model. A soft diffused light source of this type can either be used at quite an acute angle to the model to create quite pronounced modelling and large areas of shadow, or close to the camera to create a frontal and virtually shadowless light.

Whether the light you use is direct or diffused, it is likely that when used at an angle to the model the shadows it creates will sometimes need to be reduced, either to create a softer effect or to reduce the contrast of the image, This can be most easily achieved by the use of a large reflector board positioned close to the model on the opposite side to the light. Its effect can be varied by moving it closer to or further from the model.

The light source was aimed at the ceiling in this shot, to diffuse the light and create a soft, shadowless illumination. Nikon F3, 85 mm lens, Kodak Tri X, f5.6 with flash.

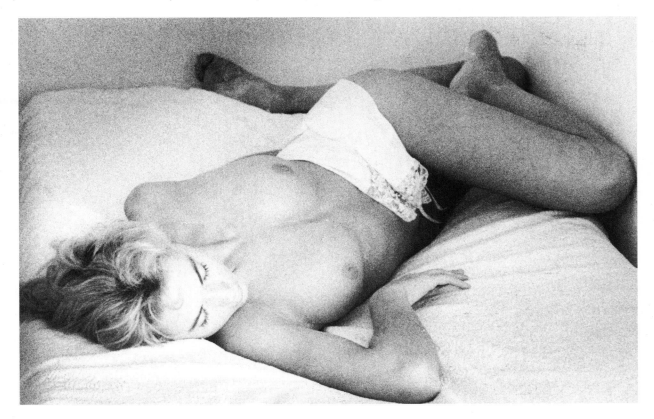

Using Multiple Lighting

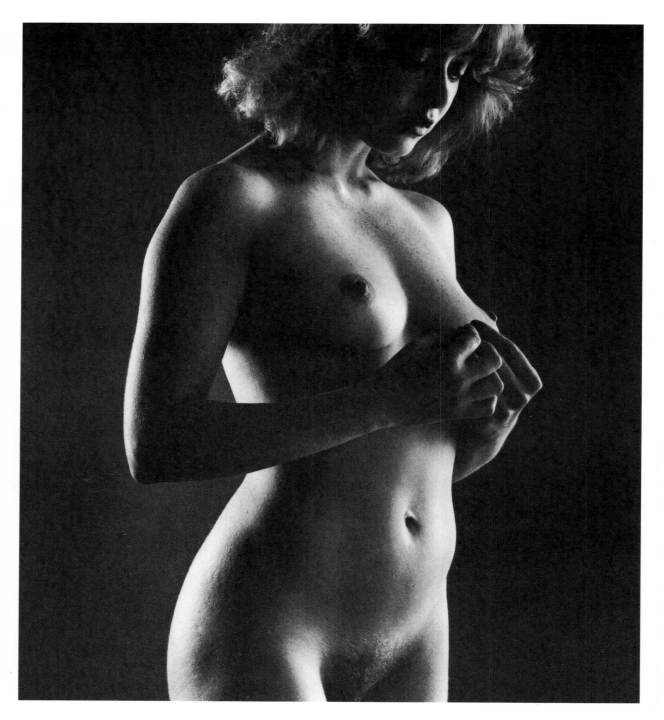

Two lights were used for this picture. A soft diffused light from a position 90 degrees to the camera and another, on the opposite side of the model and behind her, to create a rim light. *Rolleiflex SLX, 150mm lens, Ilford FP4, f11 with studio flash.*

A light with a diffusing screen was placed each side of the model and slightly behind her, to create a rounded effect, and a third light was bounced off the ceiling to relieve the shadows. *Rolleiflex SLX, 150mm lens, Ilford FP4, f11 with studio flash.*

Although much can be achieved with the aid of only one light source, two or more lights will naturally increase the range of effects you can create. It is however essential always to start with a single source. This is known as the key light or main light and it is responsible for establishing the basic lighting quality of a picture. Subsequent lights are intended only to supplement and modify the basic effect.

Finding the optimum position for the main light is dependent upon a variety of factors – the position and pose of the model, the degree of diffusion used for the main light and the effect you wish to create. As we have discussed already, a light source placed close to the camera will create minimal shadows and little modelling or form, and as it is moved further to one side or the other, and higher or lower, both the shadows it creates and the degree of modelling will be increased. The basic technique of lighting is very much a matter of moving the main light, or the model's position, and watching the effect it creates until

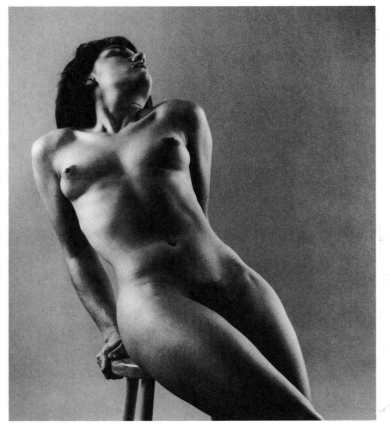

you find an angle where it produces the most pleasing quality. There are no hard and fast rules, and in nude photography in particular the relationship between the direction and quality of the light and the pose and position of the model is one full of infinite and subtle variations which are there for you to explore and exploit.

There are a variety of ways in which a second light can be used. It can for instance be used in place of a reflector to act as a fill-in light and reduce the density of the shadows and lower the contrast of the image. You must be careful, however, that this light does not create shadows of its own, as multiple shadows can be ugly and distracting. This can be avoided by ensuring that the fill-in light is either of lower power than the main light or much further away and is also placed quite close to the camera position. An alternative method of achieving a strong fill-in light is to bounce the second light off a large white reflector board placed on the shadow side of the model.

A second light is perhaps more useful for creating additional highlights. Back lighting or rim lighting are techniques that can help to create a bold separation between the model and the background, produce a three dimensional quality and add interest to the image. Rim lighting involves placing a light behind and slightly to one side of the model, just outside of the picture area, and aiming it so that it skims the model's profile. It can be used either direct or diffused, depending upon how bright the main light is and how strong you want the highlights to be. The effect will be greater on the film than appears visually and as a general rule it is best to underlight slightly rather than overlight. Completely burnt out highlights can look very unattractive. A useful hint is to view the subject through half closed eyes. This will give a more accurate impression of the relative brightness of the highlights.

It is also important to ensure that the rim light does not spill onto unwanted features or areas such as the side of the model's nose, or into the camera lens which can create flare. For this reason it is best to fit the light with a snoot – a conical metal tube that fits over the reflector to restrict its beam. A \makeshift snoot can easily be made with a piece of black card and some gaffer tape. When using

multiple lighting the light that is scattered indiscriminately can build up and diminish the effects you create. Devices such as snoots and barn doors are invaluable for reducing the amount of split and scattered light. It is equally important that the rim light does not influence the exposure reading since this could result in underexposure. As a general rule it is best to take exposure readings with only the main light switched on.

When taking head-and-shoulder pictures a rim light is often used on the model's hair. This can be achieved by suspending the second light, again fitted with a snoot, from a boom arm above and slightly behind the model's head. Be careful that this light also does not spill onto the model's forehead or nose. The distance that the light needs to be from the model's head will depend on its power and also the colour of the model's hair. With blonde hair it is important not to have too powerful a rim light, or to have it too close, as the highlight detail can easily burn out. With dark or black hair, however, you will need to position the light quite close to the model to create highlights. A back light is one that is placed directly behind the model; it must also, of course, be hidden from the camera. It can be used quite effectively to crate a halo of light around the edge of the model's body or, with a head-and-shoulder shot, her hair. With a full length shot a back light can be hidden by making a hole in the background paper in the selected position and aiming the light through it. The greater the distance is between the back light and the model the more effective it will be.

Two main lights can be justifed if you wish to create a rounded, three dimensional effect with a nude. This can be done by placing each light in a rim light position on either side of the model. In most cases it will be more effective to diffuse the lights. They should be positioned so that each spills around the side of the model's body but leaves the central area in quite dense shadow. This can be filled in by placing a reflector board quite close to her.

A third light will allow techniques such as rim lighting and back lighting to be combined with a background light, as discussed on pages 148–9, or to use a hair light as well as a rim light on the body. In addition, when a more theatrical effect is required, second and third lights can be used deliberately to create additional shadows. Although accidental multiple shadows are invariably unattractive, they can when used in considered and controlled ways create interesting and atmospheric effects. In this context a spotlight can be very useful. It has a fresnel lens and a focusing system that allows the beam to be tightly controlled, and is capable of creating jet black shadows with sharp, hard edges. This is the type of lighting favoured by the great Hollywood glamour photographers of the 1930s and is also enjoying a period of revival at the moment. Many professional photographers have recently been changing back to tungsten lights in order to exploit the possibilities of multiple lighting.

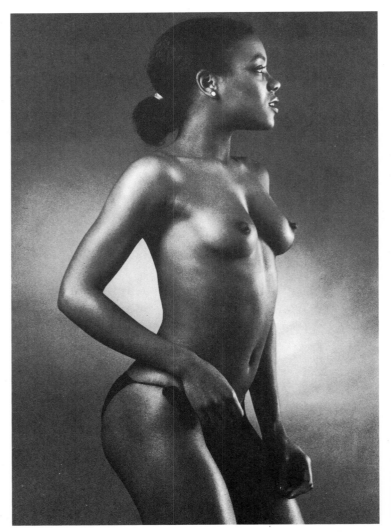

A diffused main light was placed at right angles to the camera, and a second light was bounced off a reflector close to the camera to relieve the shadows. A third light with a snoot was aimed at the background to create a pool of light behind the model. *Nikon F3, 85mm lens, Ilford FP4, f8 with studio flash.*

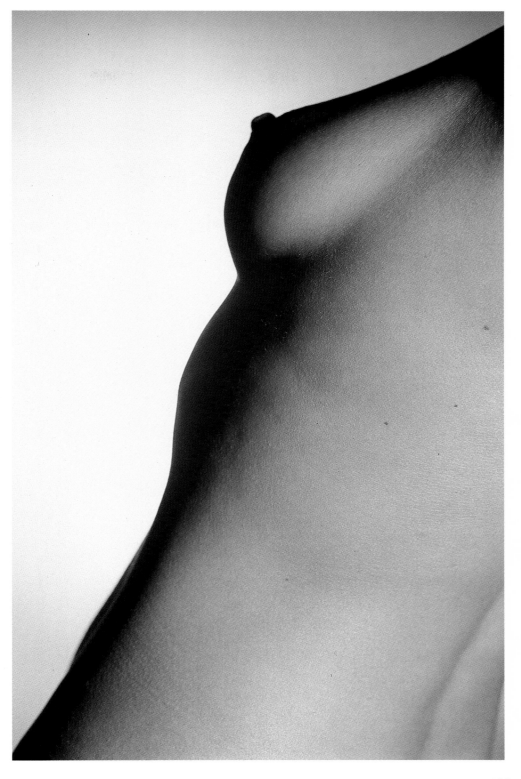

For this abstract nude a single undiffused light was placed at right angles to the camera and a second light was used to illuminate the background. *Pentax 6×7, 150mm lens, Kodak Ektachrome EPR, f16 with studio flash.*

High Key Lighting

For the majority of photographs the lighting is arranged in such a way that a full range of tones is created from white to black. However with certain subjects it can be effective to light in a different way, either to create an image where the tones are primarily from the mid to dark band of the tonal scale or predominantly from the lighter tones. The mood of a picture will be significantly affected by the tonal quality of the image and this control over lighting is an important aspect of studio technique.

When a picture is lit so that the tones are essentially light it is known as high key lighting. It creates a delicate and romantic mood and is a technique widely used for fashion and beauty photography. It can only be applied, however, to subjects that are inherently light in tone such as a fair skinned blonde model – it would not be possible, for example, to produce a high key image from a model with dark skin and black hair. Few subjects consist only of light tones but in this type of photograph darker tones should be restricted to quite small areas and details, just enough to give the image shape and definition. It is also important to recognise that the darker tones will become a focus of attention and the image should be framed in such a way that they create a balanced and harmonious composition.

The essence of high key lighting is to create a virtually shadowless light and also to use a very light toned background or setting. The main light should be a large, diffused source to create the minimal amount of shadow and this should be placed close to the camera position. The background should also be illuminated to the same, or slightly higher, level of brightness than the model. It is important to ensure that the contrast of the image is kept quite low because if bright highlights are created this will result in loss of detail. For this reason, in addition to the soft, frontal light source, it is also best to use reflectors on both sides of the model to bring the contrast level down as low as possible. When shooting close-up pictures, such as a head-and-shoulder portrait, you should also use a small reflector close up under the model's face to eliminate any slight shadows under the eyes or skin. Both soft focus and fog or diffusion filters can help to reduce contrast and also add to the effect of high key pictures.

Exposure is a crucial factor since if the image is underexposed the result will be muddy and grey and if it is overexposed detail will be lost and the image will appear bleached out. When shooting negatives a degree of exposure error can be compensated for when making the print, but with colour transparencies it is essential to get the exposure exactly right. As a general rule a small degree of overexposure will help, providing there are no excessively bright highlights.

Taking the exposure reading also needs special consideration since a reading taken in the normal way will result in a considerably underexposed image. One method is to take a

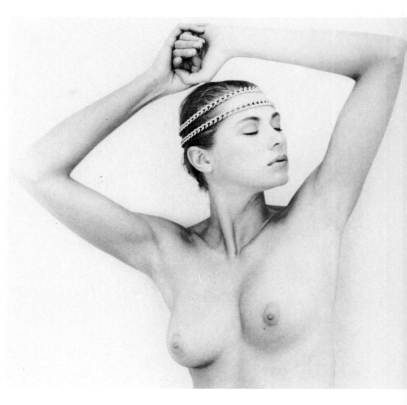

For this picture a large soft light source was aimed at the model from directly above the camera, with a large white reflector placed just below and in front of her. *Rolleiflex SLX, 150mm lens, Ilford FP4, f8 with studio flash.*

reading from a substitute grey card or use an incident light reading. However, since in nude and portrait photography the skin tones are of most importance it is often preferable to take a reading from the lightest area of the model's skin and increase the exposure indicated by two to three stops. This will record the skin as two tones down from pure white, but it is essential that no important areas of the image are more than one stop brighter than the tone from which the reading is taken.

Two lights were directed at a white background for this shot; and two large white reflectors were placed close to the model, on each side of the camera, creating soft shadowless illumination on her body. *Rolleiflex SLX, 150mm lens, Ilford FP4, f11 with studio flash.*

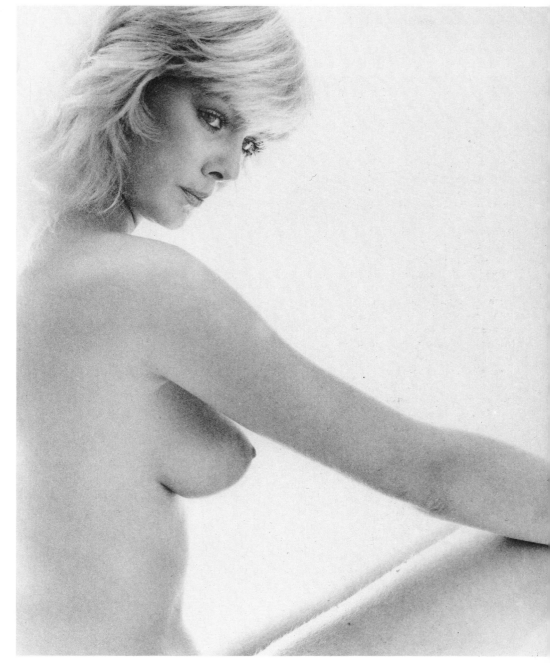

Low Key Lighting

When the subject is lit in such a way that the tonal range of the image is concentrated primarily at the darker end of the grey scale it is known as low key lighting. This effect creates a much more sombre and dramatic mood and is also suited to pictures where you wish to emphasise qualities such as form and texture which depend upon deep, rich tones. Low key lighting is particularly suited to black and white photography since a fine degree of control can be exercised over the density and quality of the image while making

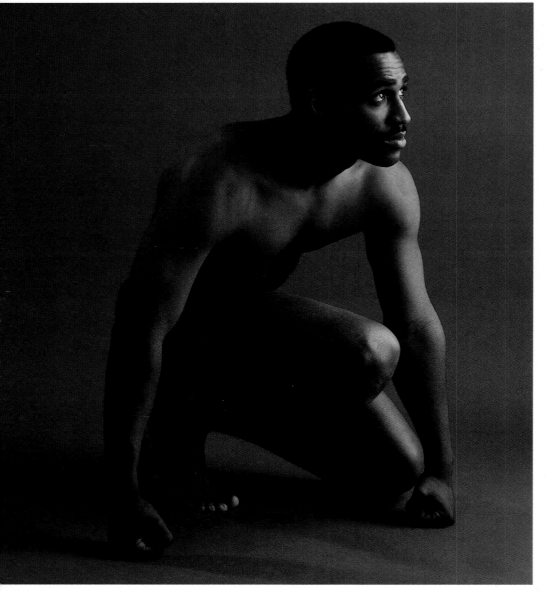

For this nude a large soft light source was placed to the side of and slightly behind the model, with a large reflector placed near the camera to relieve the shadows. *Rolleiflex SLX, 150mm lens, Kodak Ektachrome EPR, f8 with studio flash.*

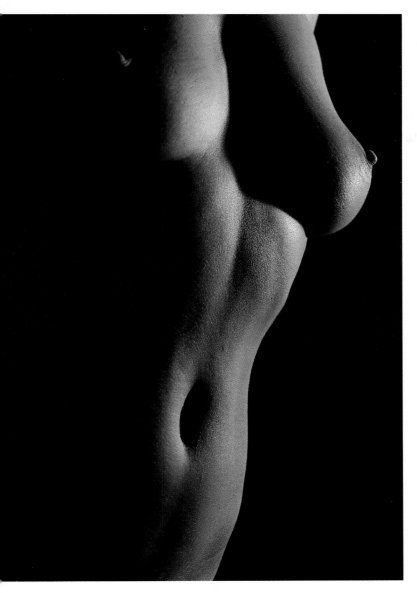

detail. As a general rule, the most effective results are likely to be obtained with an essentially dark toned subject such as a dark skinned or tanned body.

The basic approach to low key lighting is to arrange it in such a way that most of the subject is lit quite evenly and softly, creating low contrast and only very small areas of highlight. As a rule a large soft source is most effective and this can be used at quite an acute angle to the model to create good modelling and form, but reflectors should also be used to keep the contrast low. It is often effective to use a degree of rim or back lighting to create small areas of highlight. These should not be very bright however or detail will be lost and the highlights will be burnt out. It is important to appreciate that areas of highlight will become a focus of attention and a dominant part of the composition, so they should be allowed to occur only in important parts of the image or they will simply be distracting. As a general rule the important parts of the subject should not have more than about three stops difference in brightness.

As with high key effects, when shooting colour or black and white negatives you will have some degree of control over the final image density and quality when making the print, but with colour transparencies it is essential to estimate the exposure correctly. As a rule a small degree of underexposure will enhance the effect providing there are no large areas of dark tone in important parts of the image. It is also important to consider the nature of the colours since, even if they are dark in tone, strong saturated hues will not have the same low key effect as muted colours, and a harmonious colour quality will be more effective than colours which contrast.

Estimating the exposure must be done with care, and a reading taken in the normal way will result in overexposure. The best method is to take a reading from the darkest skin tone and decrease this by two to three stops. When shooting colour transparencies the precise effect is difficult to judge and it is advisable either to bracket exposures or to make a clip test. If the image contrast is quite low, acceptable exposures will be obtained over a range of about 1 to 1½ stops and the best exposure will be partly a question of personal preference.

A single undiffused light was placed slightly behind and to one side of the model, and the photograph was underexposed by one stop to give detail in the lighter tones of the image. *Pentax 6×7, 150mm lens, Kodak Ektachrome EPR, f16 with studio flash.*

the prints, and a superb black and white print of a low key subject can have a powerful visual impact.

Unlike a high key picture, a low key image is less dependent on the tonal quality of the subject. It is possible to create a low key picture from an essentially light toned subject purely by means of lighting and exposure. It is, however, important that the subject has a relatively low inherent contrast, because if there are large areas of both very dark and very light tones one or the other will lose

Lighting the Face

Although the same basic techniques apply to lighting both the face and the body there are different points to consider. Although the face possesses similar attributes of shape and form as the body it is all on a much smaller scale and the lighting needs to be more subtle and sensitive. Being much smaller, the face can easily be overwhelmed by excessive shadow, and an element of flattery is likely to be a more important factor when lighting it. This is particularly true when shooting a close-up portrait but must still be considered with half or full length shots when the model's face and expression are important elements of the picture. In these cases it is often necessary to reach a degree of compromise and sometimes to ask the model to angle her head to create a more pleasing lighting quality, particularly when a harder main light is used.

The angle of the face relative to the camera will be partly responsible for deciding on the optimum angle for the main light. It is most unlikely that the best position for the light when shooting a full face will be equally suitable for a profile. The shadow created by

A diffused light was placed at an angle of about 45 degrees to the model and his head angled so the shadows created the required effect. *Rolleiflex SLX, 150mm lens, Ilford FP4, f16 with studio flash.*

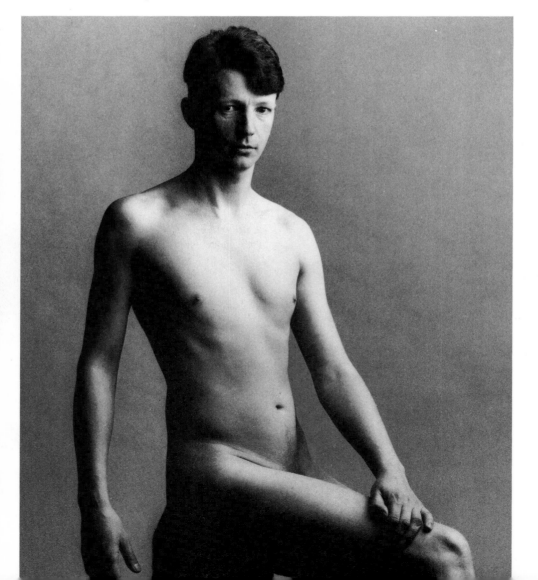

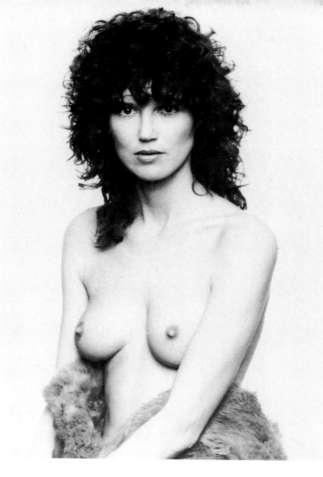

the model's nose is a good key to both the direction and quality of the main light, and it should usually be a foot or so above the model's eyeline. Higher than this and it will produce strong shadows in the eyesockets and below the chin, and if it is too low it will result in poor modelling.

You must also consider the effect you wish to achieve. When photographing a girl with the intention of creating a glamorous and flattering image, it will not be desirable to use lighting which creates too much modelling or emphasises skin texture. In this case it is best to use a very soft, large light source from close to the camera position or in line with the model's nose if the face is angled slightly. Provided this is slightly above the model's eye level it will still create a small degree of shadow and modelling on the contours created by the cheek bones and jaw. To eliminate the shadows completely and create a high key effect, the light source should be brought as close as possible to the camera lens, and reflectors can be used on both sides and under the model's face. A rim light or back light to create highlights on the model's hair can provide a flattering touch to a portrait as well to help to create good separation between the model and the background and add interest and sparkle to the image.

When a stronger or more dramatic effect is required then a less diffused light can be used from a more acute angle. Provided you are always aware of the shadows that the light creates and how they change as the model moves her position, there is no reason why this type of lighting cannot create both pleasing and flattering effects. It perhaps needs to be used with rather more care and discretion and unless a particularly dramatic effect is wanted you will find it necessary to fill in the shadows and reduce the image contrast by using reflector boards. At the risk of sounding sexist it is possible to use more aggressive lighting when photographing male models, simply because skin texture is a more acceptable and desirable quality in a male portrait, and techniques like rim lighting can be used effectively to emphasise this quality. A harder light source such as an undiffused reflector or even a spotlight can be used to advantage in this context and this type of lighting can also be used to create a more dramatic or theatrical effect.

A large diffused light source was positioned immediately above the camera, with a large reflector placed just below and in front of the model. An additional light was used to illuminate the background. *Rolleiflex SLX, 150mm lens, Polaroid BW Negative film, f11 with studio flash.*

A large soft light source was placed in line with the model's nose, and a large reflector was placed very close to her on the opposite side. *Nikon F3, 150mm lens, Ilford FP4, f11 with studio flash.*

Lighting the Body

It has been said that there is a similarity between photographing the nude and photographing a landscape. This is because both subjects are very dependent upon the quality and direction of the light for revealing the subleties of form, shape and texture which define these two, otherwise diverse, subjects. The photographer lighting the nude in the studio however has one major advantage over the landscape photographer – he has an infinite degree of control over the quality and the effect of his lighting.

Because of the virtually limitless variety of ways in which the contours of the human body can be displayed there can be no hard and fast rules about the way it is lit. It is very much a process of exploration and experiment, and subtle but very significant changes can be made in the nature and effect of the image by just a slight change in the position of either the light source or the model. For this reason by far the best way of learning the techniques of lighting the nude is by practical experience. Initially it is not necessary to make exposures, just to vary the lighting and model's pose and to study and compare the results.

We have already discussed the advantages of a soft, diffused light source for its ability to reveal form and a sublety of tone, but to begin with it can be more instructive to observe the effects of a change in the direction and angle of the light with a hard, undiffused source. You can start by asking your model to stand quite squarely towards the camera and placing a light with a normal dish reflector at right angles to her body at about head height and six or seven feet (about two metres) away. Observe carefully the nature and direction of the shadows that this creates within the outline of the body. It will be easier to see this if you use a dark background. Now move the light, ideally with the aid of an assistant, in an arc around the model, who should stay in the same position, pausing at stages of about the hour marks on a clock face. Each time make a caeful note of the changes that have occurred in the nature and quality of the shadows and tonal range and the effect this has on the image. Continue this process with the light

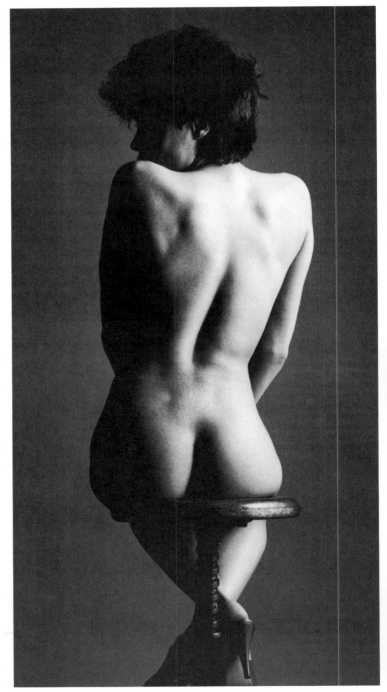

Left: a diffused light source was placed at right angles to the camera, quite close to the model, and a black screen was placed on the opposite side to increase the density of the shadows. *Rolleiflex SLX, 150mm lens, Ilford FP4, f16 with studio flash.*

For this abstract shot, two light sources were directed at the background and two large white reflectors placed each side of the camera close to the model to illuminate her body. *Rolleiflex SLX, 150mm lens, Ilford FP4, f8 with studio flash.*

A large diffused light source was suspended three or four feet above and a little behind the model with the aid of a boom stand. *Rolleiflex SLX, 150mm lens, Polaroid BW Negative film, f11 with studio flash.*

moving from three o'clock to nine o'clock, and also move the light to a much higher and lower level to see how this too affects the image. You can extend this process of exploration by now placing the light source close to the camera and asking your model to turn her body through an angle of 180 degrees, from facing towards three o'clock to nine o'clock, and again carefully observing the effect that this has.

Having become familiar with the effect of the direction and angle of the light source, the next thing to discover is how the quality of the light affects the image. With the model facing quite squarely towards the camera place an undiffused light between, say, four and five o'clock and at about head height. Now without moving the basic angle of the light source observe the effect created by making the light much softer and diffused. This can be done by using an umbrella reflector, a diffusing screen or even bouncing the light from a reflector. Compare the effects of all three methods. You will see that the basic shadow structure will not have changed but the crucial transition of highlight to shadow will have become more gradual and subtle and the image will have become much less contrasty.

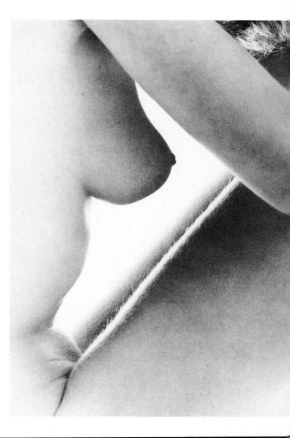

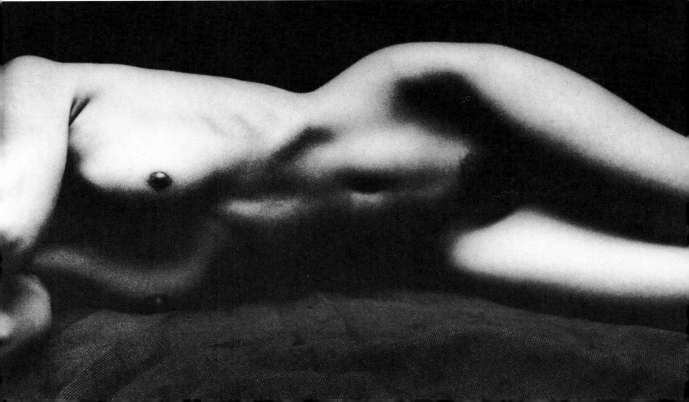

You can now see how this can be further modified by using a reflector board at varying distances from the model, on the shadow side, to vary the density of the shadows. You will also see that when the light source is softer and when the shadows are less dense it is possible for the model to change her position without having a marked effect on the lighting, whereas with a hard undiffused source even a slight change will result in a significant alteration to the quality of the image.

The lighting techniques so far have been limited to the quality and effects attainable with a single light source but you should also explore the possibilities of adding a second or third light source. The techniques described on pages 132–5 should also be introduced and the effects compared. Two soft sources, one on each side and slightly behind the model for example, can be particularly effective with nude photography as they can create a very rounded and three dimensional effect. Techniques like rim lighting can also be very useful when shooting abstract nudes to emphasise elements like texture and shape.

So far we have only explored the possibilities of lighting in relation to an upright figure. With the model in a reclining position, or any other more angular pose, the effects produced by the lighting will create further variations. With a reclining nude for example, it can be very effective to use lighting from directly above the model. An umbrella reflector or a soft box, which is a large reflector with a built in diffusing screen, can be supported on a boom arm some distance above the model. Its effect can be varied by moving it from slightly behind the model to slightly in front.

As in the case of lighting the face, a harder and less flattering light is often more appropriate when lighting a male body. The more muscular and angular contours of the male body lend themselves well to a more assertive type of lighting and elements such as skin texture, which can appear unattractive when emphasised in a woman's body, can make a favourable contribution to the effect of a male nude. In pictures of this type it can be an advantage to allow the image to become quite contrasty and for the shadows to be more dense. Try either dispensing with reflector boards, or using them at a greater distance from the model so that the shadows are not

filled in as much. Remember, however, that the contrast of the image can be considerably greater on the film than it appears when viewing the subject. A better impression of this can be gained by viewing the subject through half closed eyes, or through the camera with the lens stopped down.

A final point to consider is that ultimately it is the combination of different elements that create successful pictures. The lighting must be seen, not in isolation, but in relation to the effect that it has on the basic visual elements of the image, such as form, texture and shape as well as factors like the background or the mood of the picture. It is also worth considering that in most cases it is best to keep the lighting quite simple. Do not introduce additional sources unless they are really needed and avoid using techniques like rim lighting or backlighting just for their own sake. These should be used only when they make a real contribution to the picture.

Right: for this abstract shot, a diffused light was positioned at an angle of roughly 45 degrees to the left of the camera, and a large white reflector placed very close to the model on the opposite side. *Pentax 6 × 7, 150mm lens, Kodak Ektachrome EPR, f8 with studio flash.*

A large soft light source was placed at right angles to the camera, with a large reflector positioned close to the model on the opposite side. A second light, fitted with a snoot, was directed at the background. *Rolleiflex SLX, 150mm lens, Fujichrome RDP 100, f11 with studio flash.*

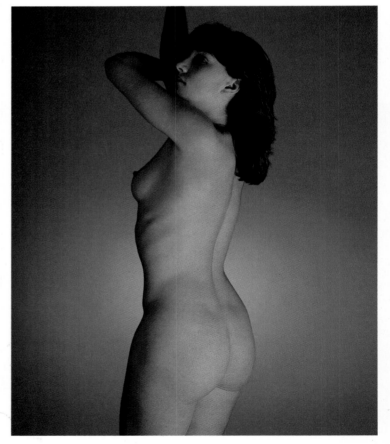

Lighting for Special Effects

Studio lighting for nude and portrait photography is normally used in a way that creates a pleasing quality, and achieves the desired effect and mood without the viewer being aware of any artifice. In other words the lighting does not draw attention to itself. However there are occasions when 'clever' or contrived lighting can be effective, especially for abstract subjects or for images which are intended to achieve maximum visual impact, such as in a poster. Like all photographic techniques, however, there is a danger in using such devices as a substitute for a genuinely good picture, rather than as the gilt on the gingerbread.

Techniques like high and low key lighting, described on pages 136–9, are examples of what might be called special effect lighting, but there are more contrived and unusual effects that can also be used. One technique that can be particularly effective with subjects like abstract nudes is the creation of a very high brightness range and image contrast. When lighting a subject in the normal way the aim is to create a brightness range between the areas of highlight and shadow which will be within the tolerance of the film. In this way adequate detail will be recorded in all tones except pure white and black. If, however, the subject is lit in such a way that the brightness range is greater than the film can accommodate, the effect will be to create large areas of either very dark or very light tones. This is most easily done by using hard, undiffused

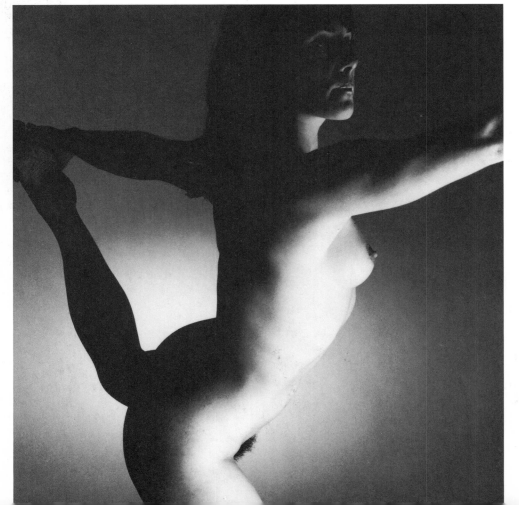

A large, soft light source was placed almost on the floor at an angle of about 45 degrees to the camera. A second light, fitted with a snoot, was aimed at the background. *Rolleiflex SLX, 150mm lens, Ilford FP4, f11 with studio flash.*

The background effect in this shot was created by projecting the image of a *moiré* pattern on to a white background. *Rolleiflex SLX, 150mm lens, Polaroid BW Negative film, 1/30 sec. at f5.6.*

lights or even spotlights and not using reflectors or fill-in lights to relieve the shadows. In a small studio with light walls there may well be too much scattered light to allow the shadows to become really dense. In this case it is necessary to use matt black screens around the model to screen her from unwanted light spill.

The precise effect created by high contrast lighting will be determined by the exposure. If it is calculated for the mid tones of the subject the light areas will be recorded as white and the dark areas black. However if the exposure is calculated to give detail in the highlight areas much larger areas of the image will record as very dark or black tones, but with rich tones and strong detail in the lighter areas. This can be particularly effective with subjects in which you wish to emphasise the element of texture. If the exposure is calculated to create detail in the darker areas of the subject the result will be to produce an image in which the mid to light tones are recorded as white or near white. This can be used to create bold areas of tone and to accentuate elements like shape and line.

Another quite simple method of creating an unusual or more interesting lighting effect is to use the main light source at an unusual or unfamiliar angle, very high above the model's head for example, or low, from floor level. This will show the planes and contours of the

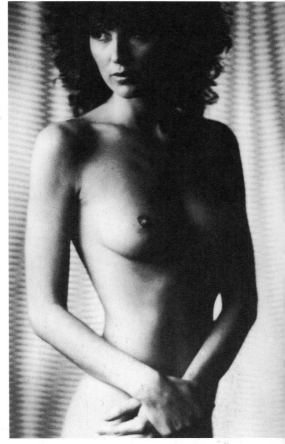

This abstract nude was lit by a single diffused light from directly above the model. *Rolleiflex SLX, 150mm lens, Polaroid BW Negative film, f8 with studio flash.*

model's body and face in quite a different context and can also be used to create an element of mood. A low light for instance can suggest a sinister or threatening atmosphere and a highly placed light source can often evoke a theatrical or mysterious quality.

When shooting in colour it can be interesting to experiment with colour filters over one or more of the light sources. A warm tinted filter such as yellow or orange, for example, can often be used to advantage on a rim light or back light to create coloured highlights on the model's hair or profile. This technique can also be used to create an element of mood. A blue filter creating a colour cast in a localised area of the image can suggest a pensive or mysterious atmosphere. It is also possible to use two light sources from different directions fitted with filters of complementary colours of the same strength. Where the light from these two sources overlap and balance

the effect will be a normal colour quality, but where either predominates a colour cast will be created. Sheets of tinted acetate filters in a wide range of colours can be obtained from professional photogaphic dealers for this purpose.

The use of non-standard light sources such as candles or oil lamps can also be a way of creating unusual effects. In these instances it is often best to use a small amount of conventional lighting to supplement the main source and to fill in the shadows a little. However, using lighting of this type will usually require the use of faster films as the light output of such sources is very low. It will also be best when shooting on colour transparency film to use artificial light film, as the colour cast on daylight film is likely to be too strong. Ultraviolet lights can also be used to create interesting and unusual effects. The types used in window displays or discotheques are idea. They emit virtually no visible light and their effect is to make the colours within the subject containing fluorescent dyes, such as clothes, props or accessories, appear to glow, creating a vivid and rather eerie quality. It is necessary to take these pictures in either a darkened room or in very subdued light, with perhaps a little rim or back lighting to add a little definition to the image. You will again need to use a fairly fast film. Daylight type colour transparency film works well but needs a UV filter to avoid any scattered UV light which might degrade the image. Interesting effects can also be obtained with a stroboscopic flash light and a moving subject. Again the type used for disco lighting is ideal. A similar effect can be obtained by using multiple exposures and a conventional flash.

Lighting effects can also be used to create more interesting and unusual backgrounds. Even the plain paper backgrounds can be made more effective by quite simple lighting techniques. A light placed behind the model, for example, can be aimed at the background to create a pool of lighter tone behind the model's head or body. It is best to use a snoot to limit the beam of light and to prevent it from spilling into unwanted areas. In some cases you can also use a coloured acetate filter over this light to add to the effect when shooting in colour. A spotlight can be used to project patterns or shadow shapes onto the background. A stencil can be cut to the

desired shape from a piece of black card and suspended between the spotlight and the background. Some spotlight units have a focusing device and a facility for projecting patterns directly onto the backgrounds, or an ordinary slide projector can be used in a similar way to project a colour or black and white slide. These techniques can be used to create a wide variety of effects. Background materials can also be selected which have interesting qualities when lit. Metallic foils, textured laminates or lurex materials for instance can be made to look quite unusual and dramatic when lit imaginatively.

A blue filter was placed over one light to illuminate the sheet of glass, and a red filter placed over the light which illuminated the model. *Pentax 6 × 7, 150mm lens, Kodak Ektachrome EPR, f11 with studio flash.*

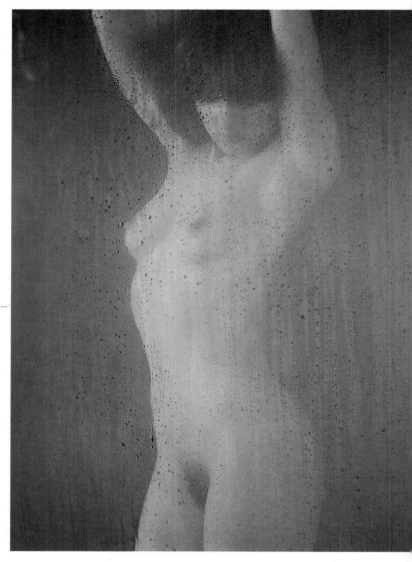

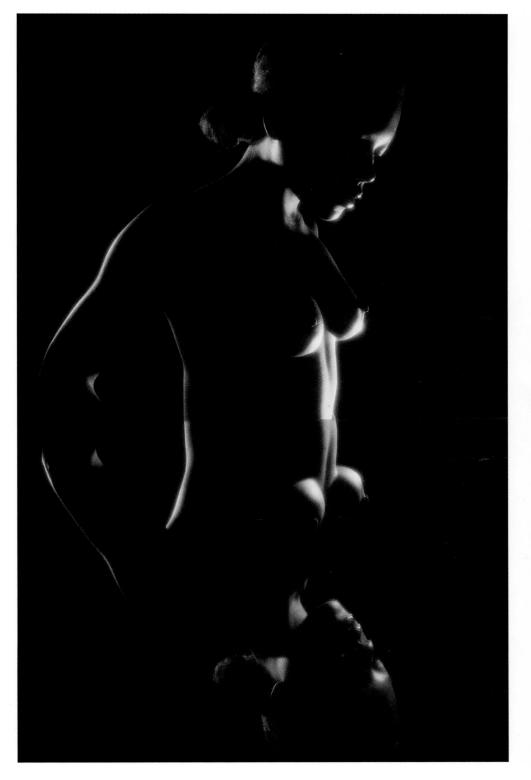

Two undiffused lights were placed each side and behind the model to produce a rim light effect. A mirror was placed on a table in front of her to create the reflection. *Nikon F3, 105mm lens, Kodak Ektachrome EPR, f16 with studio flash.*

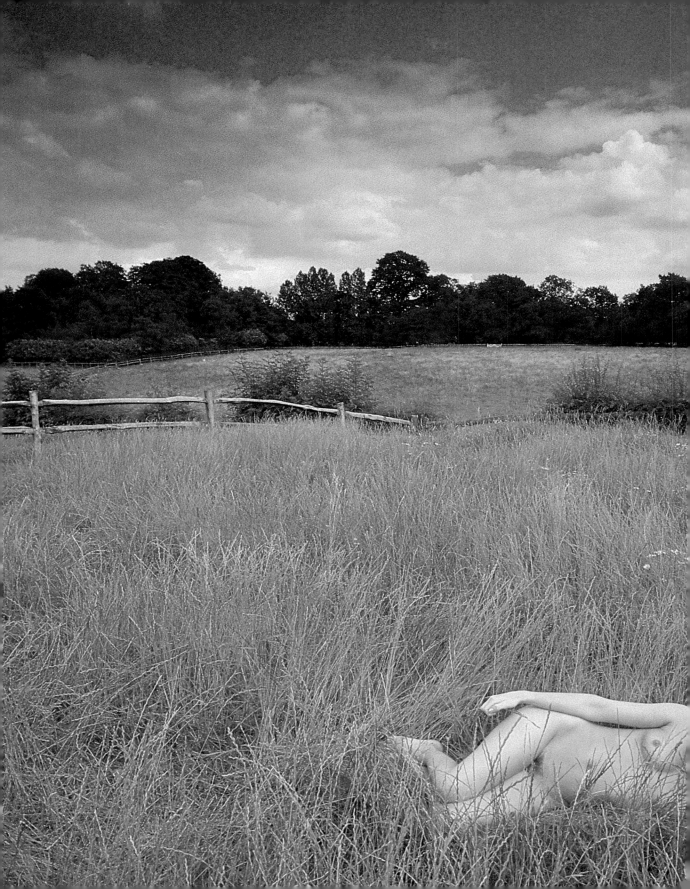

OUTDOOR PHOTOGRAPHY

Planning an Outdoor Session

There are some types of photography, landscape photography for example, where sometimes you can afford to be quite casual and even a little haphazard, leaving the actual subject and content of your pictures to be the result of spontaneous inspiration and good luck. Nude and portrait photography, however, is a positive exception since not only are you dealing with other people but in some cases you will be paying expensive model fees, and any delay or hitches in the progress of a session can be both costly and damaging to the rapport which is essential to successful photography. This is doubly so in the case of location photography because away from your home or the studio any oversights can be

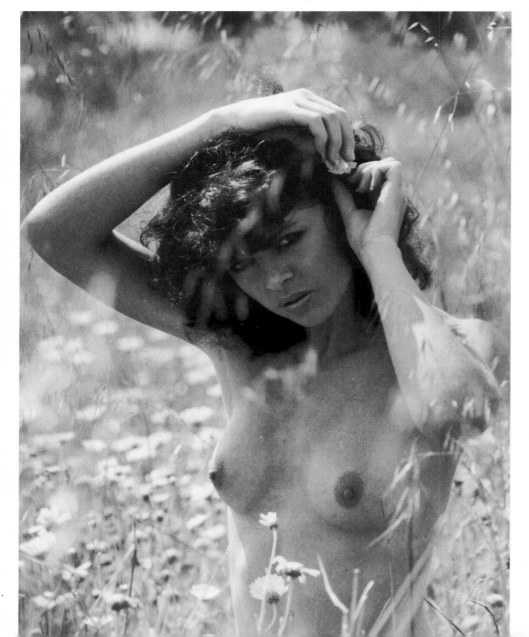

For a picture like this a tripod is a vital accessory as it aids focusing and framing, and prevents camera shake. *Rolleiflex SLX, 150mm lens, Ilford FP4, 1/125 sec. at f5.6.*

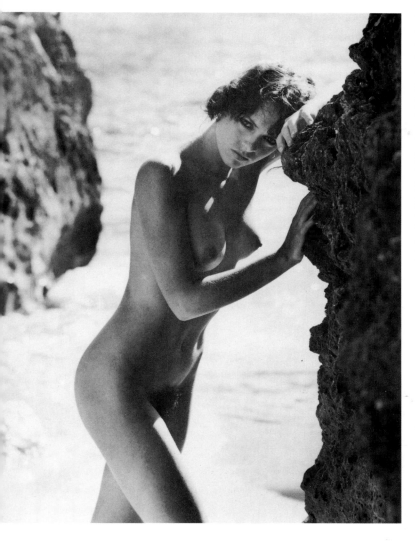

A large fabric reflector was used for this shot to bounce some light back into the shadows and reduce the contrast. *Rolleiflex SLX, 150mm lens, Ilford FP4, 1/125 sec. at f8.*

you are working on your own without an assistant. You will find that the majority of the pictures you will take will probably be with a standard, medium telephoto and medium wide angle lens, or even a single zoom. Never be tempted to try out a new piece of equipment on a session like this. Not only is there a risk of it being faulty, but unfamiliarity can cause wasted time and embarrassing fumbling. Don't forget to carry plenty of spare batteries and fuses for items that use them, together with plug adapters, particularly if you are travelling abroad. A roll of gaffer tape is also very useful for holding reflectors or flash guns, and a screwdriver and a knife are always useful. I carry a Swiss army knife which is as good as a tool kit.

A small flash gun is always worth carrying even when shooting outside as it can be used for fill-in flash or special effects. An extra-long synch lead or a slave cell will be useful, allowing you to position the flash gun away from the camera or in the background. A kit of filters is an essential accessory. Colour correction filters, contrast filters for black and white work, one or two graduated filters, a polariser and soft focus filter always travel with me, and in some instances special effects filters such as starbursts can be useful. Some camera cleaning materials are also important, especially when shooting on a beach. A blowerbrush or canned air for the removal of dust and grit, and some lens cleaning tissues or a selvyt cloth for cleaning glass surfaces are most useful.

A good firm tripod is also essential. Not only will it invariably improve the definition of your pictures but it will enable you to frame and focus more accurately and easily, take pictures when the light is poor and often at its most interesting, and it will also allow you to devote more attention to your models. Some reflectors are also important to help to control contrast and fill in shadows. These can simply be sheets of expanded polystyrene or white card or, for the sake of portability, the custom-made fabric reflectors which are stretched onto a collapsible metal frame. A large location umbrella is also very useful. It is like a plain white golf umbrella and can be held or supported over the model to eliminate any unwanted direct sunlight or top light and also to act as a diffuser.

very serious and you should ensure that every possible aspect of the day's work is considered and well planned.

It is an excellent idea to write a check list of all the things you need to take with you, from cameras and lenses down to adhesive tape and spare batteries. This could be permanently taped inside your equipment bag and quickly checked through each time you leave on a session. A spare camera body is important since you can always depend upon things to go wrong when it is most inconvenient, and it will also enable you to switch from black and white to colour whenever you wish. Don't take more equipment than you need, however, as this can become a burden, especially if

A good camera bag is an invaluable accessory. Choose one that is large enough to take all you are ever likely to need with some space still to spare – it is surprising how difficult it is to find items in a neatly packed but crammed camera bag once you start working. A rigid, box type case is ideal for transportation, particularly on airlines, as it offers the maximum degree of protection in an aircraft's hold. However, a soft compartment case can be preferable for carrying around over the shoulder, especially if you are scrambling about on a beach or in the woods. Some photographers use both, transferring items as needed from the hard to the soft case.

It is always best to take more film than you

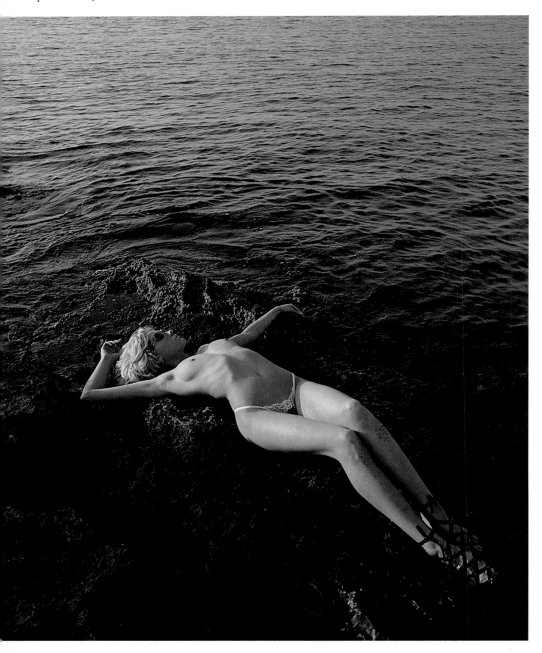

A large, soft camera bag, which can be carried comfortably on the shoulder, is ideal for locations like this where you have to scramble over rocks and need both hands. *Rolleiflex SLX, 80mm lens, Fujichrome RDP 100, 1/125 sec. at f8.*

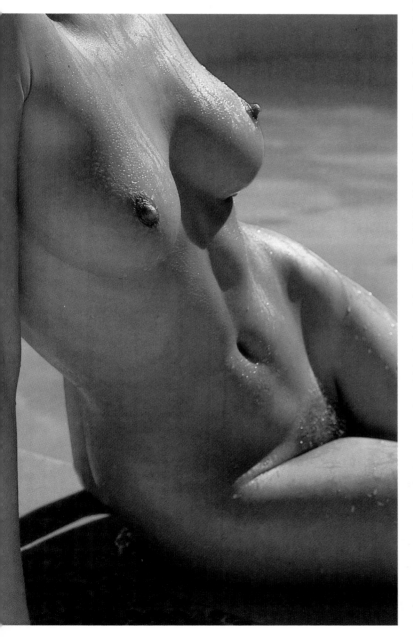

A filter kit is vital for location pictures. A Wratten 81A and a polarising filter were used for this picture to warm the skin tones and increase colour saturation. *Nikon FE2, 150mm lens, Fujichrome RDP 100, 1/125 sec. at f8.*

think you will need, in case inspiration finds you. As with your equipment it is best to stick to familiar types and to buy it from a regular source where its freshness can be guaranteed. I like to carry my film in a separate bag so that if travelling by air it can be held back from the X-ray machine and a hand search requested. A number of black plastic or foil bags are useful for exposed films, the type used to hold

printing papers are ideal, and a marking pen is invaluable for numbering rolls and writing any special instructions, such as clip tests or push processing.

If you are travelling abroad you must consider the customs regulations of the country you are visiting. Most countries have a quite limited allowance of camera equipment and film even for personal use. Although it is possible to obtain a carnet, a temporary import document, in most cases it will be sufficient simply to take a list, in duplicate, of all you are carrying, including film and serial numbers where appropriate. This can be checked by customs officials when entering and leaving the country.

Don't forget the creature comforts, both for yourself and your models. A long day's photography will be something of an ordeal is refreshments are not available, and a flask of hot coffee is the perfect cure for reviving chilled models. Consider also things like a pack of wipes or a sponge and towel to clean the marks from bottoms and the soles of the models' feet. When working on location such marks are inevitable and will look ugly if allowed to show in the picture. One well-known photographer specialising in nude work carries a cushion for his models to sit or kneel on while resting between shots to avoid pressure marks.

Lastly, and possibly most importantly, know exactly what you want to achieve. Make a list of the shots you plan to take, perhaps with some sketches of ideas, and consider props and accessories that might be needed and make a list of them together with any special equipment or effects you might want to use. Nothing is worse than running out of momentum during a session simply because you don't know what to do next and even if you have thought about it beforehand it is easy to forget in the heat of the moment. A list is always best. You should also arrange a briefing session for your models well before the day of the session. Explain the shots you want to do and how you intend to approach them. Make sure that your models know about any clothes or accessories that will be needed and have a wardrobe check. Don't leave anything to chance, as the more the models know about the ideas you have the more they will be able to contribute and the better the rapport will be.

Choosing a Location

Much of the success of an outdoor photographic session can be attributed to the choice of a good location. It is an essential part of planning a session and professional photographers spend a considerable amount of time researching suitable places. Unless it is somewhere you know very well, and have visited recently, it is very important to carry out a thorough reconnaissance of a location you plan to use. Never just take someone's word for it – the phrase 'photographer's paradise' should always be treated with suspicion!

What, then, to look for when choosing a location? Firstly for nude photography in particular it must be reasonably private. Even if the models are unconcerned it can be very disruptive to have onlookers and there is always the possibility that too much attention could arouse the unfavourable interest of the police. You must also consider access. A wild and remote spot may seem to be ideal on a casual visit, but think of it also in terms of carrying cameras, equipment, tripods, reflectors and the models' clothes and accessories.

Do not be too swayed by an impressive or spectacular view. Such a location may prove to have only one potentially useful background and if you have planned a day's photography it could quickly become limiting. In the same vein you should try to avoid having to travel too far between shots during the course of a day's photography. This can be very disruptive and tiring for the models. Endeavour to find locations where there is sufficient potential for a few hours' work before needing to move on. The main factor that determines a good location is the variety of backgrounds available. Often you will need only quite small areas and a place where you have trees or foliage, perhaps with a wall or a building and some long grass or flowers would be more useful, even if not attractive in the scenic sense, than just a lovely view. You should also look at your potential location more in terms of its colours, textures and shapes that for what it actually is. Remember it is how it looks in the camera that matters most.

You must also be aware of the lighting. Note from which angle the sun is directed at particular times of the day and plan in what order to shoot various parts of the location in order to choose the right time to make the best of the lighting possibilities. It is no good planning to shoot a sunset on a beach facing east for example.

Where should you look for locations? The great outdoors is an obvious choice. Woods, beaches, mountain and moorland – all these types of location have tremendous potential. However bear in mind that accessibility and quiet do not necessarily go together, and beautiful places that are easy to get to tend to be popular with other visitors and tourists particularly on a warm sunny day. In some instances it may be best to plan these locations for out-of-season sessions or early or late in the day. If possible it can be better to find private parks, gardens and even beaches and obtain permission to take your pictures there.

Buildings like this add the potential of an interesting shape and texture to the composition, and in this case provide a frame for the model. *Rolleiflex SLX, 150mm lens, Ilford FP4, 1/125 sec. at f5.6.*

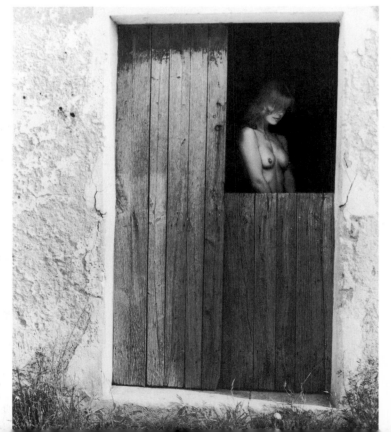

Often only a very small
area of background is
needed for nude and
portrait pictures, like this
doorway. A well chosen
location might contain a
dozen or so different
corners. *Rolleiflex SLX,
150mm lens, Ilford FP4,
1/60 sec. at f5.6.*

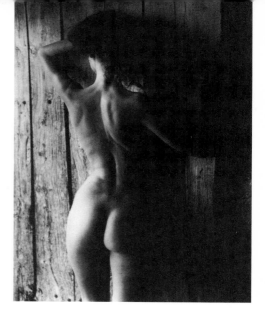

You will also find that natural settings can
sometimes be a little limiting in terms of
background colours and textures. Trees,
grass and foliage can begin to look a little
samey without other interest to give relief.
For this reason a setting with a building can
be a good compromise. Many professional
photographers like to use places like villas
and hotels with gardens, combining the ad-
vantages of both natural and man-made back-
grounds. A swimming pool for instance can
be very useful for nude shots. There is the
added advantage of such locations providing
ample opportunity for the models to change
and do their hair and make-up in comfort, as
well as a place to rest between shots and to
have some refreshment.

A location which also
offers the possibility of
interior shots will provide
much more variety and
scope for achieving
different lighting effects.
*Rolleiflex SLX, 150mm
lens, Ilford FP4, 1/60 sec. at
f4.*

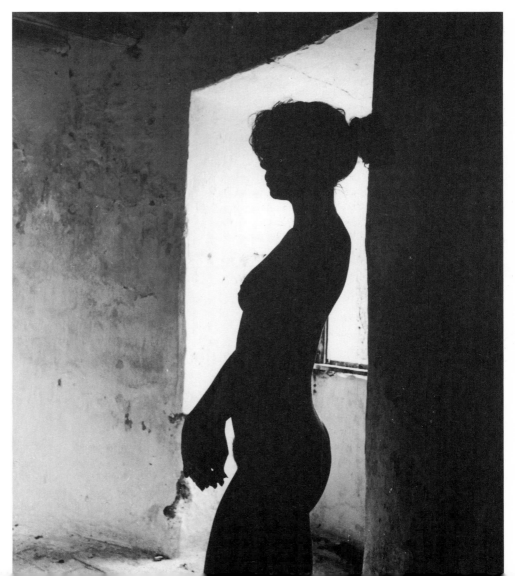

Shooting in Sunlight

A warm sunny day is in many ways the ideal choice for an outdoor nude photographic sessions. It creates pleasant working conditions, particularly for the model, gives plenty of light for a wide range of exposure options and the light itself has more variety and life than on a dull day. However sunlight can present problems for the photographer and there are special considerations to be made and techniques which can be used in order to make the best of such conditions.

On a clear sunny day with blue sky the sun creates a point source of light. This means that it casts dense, hard-edged shadows and creates brilliant highlights. This in turn produces a very high brightness range, often much higher than the film can record. With an exposure estimated for the middle tones of the subject high contrast will result in the darker tones recording as black with no detail and the lighter tones as white with the detail burnt out. In addition the shadows created in sunlight can be both unattractive and unflattering. When using direct sunlight there are a number of ways of reducing both the size and density of the shadows and also the contrast.

The most basic technique is to position your model, choose a camera viewpoint and frame the image in such a way that the shadows are at their smallest, with the sun close behind the camera for example, and calculate your exposure for the lighter tones of the subject, allowing the shadows simply to go black. Alternatively, using the same methods, ensure that the model is primarily in shadow and calculate your exposure to give a full range of tones in this area, allowing the small amount of highlight detail to become burnt out.

A more satisfactory technique is, having chosen the viewpoint and model position to create the most pleasing shadows and modelling, to use a large white reflector board to bounce the sunlight back into the shadows reducing their density and lowering the contrast. For quite close-up shots a fairly small reflector will be adequate but for full length pictures a large reflector, about five by three feet (about one-and-a-half by one metre), will

be needed to be effective at the distance necessary for it to be placed outside the picture area. Another way of overcoming excess contrast and dense shadows is to position your model in light surroundings. When shooting on a beach for example the light reflected from the sand and sea can act as a natural reflector, as can a whitewashed wall.

In some situations it can be preferable to use a small battery powered flash gun to fill in the shadows. The simplest method is first to take an exposure reading which will give the correct exposure for the lighter tones of the subject. Let us assume this is 1/125 sec. at f8. Next calculate the correct exposure for the flash according to its distance from the model. Let us assume that it requires an aperture of f5.6. However you only want the flash to make the shadows a little lighter and not to

In this picture the exposure was calculated to give full detail in the lighter tones. A white reflector was used to bounce some light back into the shadows. *Rolleiflex SLX, 150mm lens, Ilford FP4, 1/250 sec. at f8.*

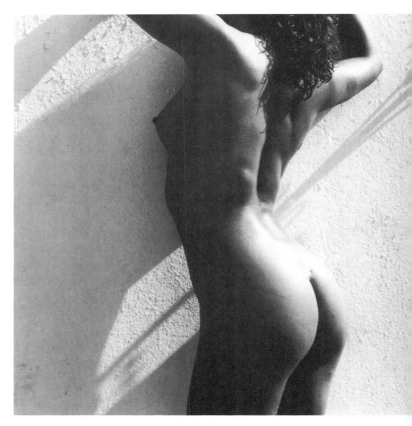

The camera viewpoint for this shot was chosen so that the sun was almost behind it, creating small shadows. A red filter was used to darken the sky. *Rolleiflex SLX, 50mm lens, Ilford FP4, 1/125 sec. at f5.6.*

eliminate them altogether, as this would look very artificial. To avoid this you should give approximately two stops less than the correct flash exposure which would be f11. All you need to do now is to reset the shutter speed to 1/60 sec. in order to maintain the same daylight exposure. The effect can be further improved by using the flash diffused, ideally with an umbrella reflector, and at a slight angle to the model rather than from the camera position. This will create a small degree of modelling and look more natural. However you will need to use a quite powerful flash gun to enable it to be used at a

convenient distance from the model and to allow smaller apertures to be used.

Shooting into the light is another effective means of creating a softer, shadow-free light on a sunny day, and it can be particularly effective with nude and portrait pictures because it tends to be quite flattering. Simply place your model and select a viewpoint which places the sun more or less directly behind her head. There will, of course, be bright highlights but with a careful pose and choice of viewpoint they will be limited to the rim of the model's face or body and in most cases it will not matter if the detail is burnt

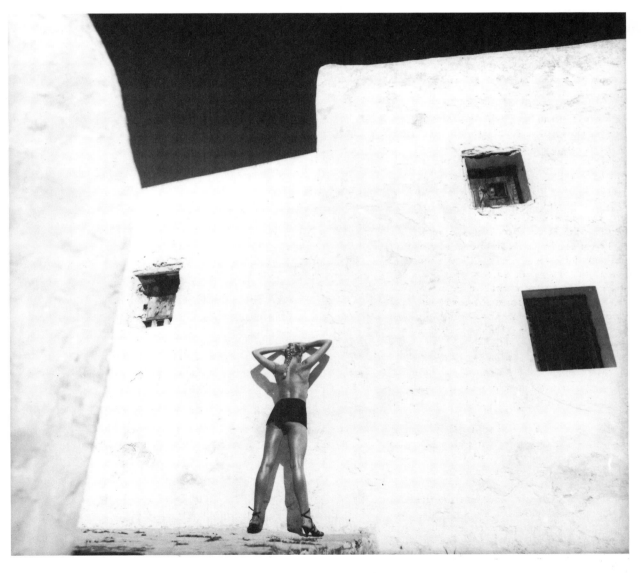

out. It can help in some cases to use either reflector boards or fill-in flash when shooting into the light in order to reduce the exposure and correspondingly the loss of detail in the highlights.

Exposure readings must be made carefully with pictures of this type as a reading taken in the normal way will result in underexposure. The best method is to take a close-up reading from a mid tone in the most important area of the image. It is best to use a warm colour correction filter, such as an 81A or 81B, as shooting into the light can create a blue cast, especially when there is a deep blue sky. You must also be careful to avoid flare caused by the sun shining directly into the lens. A good lens hood or compendium will help, or hold a piece of black card at arm's length to shield the lens. However in some instances a small degree of controlled flare can be used to create

a pleasingly soft quality in the image.

The difficulties of shadows and hard light can also be overcome by positioning your model in an area of open shade, such as by a wall or under a tree. This shields the model from direct sunlight and effectively uses the sky as the light source. When shooting colour transparencies, however, it is necessary to use a warm filter such as 81A or 81B to offset the blue cast which open shade lighting can create. Be careful to avoid excess top light when shooting in open shade since this can create unpleasant shadows under the model's eyes and chin. Shooting under a tree or in a doorway will overcome this, and if you have one, a location umbrella, a reflector board or a large diffuser held above the model's head will also help. They can also of course be used to create a small area of shade when required.

The time of day will also affect the quality

The warm quality of this shot was produced by shooting an hour or so before the sun set. The low angle has also added to the effect of this picture. *Rolleiflex SLX, 250mm lens, Kodak Ektachrome EPD, 1/250 sec. at f5.6.*

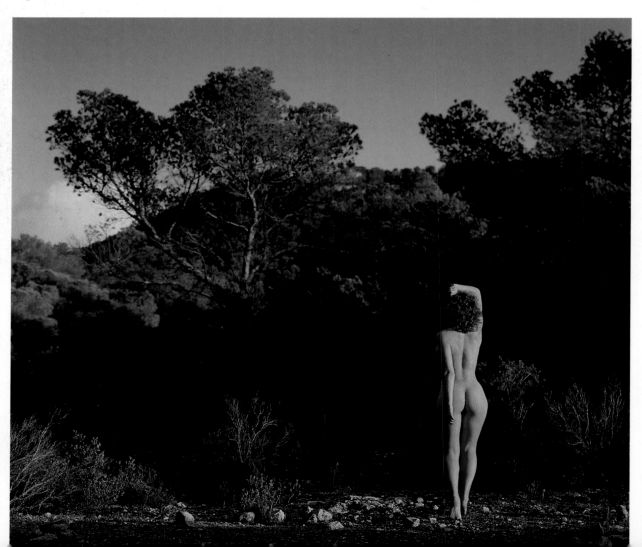

Shooting into the light has produced a pleasingly soft and atmospheric picture. A close-up exposure reading was made to avoid the possibility of underexposure. *Rolleiflex SLX, 250mm lens, Ilford FP4, 1/250 sec. at f5.6.*

of direct sunlight. As a general rule the light in the middle of the day is less suitable simply because in the summer months the sun is directly overhead and this can create problems with shadows under the model's eyes and chin. To some extent this can be overcome by the poses the model uses, like tilting the head upwards, for example, or the

use of reclining positions. However the light in the early or late part of the day is often preferable, since not only is it at a more convenient angle but it also tends to have a more mellow and warm quality. Pictures lit with sunlight when it is near the horizon can have a rich, warm quality that is quite different from that achieved by filters.

Shooting on Cloudy Days

A partly cloudy sky can create a more suitable quality of light for nude and portrait photography and even a dull, overcast sky has useful properties. Clouds can in fact work as reflectors and on a sunny day a few clouds can make the light softer and less contrasty. The conditions described on the film packs as 'hazy sunshine' or 'cloudy-bright' are ideal for this type of photographic session. In addition clouds can create more interesting lighting effects with pools of light and shade, and this can be particularly effective when shooting pictures with a landscape background. The sky itself can also become a more interesting element of the composition when some clouds are present. An unrelieved blue sky can be rather bland and boring.

A cloudy day can be particularly effective with subjects that have an inherently high contrast, when bright sunshine would increase the brightness range of the subject beyond that which the film can record. The softer light of a cloudy day can also be helpful when shooting subjects with a strong element of pattern or a pronounced texture. With this type of picture the strong shadows created by sunlight could lose the fine detail necessary to record such qualities. The colour quality of the subject can also be benefited by the use of a softer light. Bold, saturated colours for example are often more effective when illuminated by a cloudy sky and it is also easier to create images with a soft and harmonious colour quality without the dense shadows created by direct sunlight.

The daylight on a cloudy day can have a substantially higher colour temperature and a greater presence of ultra-violet light than on a clear day, and so it is especially important to use a warm colour correction filter, such as an 81A or 81B, to offset the blue cast that this would create. Filters can also be used to improve and control the effect of the sky itself. A polarising filter will make white

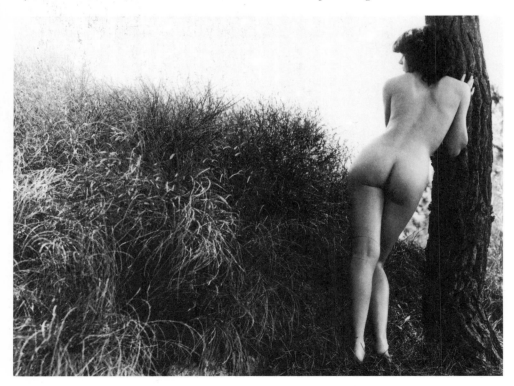

The soft light of a cloudy day has enhanced the textural quality of this picture which was framed to emphasise the grass and minimise the blank sky. *Rolleiflex SLX, 80mm lens, Ilford FP4, 1/125 sec. at f5.6.*

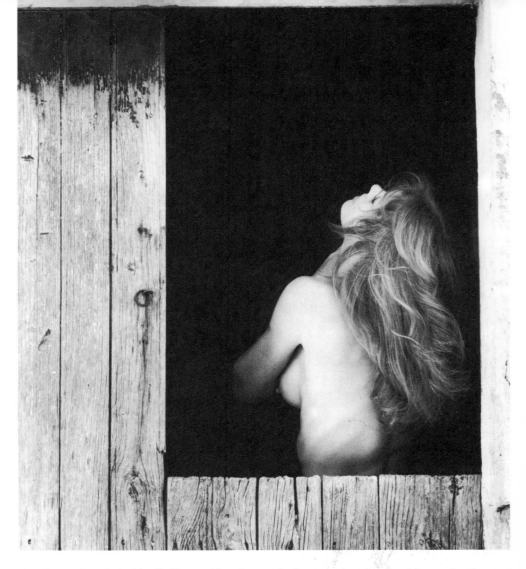

Placing the model in a doorway has eliminated top light, and the dark background has added pleasing contrast to the image. Rolleiflex SLX, 150mm lens, Ilford FP4, 1/125 sec. at f5.6.

clouds stand out in bold relief from a blue sky, for example, and a grey stormy sky can be made to appear more dramatic by using a neutral graduated filter to make it darker and record with more detail and richer tones. In black and white pictures, red and orange filters can be used to emphasise the sky.

A potential problem when shooting on a cloudy day is that the light can be directed too much from the top, the sky, and this can cause unattractive shadows under the model's eyes and chin. It will also create less effective modelling particularly with a standing figure. One solution is to pose your model in such a way that the light is directed more pleasingly, for instance, in a reclining position or with her head tilted slightly upwards. Reflector boards can also be used to eliminate these

shadows and a large white umbrella or a diffuser can be placed above the model to reduce the top light. Placing your model in a position which is naturally shaded from top light such as under a tree is also effective.

Another potential difficulty on an overcast day is that the light can be too soft, creating virtually no shadows. This can result in pictures appearing flat and dull without either bright highlights or very dark tones. It can be overcome by positioning your model, choosing viewpoints and framing the image in a way which is calculated to include areas of lighter and darker tones or bold, bright colours, such as a white wall as a background or a foreground of flowers. You can also choose props and accessories which add an element of contrast in this way.

Controlling the Background

Inexperienced photographers often regard the background of a shot in a rather negative way, as something that simply happens to be there. This attitude can be disastrous. Unsuitable or distracting backgrounds are one of the major causes of disappointing pictures. Everything that is included in the image must be the result of careful consideration, and the background in particular can have a dominant effect on the quality and impact of a photograph.

In its simplest form the background should provide a contrasting tone or colour against which the model will be both clearly defined and well separated. Shape is an important element of most nude pictures and it is essential that the choice of background enhances this quality. When shooting in black and white you should position your model and choose a viewpoint which enables a contrasting tone to be placed behind the model – a dark wall or foliage behind a light-skinned model for example.

Lighting can also be used to create a tonal contrast, if you use an area of the background which is more strongly lit than the model, or choose a viewpoint which enables a deep shadow to be placed behind her. With colour pictures it is perhaps easier to create a contrast because many colours are effective when juxtaposed with skin tones. As a general rule, however, darker hues will tend to produce a stronger separation and give more impact than softer, lighter colours.

In addition to tonal and colour contrasts you should also consider juxtaposing the model with other contrasting visual elements, such as patterns or bold textural effects. The skin tones of a model could be quite effectively contrasted with rough stone, for instance, or rippled sand. The choice of viewpoint is a significant factor in finding the best background and it is important to explore all the possibilities, including both higher and lower camera positions.

One of the difficulties in outdoor photography is that backgrounds can be too distracting, with fussy details and areas of colour which draw attention away from the model.

One very effective way of overcoming this is to use a shallow depth of field to throw the background details out of focus. In this way even boldly defined shapes and colours in the background can be reduced to a blurred, unobtrusive area of tone. It is more effective if you use a long focus lens and select a wide aperture, as this will create a very shallow band of sharp focus on the model. The effect will be further enhanced the greater the distance is between the model and the background and the closer the camera is to the model.

Shooting into the light is another effective means of creating a bold separation between

The plank background in this picture provides a bold contrast to the girl's body, emphasising its shape and line. The pool of sunlight also adds interest. *Rolleiflex SLX, 150mm lens, Kodak Ektachrome EPD, 1/125 sec. at f8.*

In this picture the background plays a much more dominant role, setting the scene for a somewhat whimsically ambiguous picture. *Hasselblad, 150mm lens, Kodak Ektachrome EPR, 1/125 sec. at f5.6.*

the model and the background, particularly when there is little tonal or colour contrast between them. This is because backlighting can create a halo of highlight around the outline of the model's face or body.

In some cases, however, the background is intended to play a more dominant role in the composition, and the details and objects included in it are important to the mood or meaning of the picture. One of the best ways of approaching pictures of this type is to use the camera viewfinder first to compose and frame the picture without the model but leaving a mental 'hole' in which she can be placed. This should be in the most dominant part of the frame and arranged in such a way that the focus of interest is directed unerringly towards the model. Also the viewpoint and framing should be done in such a way that the other elements of the image create a balance and do not draw the viewer's attention away from the model.

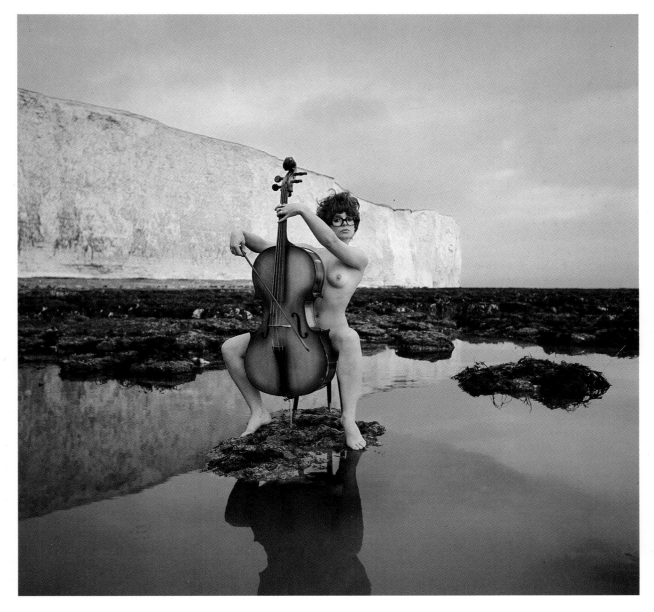

Using Foregrounds

In nude and portrait photography the model is often the closest element of the image to the camera. Indeed many pictures of this type consist primarily of just two planes, the model and the background. A picture can often be improved, however, by the addition of a third plane, the foreground. It can add interest to the image, be a powerful additional element in the composition and help to create a better impression of depth and solidity in the picture.

When choosing a camera viewpoint and positioning the model it is a good idea to develop the habit of always looking to see if there are any potentially useful objects or details which can be used between the model and the camera. Quite often just moving the camera back a few feet or to one side can make a considerable difference to the picture. Also don't overlook the possibilities of a higher or lower viewpoint to introduce foreground interest.

The perspective effect of an image can be greatly enhanced by the use of foreground details. The use of a wide angle lens will accentuate this because it will allow both very close foreground objects and more distant details to be included in the image. You will need to use the smallest practicable aperture if you wish the image to be sharp in both close and distant parts of the subject. The maximum benefit of depth of field will be obtained if you focus at a point about one third of the way between the camera and the most distant detail in which you want sharp focus. It can be effective, however, to allow close foreground details to be unsharp. In this way they can be less distracting and help to create the effect of leading the viewer's eye towards the main point of interest.

Some foreground objects can look particularly effective when allowed to become blurred — flowers, grass and foliage for instance. In colour pictures they can create a screen of pleasingly soft hues and tones. This technique can often be used to create an element of mood in the picture or a soft and whimsical quality. The effect will be more pronounced if you use either a standard or

long focus lens and select a wide aperture, focusing sharply on the more distant model.

It can also be interesting to vary the density of foreground details. A flash gun, for example, can be used to illuminate the closer parts of the image more strongly than the distant model, or a neutral graduated filter can be used to make the foreground area much darker in tone. The colour of the foreground can be altered either by using coloured graduated filters or by placing a colour filter over the flash gun.

The use of foreground objects and details can help to make the composition of the image more effective. The lines created by perspective can lead the viewer's eye towards the main point of interest and it is possible to use a much more distant and smaller image of the model juxtaposed with a close and boldly defined foreground shape, colour or texture.

In this shot the fence in the foreground has created an effective 'lead in' to the model, as well as acting as a useful prop. Rolleiflex SLX, 150mm lens, Ilford FP4, 1/125 sec. at f5.6.

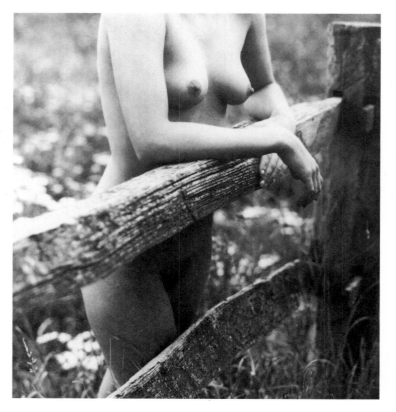

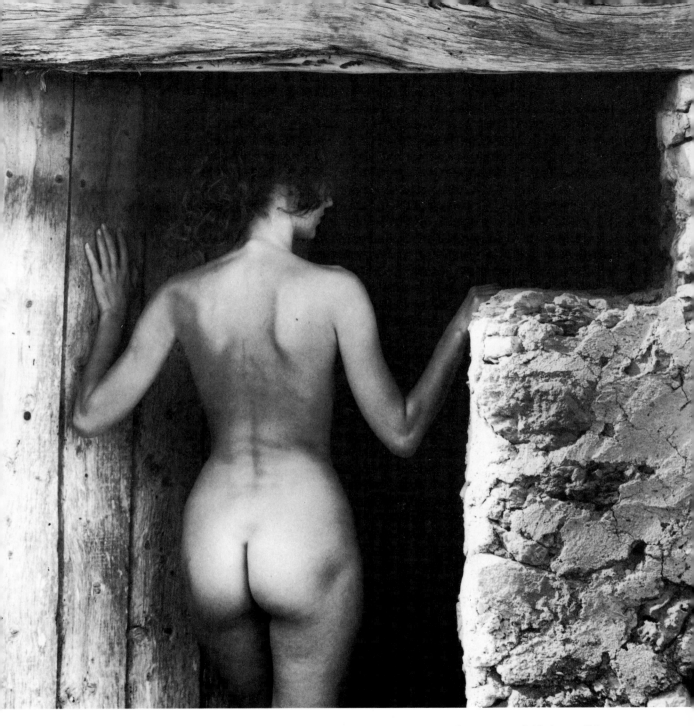

The foreground of this picture has created an effective but irregularly shaped frame around the image, creating a tight and ordered composition. *Rolleiflex SLX, 150mm lens, Ilford FP4, 1/125 sec. at f8.*

Foreground details can also be used to help to contain the image and to concentrate the attention upon the model. A classic example of this is a foreground which acts as a frame. It could be quite literal such as a window, arch or doorway or a suggested frame such as an overhanging branch. When working with more than one model it is possible to use one of them, or just part of her body in this way. Techniques of this type can also be a useful way of masking unwanted background details – an overhanging branch of a tree for instance can be a way of hiding a blank and uninteresting sky.

Using the Landscape

Of all the locations available to the photographer the countryside is the most accessible and the colours, textures and shapes that nature provides can be ideal as backgrounds and settings for nude and portrait photography. For close-up and tightly framed images it is easy for most people to find a suitable location within a short distance of their homes or studio, but when the landscape itself is intended to be an important element of the pictures it will be necessary to choose your locations more carefully.

If the landscape is to be used in a more dominant way it can be particularly effective to allow the image of the model to be quite small, a focus of interest within the overall composition rather than the prime subject. This type of picture requires perhaps a more careful and considered approach as it is easy for the model to become lost or overwhelmed in such photographs and for the result to be cluttered and confusing. It is best to view the setting you intend to use as a landscape image in its own right without, initially, the presence of the model. Choose a viewpoint and frame and compose the image to create a balanced and effective landscape picture. When you have arranged things within the

In this picture the landscape has been used as the dominant element, with the model in the foreground simply providing a disconcerting focus of attention. *Nikon F3, 150mm lens, Ilford FP4, 1/125 sec. at f8 with an orange filter.*

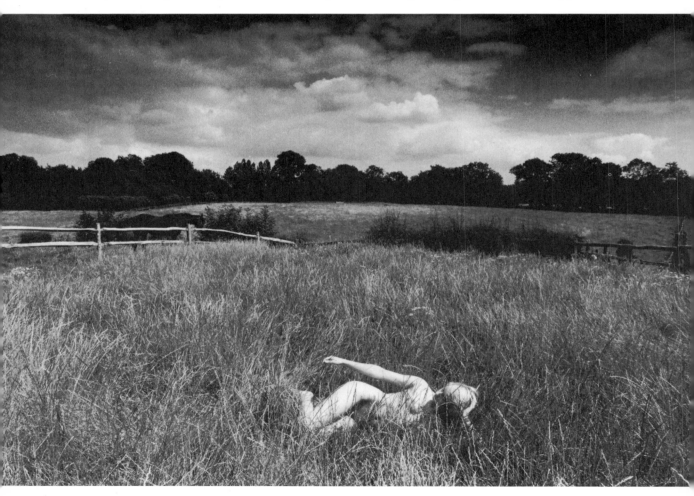

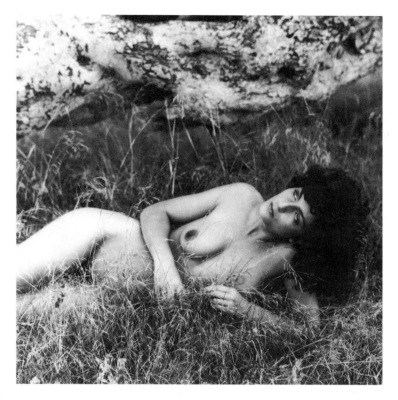

A simple setting like this can be found close to most people's homes, and is ideal for nude pictures; creating both a natural and an appealing background. *Rolleiflex SLX, 150mm lens, Ilford FP4, 1/125 sec. at f5.6.*

A landscape does not have to be a wide open view. In this picture tight framing has produced an almost abstract effect. *Nikon F3, 20mm lens, Ilford FP4, 1/125 sec. at f8.*

viewfinder to your satisfaction you can then consider where and how to position your model for the best effect. This may well require some adjustments to the initial choice of viewpoint and framing, but you will have a firm basis from which to build your picture.

The position you select for the model will, firstly, need to be in a dominant area of the frame and, secondly, in a place where there is a degree of separation between the model and the immediate background, against a contrasting tone or colour for example. Other elements of the composition can also help to focus the attention more firmly on the model. You can use foreground details or the effect of perspective to lead the viewer's eye into the image. Lighting, too, can help. Shooting into the light, for example, can create a rim of highlight around the model, or strong directional lighting on the model can, in effect, be used like a spotlight. Techniques like these can be used to ensure that no matter how small the model is in relation to the rest of the image, she will still be the centre of interest.

When a wide, open landscape is used in this way it can often be effective to make use of the sky area as an important element of the image, particularly if there are interesting clouds. To emphasise the sky, frame the picture so that the horizon is towards the bottom of the image. When shooting in colour use filters such as the polarising and graduated filters to create richer and stronger colours and tones, and when shooting in black and white, red and orange filters can be used to create more dramatic effects.

A wide, open landscape is however, by no means the only type of landscape setting that can be used effectively. Closer details such a trees, rocks, foliage and other natural features can all be used as powerful elements in a picture. The contrasts in shape, form, texture and colour of such things can create dramatic juxtapositions with the nude form and produce images with a compelling photographic quality, particularly with black and white pictures. The light will, of course, be an important factor and although bright sunlight can create pleasing and varied effects you should not overlook the possibilities of a cloudy or dull day. The softer light and more subtle tones can produce very effective images and can also often enable more atmospheric pictures to be taken.

Beach/Shore Locations

A beach or shore is of course one of the most popular locations for nude photography and there are a number of good reasons for this. Firstly it is appropriate. Nude pictures taken in settings such as woodlands or urban landscapes can have an element of incongruity, whereas a beach is a perfectly natural place for a person to be naked. Secondly a beach provides both space and plain and simple backgrounds, providing a wide choice of viewpoints and model positions. Another consideration is that the light on a beach can be particularly effective for nude photography, especially on a sunny day, because the reflective surroundings can help to fill in shadows, reduce image contrast and create a more pleasing and flattering effect.

A beach or the shore is also an ideal location for pictures like action shots and sunsets. A west facing beach, for example, will allow you to take pictures with the sunset over the sea which can create rich colour when reflected in the water and wet sand. It is very important, however, to be careful of your equipment, as both sand and sea water are extremely damaging to cameras and lenses. It is best to keep individual items in plastic bags, removing them only as and when needed and carefully cleaning and replacing them after use.

The backgrounds on a beach or shore can be quite varied. In addition to obvious feaures like sand, sky and water you may well make use of such things as rocks, fishing boats, deck chairs, sun beds, and so on. A polarising filter is a very useful accessory in beach locations because it can be used to create deep blue skies and colourful, translucent water. It can also help to reduce the glare caused by scattered and reflected light, adding definition and

Both a polarising filter and a Wratten 81A filter were used to increase colour saturation and make the sky a darker tone to offset the light colour sand. *Nikon F3, 20mm lens, Fujichrome RDP 100, 1/125 sec. at f8.*

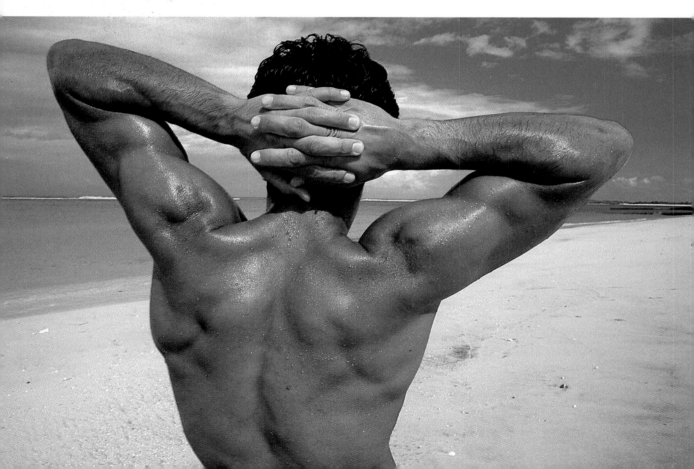

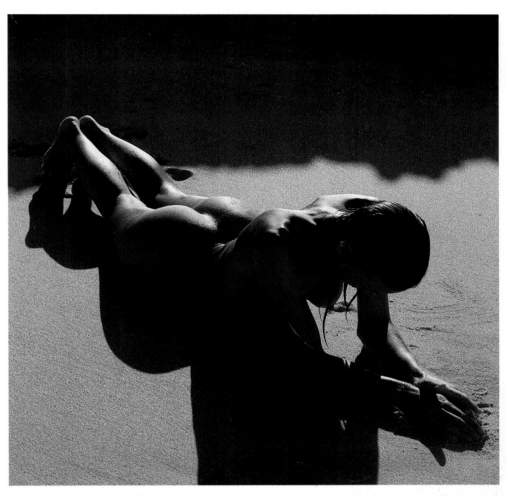

A beach offers the perfect setting for pictures which exploit the textural quality of the subject like this shot with wet skin and hair.

clarity to your pictures. However, a polarising filter can, in some circumstances, make sand appear dull and lifeless and so care must be taken.

A warm correction filter such as an 81A or 81B is also essential because there is a high degree of ultra-violet light near the sea and this will create a blue cast on colour transparencies if a filter is not used. Some care must also be taken with exposure readings. Because of the very reflective surroundings a reading taken in the normal way can result in unrealistically high readings, resulting in underexposure. It is best to take a close-up reading from a mid tone in the most important part of the subject and to ensure that the meter is not influenced by bright highlights and scattered light.

A beach is a setting in which it is possible to exploit the qualities of texture fully. Skin,

sand and rocks can be juxtaposed to create both rich and powerful images and it is of course an ideal location for a wet model. The effect of wet skin can be particularly strong in a photographic image. Both lighting and exposure are critical for this type of picture. Direct and indirect sunlight can both be used effectively and a degree of underexposure will usually help to emphasise the impression of texture. Tanned or wet skin photographs especially well in this context and a polarising filter can often be used effectively both to make the skin a deeper and richer colour, and to help to control the brightness of the highlights created on the wet skin. Droplets of water on skin are particularly photogenic and they can be created easily by flicking or spraying a small amount of water onto the model's body, which should be lightly oiled with the oil well rubbed in.

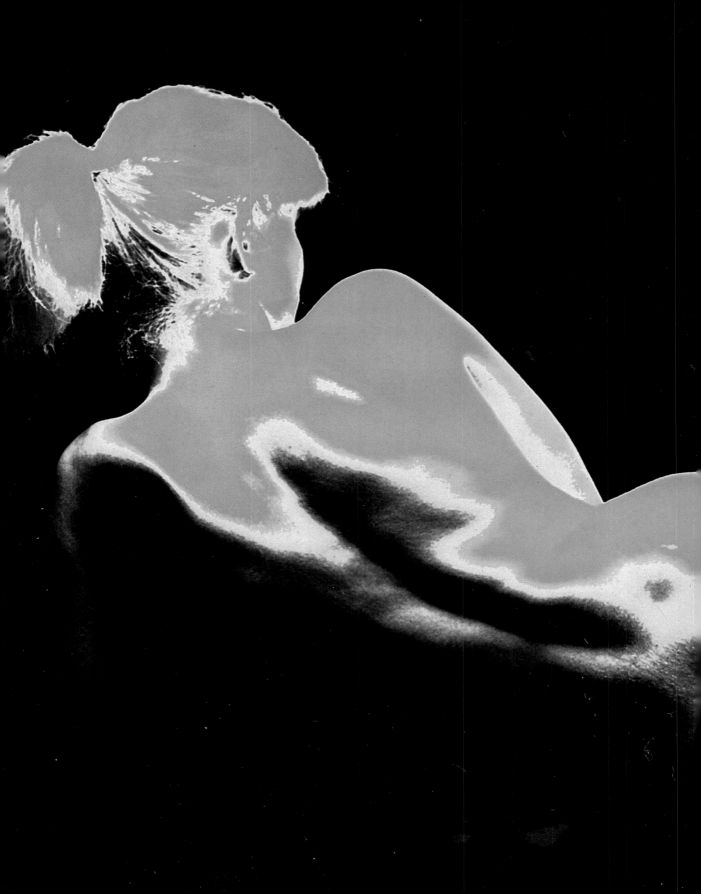

CREATING SPECIAL EFFECTS

Effects with Film

In many cases the main aim of a photograph is to record the image created by the camera lens quite accurately: however, there is considerable potential within the photographic process for modifying and distorting this image in order to produce more abstract or interpretive images.

The choice and use of film is one of the most basic means of doing this because the nature and response of the film's emulsion is largely responsible for the resulting image quality. One of the most effective techniques which makes use of the film characteristics, and one of the simplest, is to exploit the grain structure of the emulsion. It can be particularly effective with nude pictures and can be used to help to create mood as well as to introduce an abstract quality into the image. The effect of a grainy image is likely to be enhanced when the subject contains large areas of fairly even tone as opposed to fine details like patterns or textures, and it can also be very effective when used with diffused or soft focus pictures. Sarah Moon, for example, frequently uses this technique.

The simplest way to obtain an image with a pronounced grain structure is to use a fast, grainy film and to enlarge it to a high degree. The technique is equally effective with either black and white or colour images. With the latter you can simply choose a fast transparency film of, say, ISO 400 or 800 and push process it by one or two stops to further increase the grain size. The grain of colour

The grainy effect of this picture was produced by shooting on a high speed film and then enlarging a small section of the negative. *Nikon F2, 150mm lens, Kodak 2475 Recording film, f16 with studio flash.*

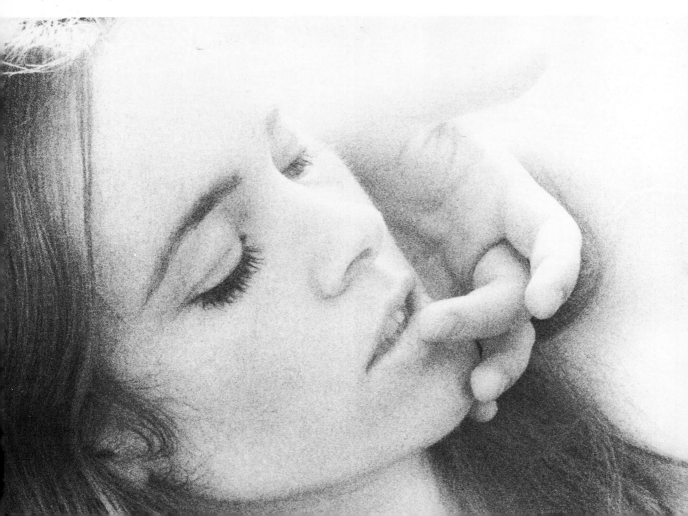

This landscape and the
nude were photographed
on Kodak BW Infra-Red
film with the aid of a red
filter; the print was made
on a hard grade of paper.
*Nikon F3, 24mm lens, 1/60
sec. at f8.*

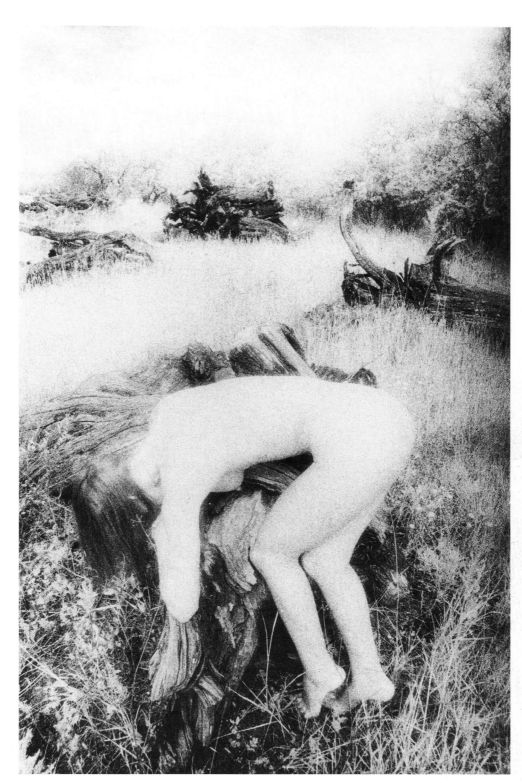

negative films is less pronounced and pleasing, and an alternative method is to make your exposures on a fast transparency film. I often use 3M ISO 640T and have it processed in colour negative chemicals. The colour is not totally accurate but the overall image quality can be very effective indeed and the resulting negatives can be printed on conventional colour print paper. With black and white films the same technique of push processing fast films can also be applied. However, there is a particularly suitable film made by Kodak called 2475 recording film. It is very fast, being rated at up to ISO 3200, but also has an especially pleasing, gritty grain structure when enlarged.

In order to enlarge the image to a high degree it is best to compose it so the actual picture area you require occupies only a small part of the transparency or negative. An easy way of doing this is to frame your picture using the most appropriate lens but to switch to one of a much shorter focal length when you make the exposure, frame it on say a 50mm lens but shoot it on a 20mm.

The grain effect will also be enhanced when the contrast of the image is increased at the printing stage. With black and white shots, for instance, you can print onto a hard grade of paper. For this reason it is preferable to ensure that the negative or transparency is of fairly low contrast. This can be done either by the lighting or the way the image is framed, but you can also use a fog or pastel filter, or soft focus attachment, to reduce the initial contrast of the image. It is also essential to ensure that the image is critically sharp when making your enlargements, as slightly out of focus grain is most unattractive. The image must be accurately focused and a small aperture used to ensure that it is sharp right into the corners.

It is worth considering that the grain technique can be applied successfully to existing pictures taken on conventional film. All that is required is to make a fairly soft print from your original negative or transparency and to copy this onto a fast film in the same way.

Another effective technique which can be used to create most unusual and dramatic effects is the use of infra-red films. These are made in both colour and black and white emulsions and are intended primarily for

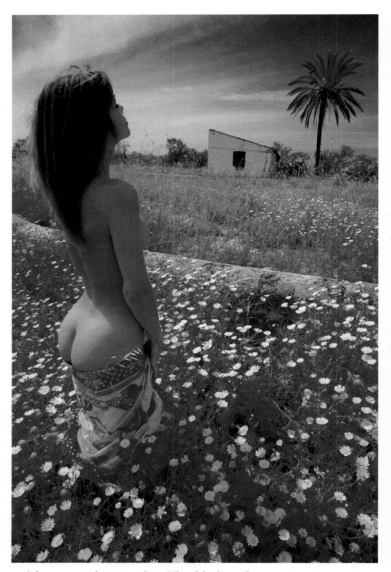

aerial survey photography. The black and white film in particular must be handled carefully. It should be loaded and unloaded from the camera in complete darkness to avoid fogging, and in fact some cameras with plastic bodies are not suitable because they allow infra-red rays to pass through. Although it is intended to be exposed using an infra-red filter, for most purposes a deep red filter is ideal. The effect of the film will vary according to the lighting conditions and subject matter. The most pertinent qualities as far as nude photography is concerned is that it creates a rather eerie, chalky white skin

The effect of this picture was created by shooting on Kodak Infra-Red Ektachrome through a Cokin sepia filter. *Nikon F3, 20mm lens, 1/125 sec. at f8.*

Right: this grainy studio shot was taken on 3M ISO 1000 film, A pastel filter was used to reduce the contrast. *Nikon F3, 105mm lens, f16 with studio flash.*

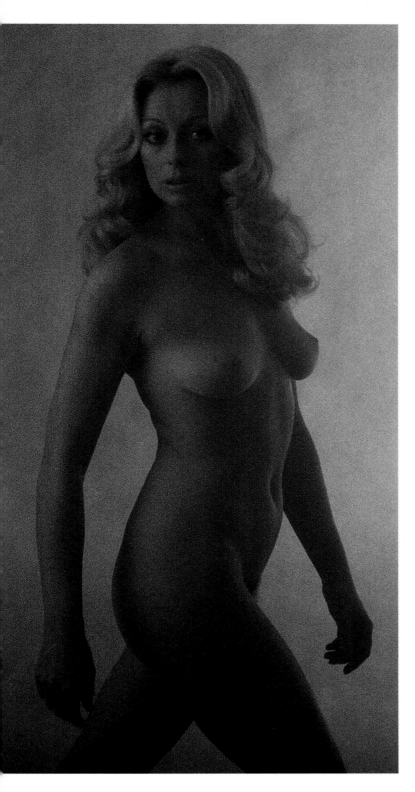

tone, and in landscape situations it records green foliage as a white tone and blue sky as almost black.

The colour version, Infra-Red Ektachrome made by Kodak, is sensitive to both visible light and infra-red radiation and the resulting images can be an intriguing mixture of both conventional colour and wildly distorted hues. It is intended to be processed in the now superseded E4 process but a number of specialist colour laboratories still provide this service. Kodak will inform you of the nearest one. It is recommended that you expose the film through a Wratten 12 filter, which is a strong yellow. With this skin tones will record almost normally but green foliage will record as red or magenta and other colours will also be distorted according to the lighting conditions and subject matter. It is a film with quite high contrast and it is best to vary, or bracket, the exposures as this can have a significant effect on the nature and colour quality of the image. It is also interesting to experiment with other filters in the warm range. I have found the Cokin sepia filter can give very interesting effects.

Other specialist films which offer interesting creative possibilities are high contrast or lith films. These reduce the image to pure whites and blacks and can be effective for images with a pronounced texture or bold, interesting shapes. Orthochromatic films, such as Agfa Ortho, can also be applied usefully to some nude subjects. They are not red sensitive and this causes them to emphasise skin texture. With a male nude, for example, it can be used to create very rich toned images when combined with strongly directional lighting. In landscape situations the film will also help to enhance the effect of mist or aerial perspectives.

Interesting effects can also be obtained by simply using the wrong type of film for the light source. Shooting artificial light film in daylight, for example, will create a strong blue cast, and daylight type film in artificial light will produce a strong yellowish cast. More subtle effects can be created by using light sources with a slightly different colour temperature. For example, you could shoot artificial light film in the reddish light of a sunset, or daylight film when there is a mixture of daylight and artificial light, such as an illuminated street or building at dusk.

Diffusing the Image

One of the qualities of a good photograph is that, in normal circumstances, at least part of the image is critically sharp. There are, however, occasions when it can be very effective to use techniques to diffuse the image and make it softer and less clearly defined. One effect of this is to produce pictures with a more romantic quality, or with an element of fantasy. The impression of texture is something which helps to impart a sense of realism in a photograph, and soft focus or diffusion eliminates the textural quality of the image and makes it seem less real. In addition soft focus techniques can be particularly useful in nude and portrait photography because they reduce the effect of skin texture, minimise blemishes and create a more flattering quality. Soft focus can be particularly attractive when used with back-lighting as the rim of highlight around the model's body or face can create a soft halo of light.

The simplest way of creating this effect is with the aid of a soft focus, or diffusion attachment over the lens. These are glass or plastic discs or rectangles which are engraved or moulded with a pattern of lines or bubbles. They slightly disrupt the light rays passing through the lens and prevent it from forming a perfectly sharp image. The effect is quite different from simply not focusing correctly, because the soft focus attachment allows a central core of sharpness to be retained, giving the image a degree of definition and clarity. Different attachments have varying degrees of effect, some creating only a slight loss of sharpness, others quite a pronounced haze. The choice of aperture is also a factor, and a smaller aperture will diminish the effect. Fog or pastel filters also create a degree of

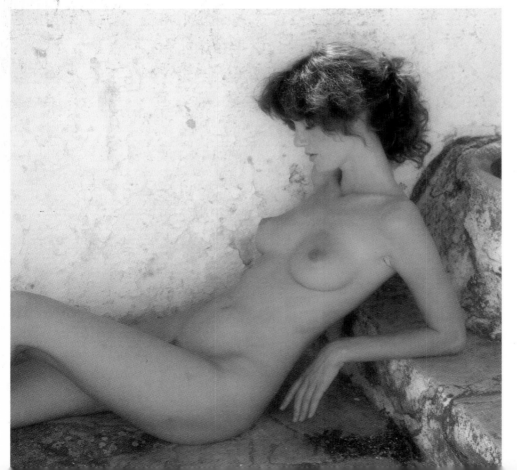

A 'Softar' soft focus attachment was used for this picture and a Wratten 81A was added to make the skin tones warmer. *Rolleiflex SLX, 150mm lens, Fujichrome RDP 100, 1/125 sec. at f5.6.*

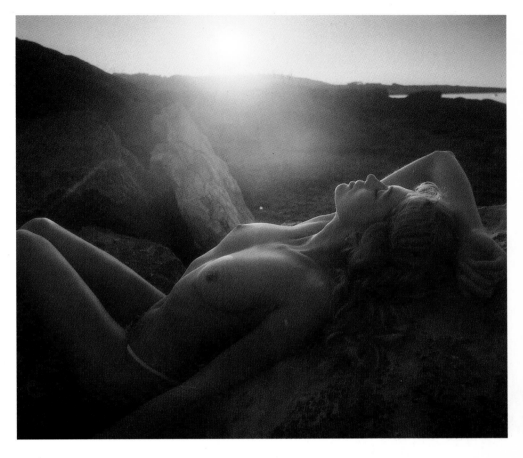

diffusion but they have less effect on the definition and are designed primarily to reduce the contrast or colour saturation of the image. They can sometimes be used effectively in combination with a soft focus attachment.

There are other ways of creating soft focus, each with slightly different effects. Clear adhesive tape, such as Sellotape, can be used by stretching it over the lens slightly in front of it – across the front of a lens hood for instance. You must leave a small, clear hole in the centre to allow a degree of sharpness to be retained. Another useful medium is fine nylon mesh, as used for ladies' tights. This, too, can be stretched across the lens, again leaving a small hole in the centre. If you use a fabric with a strong tint this can create a colour cast, such as sepia, which can also be attractive.

Vaseline, or a similar clear jelly, can also be used effectively. It should be smeared onto a filter such as an 81A, or a piece of plain, thin glass like a slide cover glass, but not directly onto the lens! It can be teased around with a cotton bud or a finger tip, leaving a clear central hole, to create various patterns. In addition to producing a soft focus effect it can also create streaks of light from bright highlights within the picture area.

If you use an SLR camera or a view camera you can replace the camera lens with a magnifying glass lens or perhaps an old box camera lens. These have a quite natural and attractive soft focus effect simply because they are greatly inferior to a camera lens and have inherent aberrations which will not allow them to create such a sharp image. A lens of this type can easily be used with the aid of a bellows extension or even a simple cardboard tube. For exposure purposes the aperture can be calculated by dividing its focal length by its effective diameter, a lens of 30mm diameter and a focal length of 120mm would have an aperture of f4, for example.

Creating Multiple Images

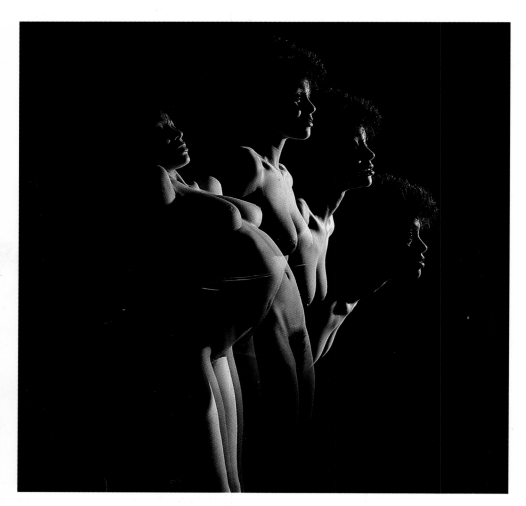

This multi-image picture was made by exposing four times as the model moved position. A black background and rim lighting have prevented the image becoming too confusing. *Rolleiflex SLX, 150mm lens, Kodak Ektachrome EPR, f11 with studio flash.*

If photography has a limitation in terms of expression and interpretation it is probably that of being too literal. The nature and effect of a photograph is largely determined by the subject and because of this it is more difficult for the photographer to create abstract and impressionist images than in other forms of the graphic arts. One way of overcoming this restriction is by the use of techniques which enable two or more images to be combined in a photograph. In this way a photographer is able, at least to some extent, to previsualise his pictures and to create what would otherwise be impossible juxtapositions. The techniques can be used either in a subtle way which deceives the viewer or in a completely contrived way to produce images of pure fantasy.

There are a number of ways of doing this which do not require the use of a darkroom and can enable two or more images to be combined within the camera. Multiple exposure is a technique which involves making more than one exposure onto the same piece of film. For this it is best to use a camera which allows the double exposure prevention mechanism to be overridden. However, it is possible to run the film through the camera more than once, after carefully marking its

starting position. The important principle to understand with this technique is that the second and subsequent exposures will only record clearly within the darker tones of the first exposure, and vice versa. This means that the superimposition of the two images must be made quite carefully and it is a distinct advantage to use a camera which enables a piece of tracing paper to be placed over the screen and the main outlines of each image marked on it. This is possible with an SLR with a waist level viewfinder, or a view camera.

As a general rule the technique is most effective when one image is more dominant than the other. Usually it is best to have a darker image acting essentially as a background and the lighter image creating the focus of interest. When calculating the exposure you must allow for the fact that each exposure will have a cumulative effect and it is necessary to give about half to one stop less for each exposure. By giving less exposure to one image than the other it is also possible to make one more dominant. An underexposed

landscape, for example, could be combined with an image of a nude to give the latter more prominence. More distinction between the two images can be created by using colour filters to produce a colour contrast between them as well as a tonal difference, or the background image could be thrown out of focus to contrast with a sharply defined primary image.

A very convenient way of making multiple exposures is to use a slide duplicator. This will enable you to preselect the best slides for the purpose and be able to position them much more carefully and accurately than would be possible in the camera when photographing the original subjects. If necessary you will be able to make one slide larger or smaller in proportion to the other to help to achieve the best combination of images.

A similar effect can be created in the studio with the aid of one, or more, slide projectors. You will need to work in a darkened room since ambient light will weaken the projected image and when shooting on colour transparency film you will need to use film balanced for artificial light. There are a number of ways of creating effects in this way, and one is to project a slide onto a model. This can be surprisingly effective and works particularly well with images which have a dominant pattern, shape or texture.

If the model is positioned against a dark background and the projector is placed close to the camera the effect will be a quite clearly defined outline of the model with the image of the projected slide imposed upon her. If the projector is placed to one side of the camera it will create shadows and a degree of modelling within the outline in addition to the projected image. If the model is placed against a white background the projected image will be continued beyond her shape onto the background and will create a more subtle or abstract effect.

Another variation on this technique is to combine the projected image with a small and controlled amount of lighting. In this way it is possible to give the image of the model more definition and clarity but still create a combination of images in the areas which are less well illuminated. The lighting will eliminate the projected image wherever it creates highlights, and will produce a double image effect in the middle tones, while the shadow areas

For this picture the model was placed close to a white background and the image of a tree was projected on to both model and background. *Rolleiflex SLX, 150mm lens, Kodak Ektachrome EPT, 1/30 sec. at f5.6.*

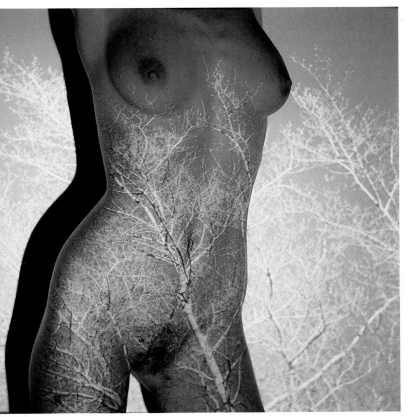

will allow the projected image to dominate. Rim lighting or back lighting can be the most effective since it leaves large areas of darker tones and also helps to define the model's shape. The lights should be fitted with snoots to limit the amount of spilled light, and black screens can also be placed around the model to shield her from any scattered and reflected light which would weaken the projected image.

Making a slide sandwich is a quite simple and straightforward technique but one which can be used to create quite complex and intriguing images. Essentially it involves placing two colour slides together in the same mount. However, the choice of slides is, of course, crucial to the effect. Since the density of the slides is cumulative it is best to choose ones which are slightly overexposed. Initially you will probably be able to find slides from your existing stock which can be used for this technique but it will be more satisfying and effective to visualise the final image and to take pictures especially for the purpose.

The most effective images are likely to be created by using one slide which is essentially a background image and the other as a main point of interest. A transparency with a boldly defined shape or outline will often work best as the main image, a semi-silhouette of a nude, for example, against a light toned background. The secondary image will be most effective if it has a fairly subtle pattern or texture and is essentially light in tone, like raindrops on a window, for example. It helps if the images are not too tightly cropped, then they can be superimposed in a variety of ways to create the best effect. You will need a light box or something similar on which to manoeuvre the slides and to assess the effect, and when the best combination has been found they can be carefully taped together along two edges before being mounted. The final slide sandwich can be projected as it is, or you can make a colour print or duplicate transparency from the combination.

A transparency of a seascape and a nude photographed against a white background were sandwiched together to create this image. Its effect partly depends upon the fact that the lighting and perspective of both images are in the main compatible.

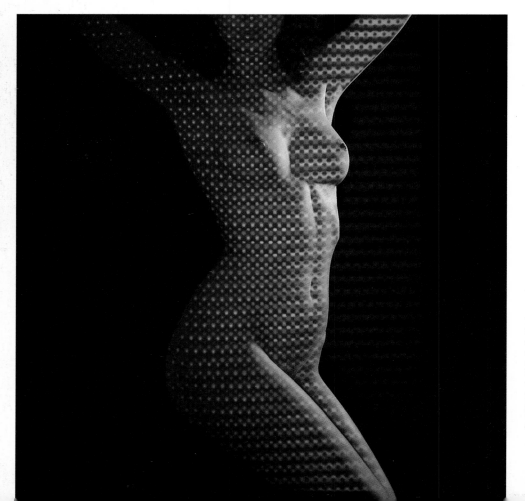

This effect was produced by projecting the image of a *moiré* pattern onto the model, who was placed against a black background. A rim light was used to add definition to her outline. *Rolleiflex SLX, 150mm lens, Kodak Ektachrome EPD, 1/30 sec. at f5.6 with studio flash.*

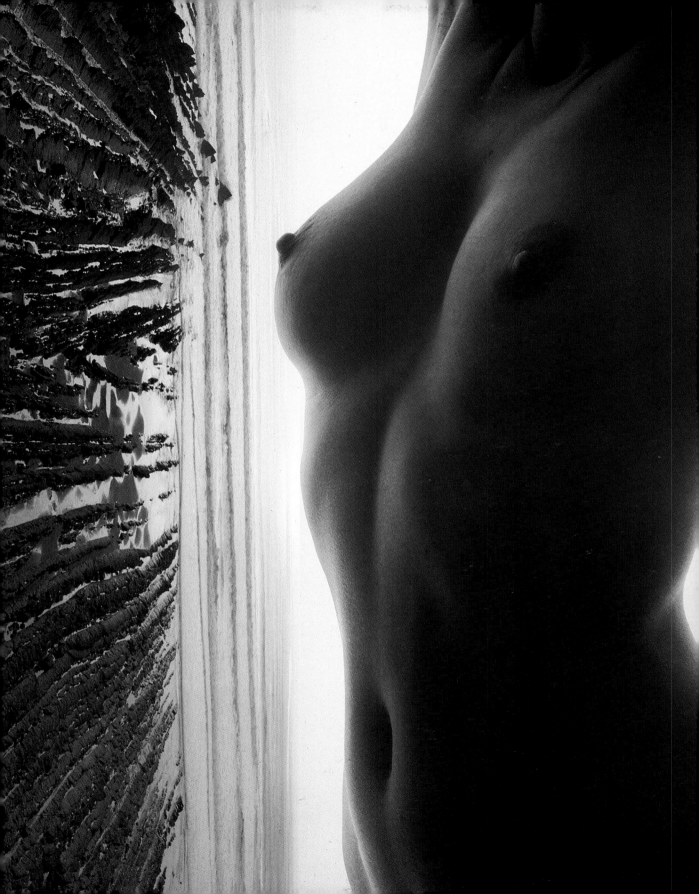

Creative Printing

The photographer who makes his own prints has a wide range of additional creative control over his photographs and there is a variety of techniques which can enable the full potential of an image to be realised as well as being an important means of creating a more personal and interpretive style. Black and white photography in particular needs the art of printing to reveal the full quality of an image, and a finely made black and white print can have a powerful visual impact.

In a purely technical sense, a good print is one which accurately records the tonal range of the original negative or transparency. However, in the creative sense a good print is simply one which creates the most telling effect. Printing from black and white negatives allows considerable control over the density and contrast of the image – a harder grade of paper can be used to increase image contrast, for example, and is an effective way of enhancing qualities such as texture and a pattern and of creating more bold and assertive pictures. Printing on a hard paper is also a way of simplifying the image, by reducing detail in either the lighter or darker areas of the subject, and a means of accentuating the effect of grain. Printing onto a softer grade of paper to reduce image contrast can be used to produce more delicate images, and will also help to reduce skin texture and the effect of harsh lighting, creating a more flattering effect.

Shading and printing in are techniques which can be used to alter the balance of tones and areas within the image. Shading is a way of holding back selected areas during the exposure to make them lighter in tone when printing from negatives or darker when printing from transparencies. A piece of black card cut to shape, or even your hand, can be used but it is essential to keep it moving slightly to avoid a hard edge being created. A small area can be shaded by using a small piece of card taped to a length of wire. Printing in involves giving additional exposure to parts of the image to make them darker in tone, or lighter if printing from a transparency. Again your hand and card shapes can be used for larger areas but a small area can be printed in by using a small hole cut from a large piece of card.

It is also possible to create multiple images at the printing stage and this can be done with more accuracy and control than when making multiple exposures in the camera. It is important to appreciate that when printing from negatives it is necessary to have an essentially light background for each image. This can be achieved either by selecting pictures with inherently light backgrounds or using shading techniques to create light tones in the areas where additional images are to be superimposed.

The first step is to select the negatives you wish to combine and make a rough sketch of the finished effect, noting where it may be necessary to do any shading. Next size up and focus the first negative in the enlarger. Tape a piece of white paper onto the enlarger masking frame, and trace on to it the main outlines of the image. Now make an exposure test in

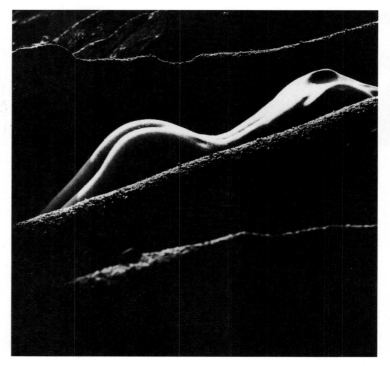

This print was made by using a very hard grade of paper and overexposing to lose shadow detail and to emphasise the lines created by the highlights.

This montage was actually quite simple as the nude was photographed on a white background. It was only necessary to shade out the sea in the other picture when making the second exposure. Once again, it works well because the lighting quality in both pictures is similar.

the normal way. Replace the first negative with the second and size up and focus this onto your tracing, moving the masking frame to position the second image correctly, and then make an exposure test from this negative. Repeat this process for any subsequent images.

You are now ready to make your first montage. Make an exposure in the normal way from your first negative using any necessary shading. After carefully marking the exposed paper in one corner so that it can be replaced into the masking board in exactly the same position, place it in a light-tight box.

Next using your tracing, size up, focus and position your second negative and using the same piece of paper replaced in the masking frame in the same position, make your second exposure, not forgetting to do any shading which may be necessary. Continue this process with any other negatives and then process in the normal way. It is almost certain that you will need to make another print modifying the shading or overall exposures to create a smoother or more effective blend of images. Remember that making one image lighter in tone will give the other more prominence.

Tone Manipulations

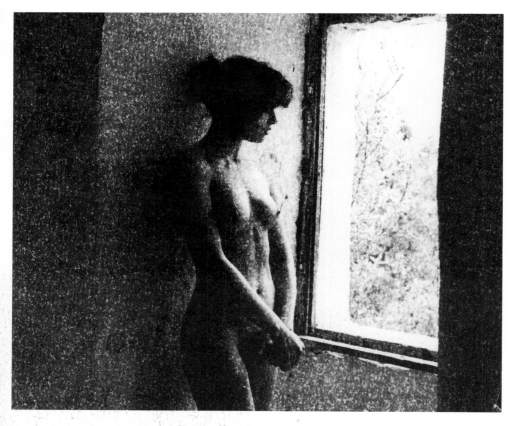

The textured effect of this image was produced by printing the negative in combination with a piece of the translucent paper used for negative storage bags!

There are a number of quite simple darkroom techniques that can be used to alter significantly the basic quality of a negative or transparency and which can add interest and impact to a picture.

Bleach outs are normal negatives or transparencies which have been reduced to pure black and white, eliminating the intermediate grey tones. It is quite simple to do and can be very effective but requires the use of special lith film or paper and chemicals. These can be obtained easily from professional dealers. The main control over this technique is in the exposure since it is this that determines at which point the image divides into black or white. When working from a negative, more exposure will produce an image in which all but the lightest tones are recorded as black, and less exposure will produce an image in

which only the dark tones record at all. The technique can be very effective with images which have a pronounced texture or a bold shape and it can also be used to create a quite dramatic effect with very grainy images.

Tone separation is an extension of the bleach out method and is a way of creating an image with just four tones. It requires making three positives on lith film – one exposed so that only the darkest tones of the original negative are recorded, one with all but the lightest tones recorded as black and one exposure between the two. These three positives must now be contact printed in precise register onto a sheet of ordinary negative film: you can use a punch register to do this. Make an exposure test to find the exposure which records the clear film as a light tone of grey and then give the same exposure to each

positive in turn onto the same piece of film, and process in the normal way. The result will be a negative which will produce a print with just four tones, white, black, light grey and dark grey.

Another interesting effect is that of solarisation, or the Sabbatier effect. This involves re-exposing, or fogging, a negative halfway through development. The result is a partial reversal of the image combined with a line created between different tonal areas. It is very much a process of trial and error and since you will not want to risk an original negative it is perhaps best to try this by making a black and white negative from a colour transparency. There is a loss of contrast so it is an advantage to make the negative on lith film. The duration of the second fogging exposure is a matter of trial and error but it is easier to control by placing the partially developed film under the enlarger and giving a timed exposure with the negative carrier removed. As a starting point you

could try a fogging exposure of about half of that which was required for the negative. It is also possible to produce this effect chemically using *Tetenal's Fotografik* paper and developer.

A texture screen is an image on a piece of film which is combined with a negative or transparency to impose a texture or pattern effect, in a similar way to a slide sandwich. It is very simple since it only requires placing the negative and texture screen together in the negative carrier of the enlarger and making a print in the normal way from the combination. It is possible to buy ready made texture screens from photographic suppliers giving effects like silk, hessian, and mesh for example, but it can be more interesting to make or find your own. The translucent paper bags used for storing negatives can be used to create an attractive crystalline texture, and it is also possible to make weak negatives, or positives, on ordinary film in the camera from objects with surfaces such as leather and wood or even something like a field of grass.

Right this image was produced by first making an enlarged positive from the negative of the male portrait on to lith film, and then contact printing this on to another sheet of lith film to produce a negative from which the final print was made.

The texture screen for this picture was made by photographing a piece of hessian, and using a thin negative of this sandwiched together with the negative of the nude.

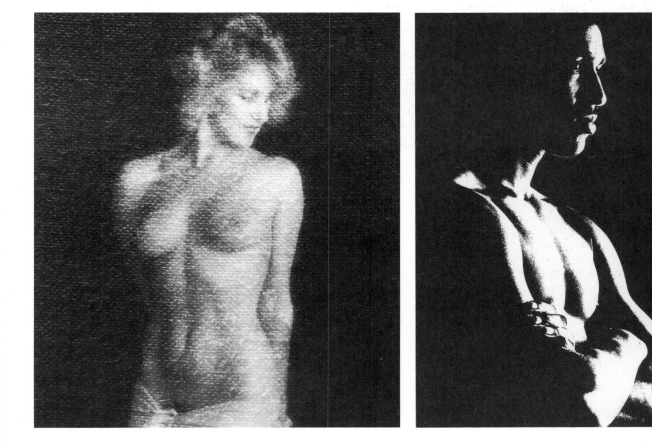

Toning and Hand Colouring

As we have discussed before, realism is a quality of the photographic process which can inhibit the use of the medium for creative and interpretive work. The use of colour film is responsible for creating an even greater sense of realism than black and white materials and can make it even more difficult to produce impressionist or abstract images. One way around this is to use techniques to add colour to black and white images making the result more controlled and less real.

Colour toning is a simple and effective way of doing this. The most commonly used is sepia toning and it can be particularly suitable for nude and portrait photographs. Most processes require a normal black and white print, which has been well washed, to be first bleached in a special solution and then re-developed in the toner and afterwards washed in running water. The process can be carried out in daylight. However, a wide range of colours can be created in this way using different chemicals, red, brown, blue and green and shades between are all possible, some simply requiring the print to be immersed in a single solution and then briefly washed.

It is also possible to dye prints. The effect is different because toning changes the colour of the image and a dark tone will produce a richer colour, whereas dyeing affects the white and light tones of the image leaving the darker tones unaffected. It can be particularly effective with bleach out prints or tone separations for example. It is possible to buy special photographic dyes but ordinary fabric dyes, well diluted, can also be used. It is also possible to combine the effects of toning and dyeing. Kits of chemicals and dyes, such as *Colorvir*, can be obtained from photographic dealers enabling a wide range of different effects to be created. A masking solution can also be applied to the print so that selected areas can be dyed or toned, and if required

This image was produced by blue toning, using the Colorvir process. The effect was chosen to suit the mood of the picture.

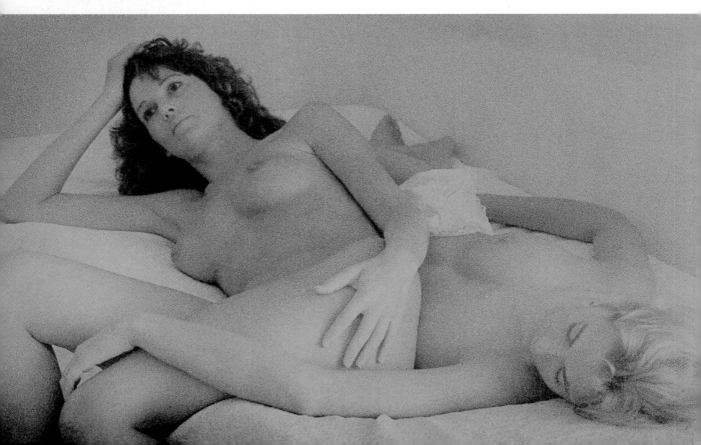

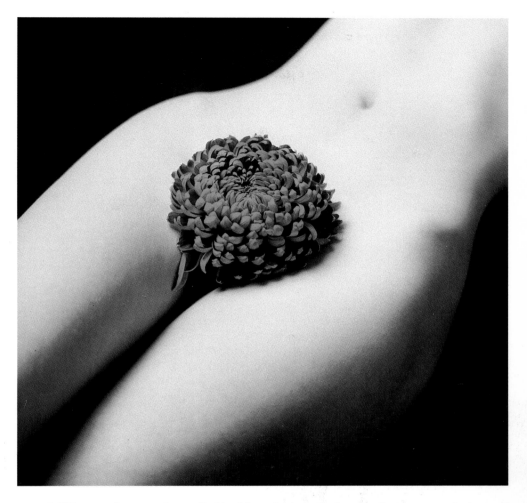

This was a relatively simple piece of hand colouring. Since only one colour was added to one area of the image, the print was first sepia toned.

several different colours can be applied in this way.

Hand colouring is another means of adding colour to a black and white print in a very selective and controlled way. It is most easily done with the aid of transparent photo dyes but oil colours can also be used most effectively by those with some painting skills. The process works best with a fairly soft and light toned print. Many workers prefer to sepia tone the print first, and it is easier to work on a pearl or stipple surface than a glossy print.

It is also best to apply the colour to a print which is damp, just blotting the surface moisture away. It should be taped to a board and the weaker colours should be applied first to the larger areas of tone. It is a good idea to have a second print upon which you can try out the colours first, mixing and diluting

them on a palette until you can get the hue and saturation you want in a single application. Large areas of colour can be applied either with a large soft brush, or cotton wool swab or bud. Work from the larger areas and paler colours to the smaller details and more saturated colours, these should be applied with a fine sable brush.

It is not necessary, or even desirable, to try to emulate the effects of colour film. Indeed the most effective images of this type are often pictures which are left primarily in monochrome with only small details and areas picked out in colour. It can also be effective to combine the effects of colour toning with hand colouring – a green toned print of a nude in a landscape could for instance be quite striking if just the skin tones are given an application of colour.

INDEX